W9-CLW-502

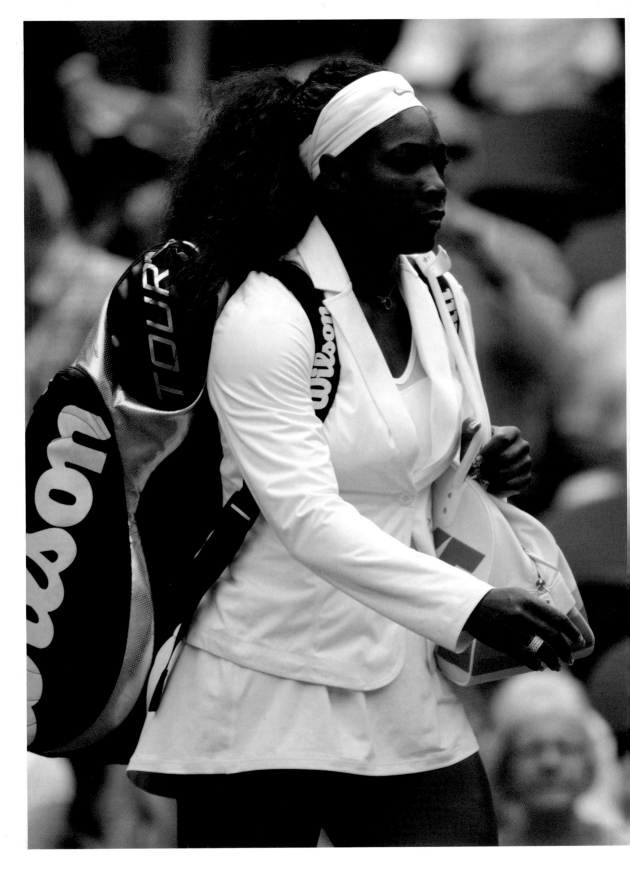

SERENA

A GRAPHIC BIOGRAPHY OF THE GREATEST TENNIS CHAMPION

Mark Hodgkinson

WHITE LION PUBLISHING

Cover image: 2019 Australian Open, Getty (JEWEL SAMAD / Contributor)

Brimming with creative inspiration, how-to projects and useful information to enrich your everyday life, Quarto Knows is a favourite destination for those pursuing their interests and passions. Visit our site and dig deeper with our books into your area of interest: Quarto Creates, Quarto Cooks, Quarto Homes, Quarto Lives, Quarto Drives, Quarto Explores, Quarto Gifts, or Quarto Kids.

First published in 2019 by White Lion Publishing,
an imprint of The Quarto Group.
The Old Brewery, 6 Blundell Street
London, N7 9BH,
United Kingdom
T (0)20 7700 6700
www.QuartoKnows.com

© 2019 Quarto Publishing plc.
Text © 2019 Mark Hodgkinson

Mark Hodgkinson has asserted his moral right to be identified as the Author of this Work in accordance with the Copyright Designs and Patents Act 1988.

All rights reserved. No part of this book may be reproduced or utilised in any form or by any means, electronic or mechanical, including photocopying, recording or by any information storage and retrieval system, without permission in writing from White Lion Publishing.

Every effort has been made to trace the copyright holders of material quoted in this book. If application is made in writing to the publisher, any omissions will be included in future editions.

A catalogue record for this book is available from the British Library.

ISBN 978 1 78131 906 2
Ebook ISBN 978 1 78131 907 9

10 9 8 7 6 5 4 3 2 1

Design: www.fogdog.co.uk
Infographics by Paul Oakley and Nick Clark
Printed in China

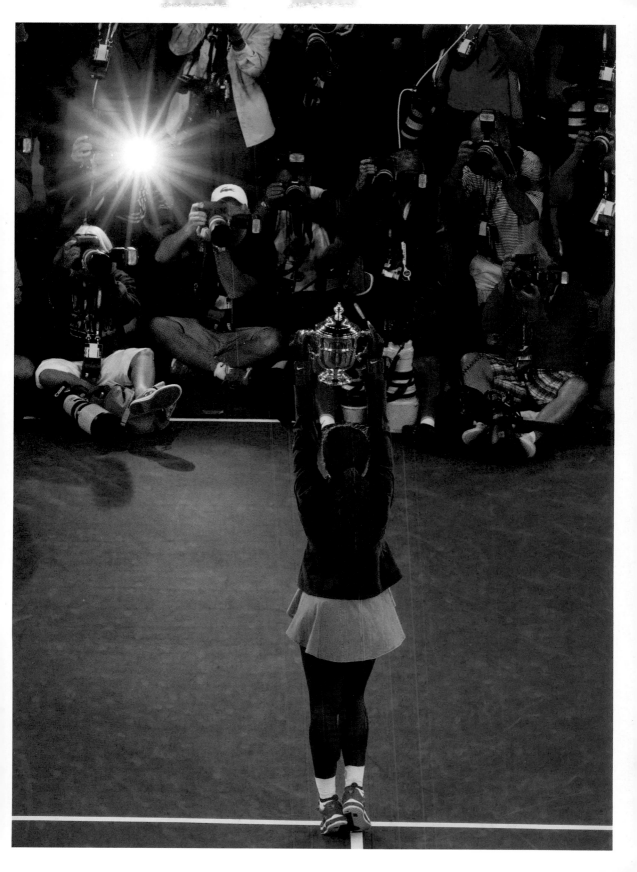

CONTENTS

PROLOGUE

Most infants have soft toys on the shelves of their rooms; Serena's daughter, Olympia, has a replica of the Australian Open trophy. 'I feel like it's hers,' Serena has said. After all, Olympia was on court throughout the 2017 Australian Open – Serena was two months' pregnant during that tournament, where she became the first woman in history to win a Grand Slam title while expecting a baby.

Iconic is a word that is used too liberally and casually – not just in tennis, but in all industries. Yet Serena confirmed her status as a true tennis icon during her first trimester, taking her twenty-third Grand Slam singles title to become the most successful tennis player, man or woman, of the post-1968 Open Era. Winning a major is hard enough already – just try doing so when eight weeks' pregnant, when your body is undergoing enormous change, and when you know you'll need to win every match in straight sets: you simply won't have the energy in the Melbourne heat for any deciding third sets.

Only Serena's inner circle knew her secret, including her future husband Alexis Ohanian, her agent Jill Smoller and her elder sister Venus. Even Serena's coach, Patrick Mouratoglou, the Frenchman who had taken her from 'great to history', was unaware that the American had been pregnant when she ripped through the entire fortnight, including beating Venus in the final, without dropping a set. A couple of months later, the world of tennis re-evaluated Serena's achievement when she revealed her pregnancy by accidentally posting a photo of her bump on Snapchat.

Victory broke her tie with Steffi Graf on twenty-two majors apiece. Unlike Serena though, Graf had started her family after retiring from tennis, and the German had won her Grand Slams in a more concentrated period of time, in the twelve years between 1987 and 1999. Some eighteen

years had passed between Serena's first major, at the 1999 US Open, and this triumph at the Australian Open. She had won Grand Slams under four different US Presidents: Clinton, Bush, Obama and Trump. At the age of thirty-five, Serena had also extended the record she herself had set, for being the oldest Grand Slam singles champion in history.

The winning of that unprecedented twenty-third Grand Slam title encapsulates several elements of Serena's story. One is her desire, from an early age, to take a giant swing at sporting history and her quest to win more Grand Slams than anyone else – and this coupled with the ambition of being recognised as the greatest tennis player of all time.

Another element is how far Serena and Venus have both travelled in their tennis lives – from the cracked public courts of Compton, California, where practice was occasionally broken off because of the sound of gangland shootings, to the biggest stages of all. Their success serves as a reminder of their father Richard's astonishing vision and perseverance: he, who, when his daughters were no higher than a net post had predicted their global domination of the sport, in a world that had not previously known too many black champions, let alone ones from places like Compton. Richard had also forecast that Serena was the 'better, badder and meaner' of the two, something very important to the younger Williams sister. Venus has always been so much more than sibling, friend, confidante and practice partner for Serena; she has also been her greatest rival, and the 2017 final was the ninth occasion that they had played against each other in a Grand Slam final, in a series that stretched back to the 2001 US Open.

The night was also an illustration of how Serena has had to overcome much more than her opponents; playing a Grand Slam during the early

stages of pregnancy was just another challenge in a career spliced with adversity and struggle. It was mere days before the Australian Open began that she learned she was pregnant. Perhaps other leading tennis players, on discovering such news on the eve of a major, might have withdrawn, or would have played without being fully committed. That wasn't Serena. Once she had got over the initial shock, and the doctor had confirmed that there was no risk attached to competing, she resolved to win the title.

For all her greatness and career longevity, with more than twenty years in the tennis elite, little has been straightforward about Serena's career. Twice she has come close to death – after developing blood clots on her lungs, and following the birth of Olympia – and she has grieved for her murdered half-sister and coped with periods of depression. She has been subjected to racist abuse, on and off court, and been trolled about her body shape. There have also been freaky, unsettling injuries (one sustained while dancing in heels in a Los Angeles nightclub, and another from stepping on broken glass in a restaurant in Munich), as well as several high-profile controversies of her own making. She has been through so much that, at times, when reviewing her career, it is tempting to question how she has ever had time to fit in the tennis. Yet, from the very beginning, from the very first time she swung a racket in Compton, she has embraced that fight and struggle to achieve her dreams.

Anyone who has amassed more than twenty Grand Slam singles titles has a compelling narrative, but, with Serena, the lifting of those trophies is only one element of her story.

◀ Pregnant with her first child, Serena didn't drop a set all tournament at the 2017 Australian Open.

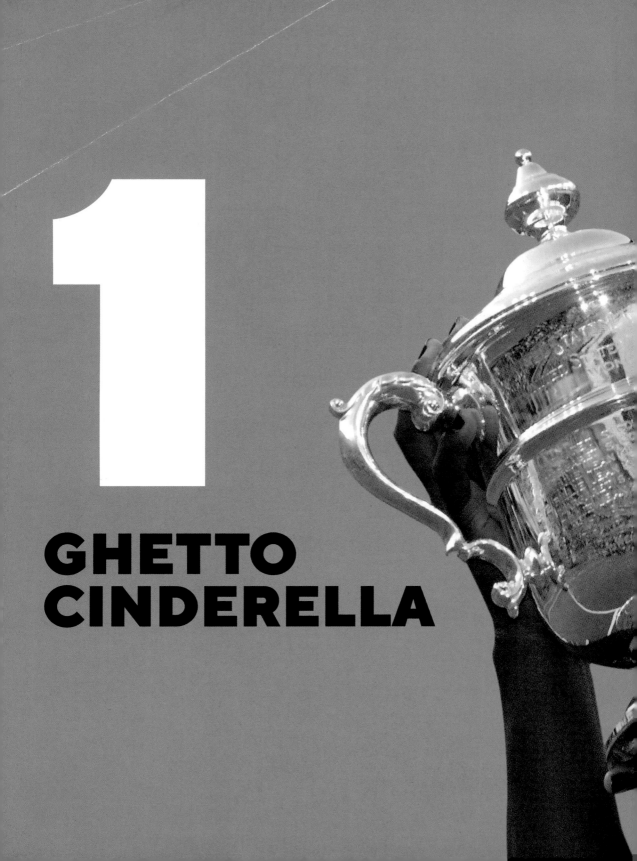

1
GHETTO CINDERELLA

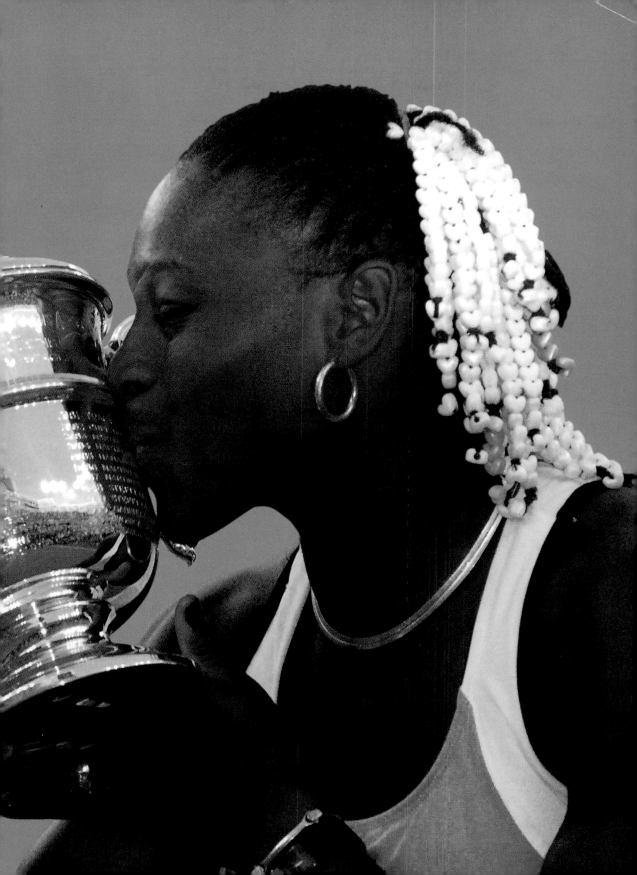

Even Serena Williams can't always separate the urban tennis myths from the reality of her days at the 'East Compton Hills Country Club', as her father and coach Richard used to call the cracked public courts in gangland Compton.

While her greatness is undisputed, there are elements of her story which may or may not be rooted in reality: what was fact and what was fiction in that city south of Los Angeles, California, far from known as a training ground for tennis champions? Serena's childhood memories are sometimes at odds with her father's recollections – a man who once said that he was going to buy the Rockefeller Center in New York for $3.9 billion. The Williams sisters already had the best backstory in tennis, and that didn't need any embellishment, but Richard felt it could be improved and he was as energetic about promoting his daughters as he was about coaching them. In that he was aided and abetted by others, including the media. As Serena has observed of the stories doing the rounds in tennis: 'Some of them are even true.'

Scratched and scarred on to Serena's memory of her early tennis life – which began when she was just three years old – is how the Compton courts were covered with shards of glass, crumpled soda cans, beer bottles and fast-food wrappers. In among the cracks were weeds. What she can't quite recall – but she's been told – is having to sweep away the syringes, the

▶ Serena (far right) with her sister Venus and father Richard in Compton.

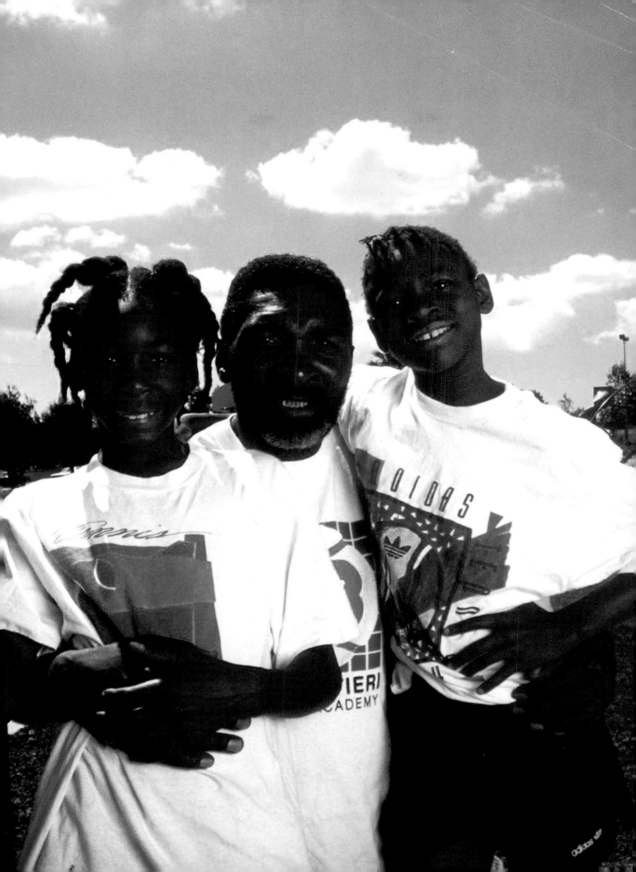

empty crack vials and other drugs paraphernalia before practice. In the 1980s and early 1990s, gang violence between the Crips and the Bloods made Compton 'the worst neighbourhood in the world', according to Richard. In the midst of these drive-by shootings and firefights, Serena and elder sister Venus were trying to develop the powerball game that in years to come would bring them multiple Grand Slam titles and reinvent women's tennis.

The first few times Serena heard a drive-by shooting close to the courts, she recalls thinking it was kids fooling around with firecrackers or popping balloons. Once she understood what those bursts of sound were, 'that would shake me up pretty good', and she would stop in the middle of a drill or a point.

When cars backfired, Serena and Venus would also often hit the floor, the sound being so similar to gunfire. Venus recalls one drive-by, 'when a guy got out of the sunroof and started shooting – and then we went back to practice'. Once the shooting stopped, or it sounded as though it was some distance away, Richard would gently ask his daughters to continue: 'Never mind the noise, just play.'

Gang members were curious about this family, who would arrive at their 'country club' in their dirty Volkswagen minibus, before unloading shopping carts full of old, squidgy tennis balls that had long since had the life battered out of them. Those gang members turned into the Williams' unofficial protectors, doing their utmost to ensure their practice would not be interrupted. That extended, so one story goes, to those gangsters teaching the girls how to avoid being caught in the crossfire of a gun battle: crawling on their hands and knees across the hard courts in search of some cover.

Relations between the Williams family and the gangs apparently weren't always so cordial, however. Richard, who has likened the Crips and Bloods' domination of Compton to a military occupation, has said he was beaten up while trying to take his daughter to the courts, leaving him with several broken ribs and missing teeth. As Richard once said: 'We play in hell.'

It would be tempting to characterise the Williams family as using tennis to 'escape the ghetto'. Richard referred to his own girls as 'Ghetto

SPEED OF SERVE

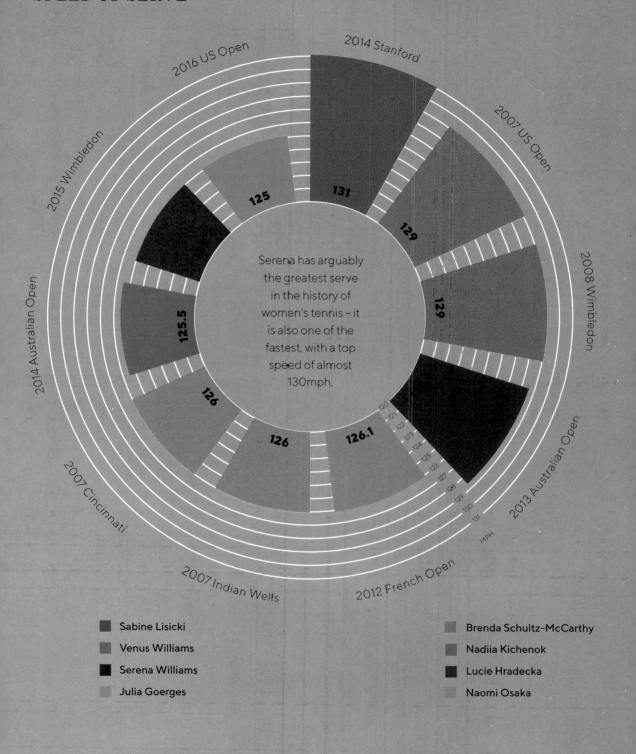

Serena has arguably the greatest serve in the history of women's tennis – it is also one of the fastest, with a top speed of almost 130mph.

2014 Stanford — 131

2007 US Open — 129

2008 Wimbledon — 129

2013 Australian Open — 126.1

2012 French Open — 126

2007 Indian Wells — 126

2007 Cincinnati — 125.5

2014 Australian Open — 125.5

2015 Wimbledon

2016 US Open — 125

120 121 122 123 124 125 126 127 128 129 130 131 MPH

Legend:
- Sabine Lisicki
- Venus Williams
- Serena Williams
- Julia Goerges
- Brenda Schultz-McCarthy
- Nadiia Kichenok
- Lucie Hradecka
- Naomi Osaka

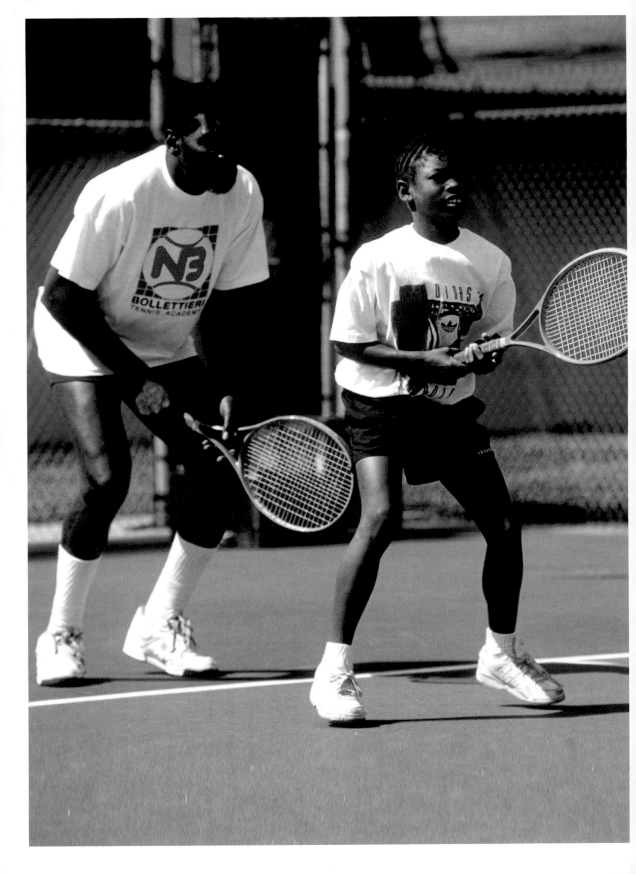

'How much easier would it be to play in front of thousands of white people if they had already learned to play in front of scores of armed gang members?'

Cinderellas' and, in years to come, he would send out press releases about his girls' tournament results, as well as about how they had trained under fire. But far from 'escaping the ghetto', Richard had sought out Compton: it was at his insistence that the family had moved there. 'What led me to Compton was my belief that the greatest champions came out of the ghetto,' Richard wrote in his autobiography, *Black and White: The Way I See It*. 'How much easier would it be to play in front of thousands of white people if they had already learned to play in front of scores of armed gang members?'

Born in Saginaw, Michigan, on 26 September 1981, Serena was the youngest of five girls. Legend has it that Richard was channel-hopping one night when he happened upon footage of a Romanian tennis player, the 1978 French Open champion Virginia Ruzici, being presented with a cheque for $40,000 at a regular event on the women's tour (a lower level than the Grand Slams). In the space of a few days, she had earned what Richard did in a year. Unsure whether he had seen and heard that figure correctly, he bought a newspaper the next day to make sure. On returning home, Richard said to his wife, Oracene: 'We need to make two more kids and to make them into tennis superstars.' As they were already bringing up her three daughters from her first marriage – Yetunde, Isha and Lyndrea – Oracene was reluctant to add to their family. Richard would not be dissuaded though and hid Oracene's birth-control pills. Venus and Serena were the result.

Over the years, Richard has endured more than just physical beatings: he has had to deal with the laughter and mockery of the tennis

◄ Serena practising in Compton, under the guidance of father and coach Richard.

establishment, who saw him as the ultimate outsider, as the looniest tennis father of them all. Inspired by Ruzici, and the possible financial rewards for his own family, Richard was the man who went from being a tennis know-nothing – with no background whatsoever in the sport, of playing or coaching – to producing two of the all-time greats.

In Serena's analysis, many others have come to tennis with a background of 'privilege' and a sense of 'entitlement'. She had neither – just a mother who was a nurse, and a father who worked in security, and who had experienced appalling racially motivated violence in his youth. In Louisiana in the 1950s, a teenage Richard was attacked by a group of white youths who drove a railroad spike into his leg. The son of a sharecropper, Richard will never forget how he was brutalised by the Ku Klux Klan – and how his father just stood there and watched.

To teach themselves how to play tennis, Richard and Oracene watched instructional videos. Richard also had lessons with a man known as Old Whiskey, whom he paid in hard liquor. Learning quickly, Richard would write a 78-page document on how to raise tennis champions. All five daughters would show up at the Compton courts, though in time five became two, with Yetunde, Isha and Lyndrea's interest in tennis fading, leaving just Venus and Serena to strive for greatness. Richard, Venus and Serena would spend several hours a day on court. Still, for Richard, there was the concern that relocating his family to Compton, with its grinding poverty and high murder-rate, had been a dangerous miscalculation, and he 'prayed hard' that the gangs wouldn't kill his wife and daughters, even though some of the gang members seemed to be looking out for them.

At the same time, and this might seem odd for someone troubled by his children's safety, Richard paid local kids to stand behind the court and shout racist abuse at his daughters through the wire fence. Richard's astonishing idea was that making his daughters listen to those racial slurs while doing baseline drills would harden them up for competition and prepare them for the unexpected.

In that fraught, volatile environment, Serena and her siblings learned a sport, once more commonly associated with the summer garden parties of aristocratic Victorian England, where the greatest danger was the

▶ Richard Williams, who had no background in tennis, is arguably the greatest coach of all time.

RETURN OF SERVE

The numbers behind Serena's return.

0.69
SECONDS

AVERAGE
REACTION
TIME WHEN
RECEIVING
SERVE

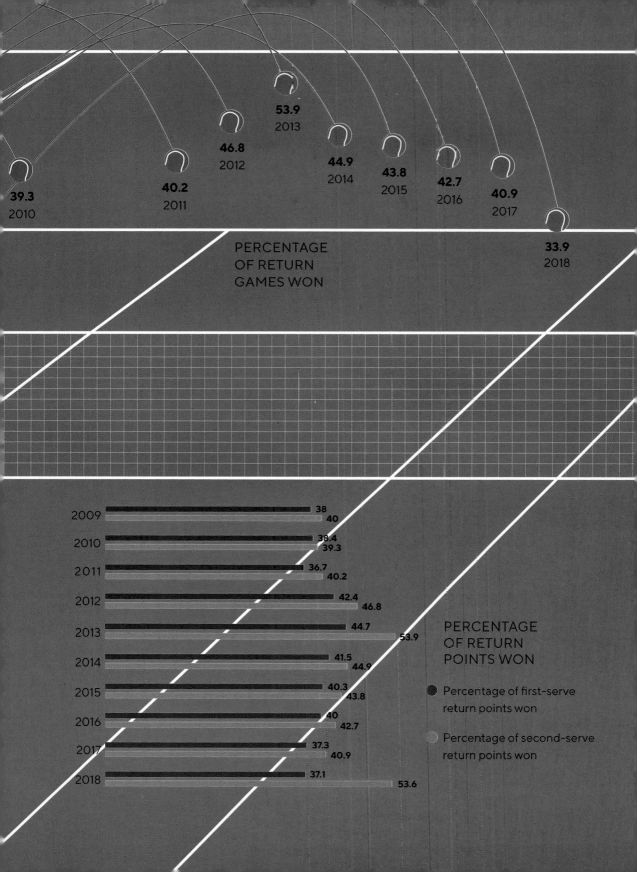

39.3
2010

40.2
2011

46.8
2012

53.9
2013

44.9
2014

43.8
2015

42.7
2016

40.9
2017

33.9
2018

PERCENTAGE
OF RETURN
GAMES WON

PERCENTAGE
OF RETURN
POINTS WON

Year	First-serve	Second-serve
2009	38	40
2010	38.4	39.3
2011	36.7	40.2
2012	42.4	46.8
2013	44.7	53.9
2014	41.5	44.9
2015	40.3	43.8
2016	40	42.7
2017	37.3	40.9
2018	37.1	53.6

● Percentage of first-serve
return points won

Percentage of second-serve
return points won

possibility of spilling lemonade down one's tennis whites. Geographically –
and in almost every other way – Compton was a long way from the grass
courts of Wimbledon, in south-west London, or, indeed, from the Australian,
French and US Opens. Soon enough though, those tournaments were on
Serena and Venus's minds. They might not have chosen tennis, but their
obvious talent meant the girls were soon consumed by the sport.

The instruction didn't end when they left the public courts. Richard
put up signs in their front yard to build their mindset, such as: 'Serena, You
Must Learn to Use More Top Spin on the Ball' and 'Venus, You Must Take
Control of Your Future'. Richard was a prolific sign maker; in years to come,
he would hold up handwritten banners during their matches on tour, such
as 'Welcome to the Williams Show', 'I Told You So' and 'It Couldn't Have
Happened to a Better Family'.

In Richard's world, it was important to strive and to toil; he claimed that,
at a very young age, he had his daughters delivering phonebooks for money.
To stop his daughters from even contemplating the thought of young
motherhood, it's said that he would rip the heads off their dolls – odd perhaps
and yet maybe another example of the shock tactics he used to toughen
them up and make them feel different from the other Compton girls.

Raised as Jehovah's Witnesses because of their mother Oracene, Venus
and Serena had a faith that gave them a moral code. They have continued
to adhere to their religious teachings in adult life. For instance, Jehovah's
Witnesses don't celebrate birthdays so when Serena's daughter, Olympia,
turned one, the new mother didn't break with that practice. Over the years,
Serena has knocked on doors to talk to strangers about her god – she would
have liked to have done so more often, but people tended to recognise her,
distracting from the message she wished to impart.

Oracene's role in the Williams sisters' lives is sometimes completely
overlooked, but there is no mistaking her influence on her daughters,
both as a parent and coach. Serena fondly refers to her mother as 'a real
no-nonsense lady'.

From an early age, Serena was competitive, bordering on ruthless.
Whether playing the card game Uno or contesting family talent shows
where she would always perform Whitney Houston's 'Greatest Love of All',

Serena was determined to win. When she didn't, she would howl and sob. Recalling that time, Serena has referred to her 'rotten streak' and how she could be 'a real witch'. Being the 'baby of the family', the 'princess' and 'everyone's pet', as well as being 'cute', Serena felt as though she could get away with anything. Most of the time, of course, she was right.

▲ Richard Williams became known for holding up handwritten signs during his daughters' matches.

• • •

Sports Illustrated's Jon Wertheim once wrote about Richard Williams that 'getting a grip on the man can be like trying to grab a handful of cigarillo smoke'. Yet, in most people's minds, Richard has been forgiven for

his wild storytelling. Here is someone who has done something quite remarkable. The best thing going for Richard – and consequently also for his daughters – was that he had no background in tennis and that freed him up to do things differently. There certainly wasn't any gilded pathway from Compton to the US Open's Arthur Ashe Stadium. And if Serena is the greatest tennis player of all time, then perhaps her father is the coaching GOAT (Greatest of All Time). After all, which other coach has successfully batted away the old traditions and practices of tennis with such glee and gumption?

When Serena was nine years old, the Williams family moved from the West to East Coast, journeying from California to Florida in a Winnebago, fretting all the way that they were missing out on valuable practice time. That move might have looked like a significant concession to the wisdom of the tennis establishment – the Williams sisters were to train with renowned coach Rick Macci – but Richard was still very much doing things his own way. He wasn't handing full responsibility over to Macci – he would continue coaching his daughters.

While Venus and Serena played some tournaments, Richard came to the view that the junior tennis circuit was a 'freak show', and that he would no longer allow his daughters to be a part of it. Richard wanted his daughters to lead a 'normal life' as children, away from the pressures of junior tennis, which could be a vicious place in which to live and play. They could stay where they were in Florida and work just as hard on their education as on their groundstrokes. Richard also felt as though the guidance of coaches such as Macci and Nick Bollettieri, as well as hitting with boys and men, would give his daughters greater opportunity to improve their game. Inevitably, the decision to keep them back from the junior scene, where their tennis could be judged against their peers, added to the intrigue and mystique that was building up around the sisters – and intrigue and mystique attracted sponsors, allowing Richard to give up his job and fund his daughters' tennis education.

'People in tennis seem to like it when things go a certain way, and here was this tall, proud, black man from California, who'd never played tennis himself, raising up a real prospect and her kid sister, who might just turn out

◄ Serena was kept away from the junior tennis circuit, as her father thought it was 'a freak show'.

to be a real prospect as well, and going against the way things were done,' Serena wrote in her 2009 autobiography, *My Life: Queen of the Court*. 'He seemed to be thumbing his nose at the tennis establishment, but of course it wasn't like that.'

There were other, longer-term benefits to keeping Serena and Venus away from other juniors; it would keep them from 'burning out' as adults. Richard once said he wanted his daughters to retire in their mid-twenties, but both have carried on well into their thirties. Serena started young, too. A month after her fourteenth birthday, she sampled professional tennis for the first time, when she entered the qualifying competition for the 1995 Quebec tournament, where those with low or no ranking attempted to hustle their way into the main draw. There wasn't much hustle from Serena. Playing against a fellow American, Annie Miller, Serena won just two games in her first match. Unfortunately for Serena, her tennis was held back by her low self-esteem; she was small and felt that she was 'ugly'. While she saw her sisters as having grace and beauty, she hated how she looked, and that self-loathing began to impact on her playing. She wouldn't play another tournament in 1995 – or, indeed, throughout 1996.

It wasn't until the spring of 1997, at the hard court tournament in Indian Wells in the Californian desert, that Serena reappeared, and she didn't hang around for long, losing in the first round of the preliminary qualifying event. She had much more impact at a tournament in Chicago towards the end of the season, where she beat France's Mary Pierce, the world number seven, and Yugoslav–American Monica Seles, the number four, on the way to the semi-finals. Following their father's lead, both Serena and Venus had an unconventional approach to life on the tour, down to writing and editing a newsletter, called 'The Tennis Monthly Recap', which included interviews with other players and tour gossip, and which the sisters distributed in the player lounges at tournaments. If anything, the newsletter helped to endear Venus and Serena to their peers on the circuit. In more ways than one, Serena and Venus were getting themselves noticed, Serena, in particular, for her serve.

While Venus always seemed to be tall for her age, Serena was 'on the tiny side' as a child, and the younger sister adapted her game accordingly,

▶ Serena was just seventeen years old when she won the 1999 US Open.

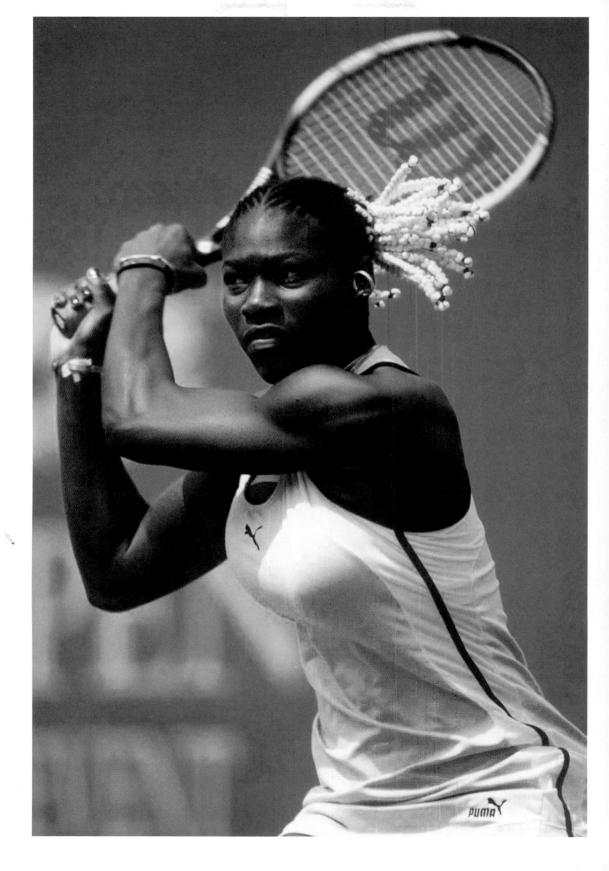

SERVE SPEED AND DIRECTION

A look at how Serena varies the speed
and direction of her serves.

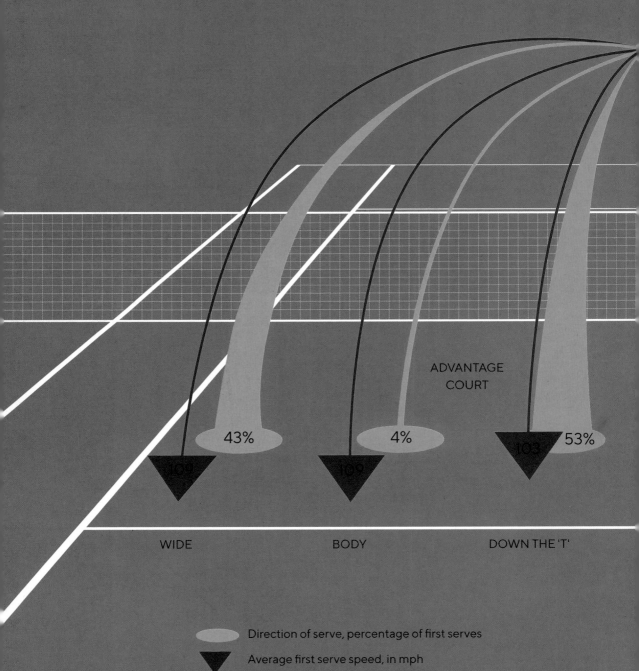

ADVANTAGE
COURT

43%

4%

53%

109

109

103

WIDE

BODY

DOWN THE 'T'

Direction of serve, percentage of first serves

Average first serve speed, in mph

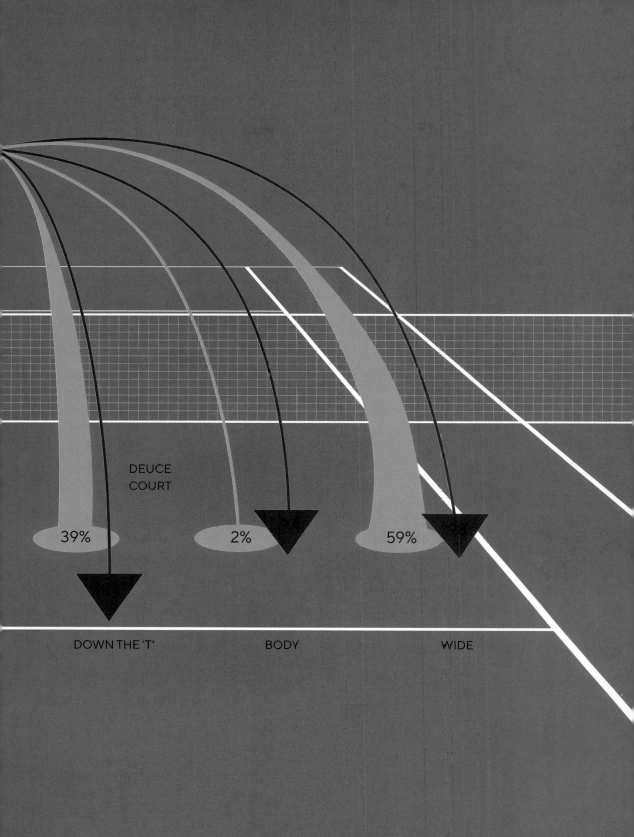

DEUCE
COURT

39% 2% 59%

DOWN THE 'T' BODY WIDE

using lobs and drop-shots and spins and angles, building a versatility that in future years would ensure she had more options than simply smacking the felt off the ball. Around the age of sixteen, she had what she described as a 'monster growth-spurt' and, with her new stature and new muscles, she could add plenty of pop and power to her game. Throwing American footballs around, which was certainly unorthodox, only added to the strength in her shoulder. Just as unconventional was flinging old rackets as far as she could across a yard. Serena's serve was becoming a weapon – here was the first sighting of a shot that would help bring her so many Grand Slam titles and propel her to greatness.

◄ Serena remains close to her father, who has often taken his own pictures of his daughters competing.

● ● ●

Playing in her first Grand Slam, the 1998 Australian Open, Serena lost to Venus in the second round, which did nothing to disturb the general consensus in tennis that the elder Williams sister was the greater prospect. Perhaps inevitably, Richard had a different angle on things. Not that tennis listened to him at the time. The tennis establishment ignored Richard – or worse, derided him – when he said his daughters would go on to world domination. They also ignored him for suggesting Serena was 'better, badder and meaner' than Venus.

Before she became a Grand Slam singles champion, Serena picked up some doubles majors – she took the 1998 Wimbledon and US Open mixed doubles titles alongside Max Mirnyi from Belarus, as well as the women's doubles title at the 1999 French Open with Venus. It's very possible to win doubles Grand Slams in relative obscurity, however, with the team version of the sport very much secondary to the singles, and it was while playing solo at the 1999 US Open that Serena bumped up her status to teenage tennis star. Winning her first title on the women's tour, in Paris in 1999, had been a significant moment for the player, as had taking that year's Indian Wells title, by beating Germany's Steffi Graf in the final, but landing a first Grand Slam singles title was on a whole new level, especially as she did so in America, on the cement courts of New York City.

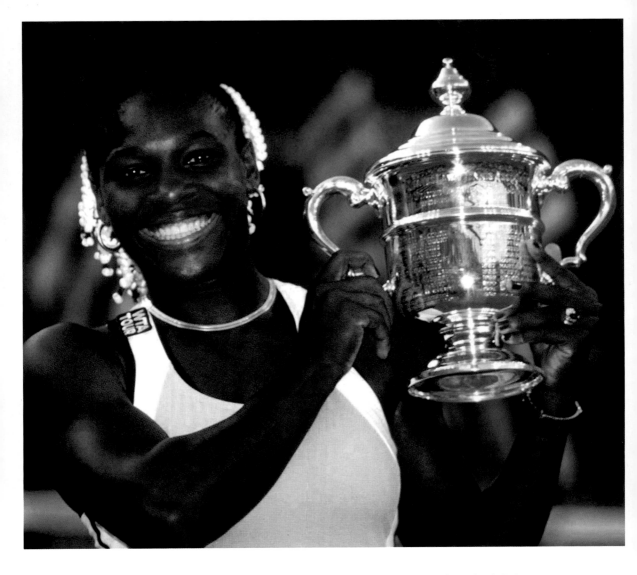

▲ Serena celebrates her victory at the 1999 US Open, where she became the first of the Williams sisters to win a Grand Slam.

It was quite the giddy ride into her first Grand Slam final. Only seventeen years old, Serena defeated the likes of Belgium's Kim Clijsters and Spain's Conchita Martinez, before beating Monica Seles, the then world number four, and fellow American Lindsay Davenport, the number two. One prediction that Richard did get wrong was that Venus and Serena would meet in the New York final, which required Venus defeating Martina Hingis, the world number one, in the last four. The Swiss player went on to block what would have been the first Grand Slam final between two sisters since the nineteenth century. Just to irritate Richard even further, Hingis accused the Williams patriarch of having 'a big mouth'. Serena retorted that

'I thought for sure my day couldn't get any better. Next thing I know, someone was telling me, "The President of the United States wants to talk."'

Hingis's comment was born out of a lack of a 'formal education'. For the first time – but certainly not for the last – Serena was at the centre of controversy at the US Open for something she had said.

Any off-court drama was eclipsed by the tennis she was playing though. With white beads in her hair, and with menace in her serve and groundstrokes, Serena defeated Hingis in straight sets. This was fresh, punchy, exhilarating tennis, and it was also historic – Serena was the first African-American woman to land a Grand Slam singles title since Althea Gibson had won at the 1958 US Open. She was also the first African American of either sex to win since Arthur Ashe became the 1975 Wimbledon champion. Perhaps even more significantly, Serena was the first Williams sister to snaffle a singles major. She wasn't sure whether to 'scream, yell or cry'. 'I guess I ended up doing them all.' The importance of her achievement wasn't lost on others – as Serena noted: 'I thought for sure my day couldn't get any better. Next thing I know, someone was telling me, "The President of the United States wants to talk."'

Serena herself wasn't surprised by her victory – she had had 'a feeling' before the tournament that she would win. The surprise would be what happened next. Back in 1999, no one, let alone Serena herself, imagined that she would go on to land so many more majors. Although Richard Williams had vigorously promoted his youngest daughter, even he hadn't been so bold as to forecast that Serena would go on to win a record number of Grand Slam titles in the Open Era; how she would take a twenty-third major to become the most successful player, irrespective of gender, since 1968. Looking back, Richard may even have felt that he had undersold his youngest daughter.

2

THE
SERENA SLAM

In their early thirties, Serena and Venus used to take their annual dance-off seriously. But those were gentler times at the Williams Invitational, a kind of family mini Olympics which also includes ping-pong, tennis and dodgeball, and which pitches Serena against Venus.

In Serena's view, the competitive nature of the dancing has escalated since then, going from 'serious' to 'over-serious', before hitting a level of professionalism and commitment she describes as 'Broadway'. That means choreography coaches, dozens of backing dancers, weeks of practice, a judging panel and the resulting great surges in adrenaline which the sisters have rarely experienced outside of a Grand Slam final.

For a greater appreciation of the bond between Serena and Venus, and also to understand how tennis's conspiracy theorists were plain wrong about the sisters agreeing to fix matches at their father's behest, you have to take yourself inside the Palm Beach theatre where these dance-offs are held. Try to imagine you are there and consider how deeply the Williams sisters care about something seemingly so frivolous. Serena's dance programme one year consisted of ten different routines and, according to *Vogue*, which covered the event in the same manner that *Sports Illustrated* might cover the US Open, it involved 'almost as many costume changes'. For many, the highlight that year was the sight of Serena suspended from the ceiling in a hoop, or perhaps the routine that saw Serena and her backing dancers in LED light suits.

▶ Serena and Venus have won fourteen Grand Slam women's doubles titles together.

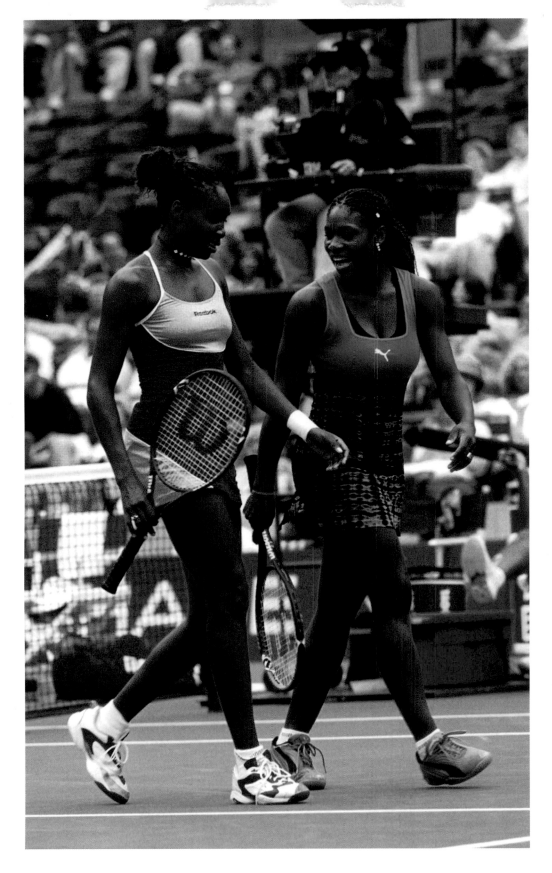

Everything Venus, 'the ultimate big sister', did, Serena wanted to do, too.

There has always been sibling rivalry between the Williams sisters, more so on the part of Serena, by her own admission. On joining the women's tennis tour in the mid-1990s, the relationship between Serena and Venus remained much the same as it had been when they were kids growing up in Compton in the 1980s: one of great affection mixed with intense competition. With five sisters and only four bunk beds in one room in their Compton house, a young Serena had to choose every night which of her siblings to share a bed with. More often than not, Serena climbed in with Venus and they sometimes discussed the tennis they had played on the courts that day or looked ahead to their practice the next day. While the sisters were extremely close, and for all the kindness that Venus showed her younger sister away from the court, Serena was so determined to win their practice matches that she often resorted to cheating over line calls. It was a cold-hearted play, and not one that she felt good about in retrospect, but one that revealed her ultra-competitive spirit and her determination to beat a superior opponent. That same uncompromising, ruthless spirit has been with her throughout her adult life and tennis career – many years later at a tournament she would wear a T-shirt with the slogan: 'Can't spell dynasty without nasty.'

Everything Venus, 'the ultimate big sister', did, Serena wanted to do, too. When going out for family meals, Serena would always be made to order first, as otherwise she would just copy what 'V' was having. When an American newspaper published a feature on Venus, which predicted in passing that Serena would 'never be anything more than a footnote to Venus's career', the younger Williams sister became even more determined to succeed. Long forgotten by readers, and perhaps even by the writer, that story became Serena's 'silent fuel'.

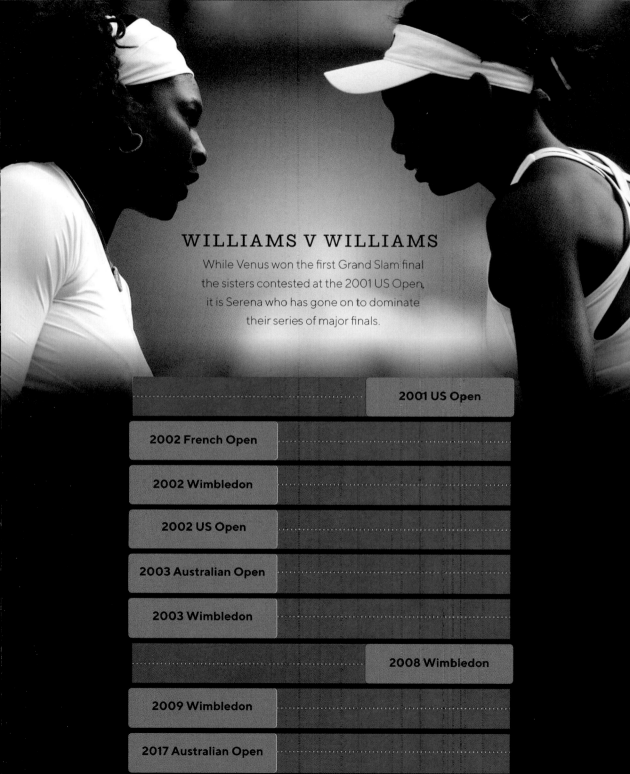

WILLIAMS V WILLIAMS

While Venus won the first Grand Slam final
the sisters contested at the 2001 US Open,
it is Serena who has gone on to dominate
their series of major finals.

	2001 US Open
2002 French Open	
2002 Wimbledon	
2002 US Open	
2003 Australian Open	
2003 Wimbledon	
	2008 Wimbledon
2009 Wimbledon	
2017 Australian Open	

DOUBLES GRAND SLAMS

Serena and Venus are one of the most successful women's doubles teams in history, with their victory at the 2016 Wimbledon giving them a 14th Grand Slam. At the time of writing, they are unbeaten in Grand Slam finals. Only Martina Navratilova and Pam Shriver have won more as a team, with 20 major titles.

SERENA + VENUS
WOMEN'S DOUBLES GRAND SLAMS

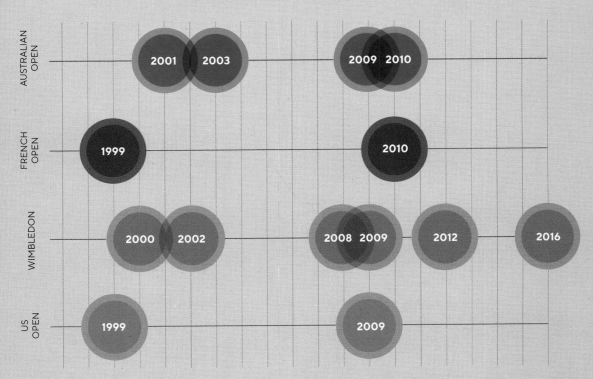

SERENA + MAX MIRNYI
MIXED DOUBLES GRAND SLAMS

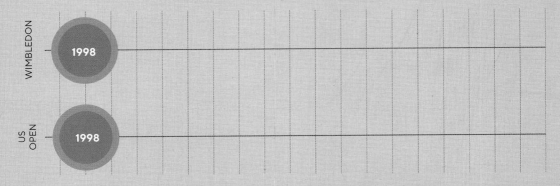

'I love doubters,' Serena once told the *New York Times*. 'Ever since I was young, even when I came on tour, it was Venus, Venus, Venus, Venus. Oh, and the little sister. My whole goal in life was just to prove people wrong.'

Born fifteen months apart, and united by a common desire to dominate the world of tennis, together they pushed each other to greater heights, especially in the early years when it was all so new for the Williams sisters, and also for the sport, to have one family take centre stage. You might reasonably speculate, however, about whether Serena would have won more Grand Slams if Venus hadn't also been a tennis player – after all, Venus beat Serena in a couple of major finals – at the 2001 US Open and 2008 Wimbledon Championships. You could also contend that Serena would never have become the champion she did without her sister by her side, always on hand as a friend, confidante, tactical advisor and practice partner, whether during or between tournaments. This went both ways, of course – Serena also inspired Venus to kick on and start winning majors. Serena's victory at the 1999 US Open – when the seventeen-year-old became the first of the sisters to win a Grand Slam – was a jolt for Venus, who went on to win two majors in 2000, and then another couple in 2001.

On their own, the Williams sisters have been hard to beat in singles; together on the doubles court, Venus and Serena have been unstoppable – from the 1999 French Open to the 2016 Wimbledon Championships, they won all fourteen of the Grand Slam doubles finals they played in. To have one African American at the top of the sport is a fabulous story in itself; two is nothing short of extraordinary.

● ● ●

Back when she was a teenager with beads in her hair, and when everything was a blast, Serena's favourite tournament was Indian Wells. It was there, in the Californian desert, that she won her first professional match at the age of fifteen, when she played alongside sixteen-year-old Venus in the 1997 doubles competition. Two years on, when Serena was just seventeen, she landed the biggest singles title of her career to date,

▶ Serena in Indian
Wells in 2001, where
she was racially abused
by 'some kind of genteel
lynch mob'.

beating German Steffi Graf in the final. But then, in 2001, there was an episode so ugly and reprehensible that it changed everything for Serena and her family. It involved sustained jeering and booing from the crowd, and shouts of 'nigger'.

Serena was just nineteen years old at the time. When she looks back at photographs of herself at that time, she thinks how 'cute' she looked in her pink outfit and with braids in her hair. She was completely taken aback by what happened when she walked out to play Belgian Kim Clijsters in that Indian Wells final. Just as soon as Serena had made her entrance, sections of the crowd turned on her. Before she felt scared, Serena was just confused. What had she done to provoke such a reaction? It took her a while to realise that the crowd was punishing her for what had happened a round earlier. All this unrest, the booing, the racist abuse – what Serena later called 'the fiery darts of Indian Wells' – were because Venus had had to withdraw from her semi-final with Serena due to injury. That news had been relayed to the crowd just minutes before the semi-final had been due to begin, even though Venus had given the tournament several hours' notice.

Serena heard cries of 'nigger'. So did her father Richard as he and Venus made their way down to their seats. 'I looked up and all I could see was a sea of rich people – mostly older, mostly white – standing and booing lustily, like some kind of genteel lynch mob,' Serena has written. 'I don't mean to use inflammatory language to describe the scene, but that's really how it seemed from where I was down on the court. Like these people were gonna come looking for me after the match.'

Unfortunately, it seemed, her father had been right – by asking local kids in Compton to racially abuse his daughters as children, he really had offered them a preview of the terrible reality of what would happen on the professional women's tour.

As Serena noted later: 'Nobody would have booed some blonde, blue-eyed girl.' While the crowd cheered every move that Clijsters (who is blonde) made, they continued to harass and heckle the American, who was supposedly playing at a home event. Disgusted by how the crowd was treating his daughter, Richard shook his fist at them, which only served

to further enrage probably the most privileged mob in sporting history. During one changeover, Serena cried: she hid her tears beneath a towel, not wanting the crowd to know the effect they were having on her. At another change of ends, she said a prayer out loud: 'Jehovah, give me the strength to get up from this chair. Give me the strength to finish this match. Give me the strength to persevere.' Serena felt alone and distressed.

'The undercurrent of racism was painful, confusing and unfair. In a game I loved with all my heart, at one of my most cherished tournaments, I suddenly felt unwelcome, alone and afraid,' Serena wrote years later in *Time*. 'My father dedicated his whole life to prepping us for this incredible journey, and there he had to sit and watch his daughter being taunted, sparking cold memories of his experiences growing up in the South.'

For all the mayhem and menace of the day in the desert, and for all the confusion and doubts in her head, Serena somehow gathered herself: she was determined to win the title to show the crowd that she would not be intimidated. In the end, she prevailed, perhaps helped by Clijsters' game also being thrown off by the crowd's behaviour. But, of all the titles that Serena has won over the course of her career, this was by far the most dispiriting. She wept again in the locker room, and on the journey back to Los Angeles, she felt as though she 'had lost the biggest game ever – not a mere tennis game but a bigger fight for equality'.

In all their ugliness, a small section of the American tennis public, and a well-heeled section at that, demonstrated what they really thought about the emergence of two black athletes at the top of the sport. How could Serena ever feel the same way about Indian Wells again? How could she ever go back? She would boycott the tournament until 2015, with Venus also refusing, during that time, to return to the desert.

On her return, Serena had an essay published in *Time*, in which she wrote about her love of the game and her 'new understanding of the true meaning of forgiveness'. She had skipped thirteen editions of the tournament. She didn't care about the titles, the money and the ranking points she could have accumulated in the desert over that time. Even fines of millions of dollars wouldn't have ended her boycott. Yet, in the end, she returned.

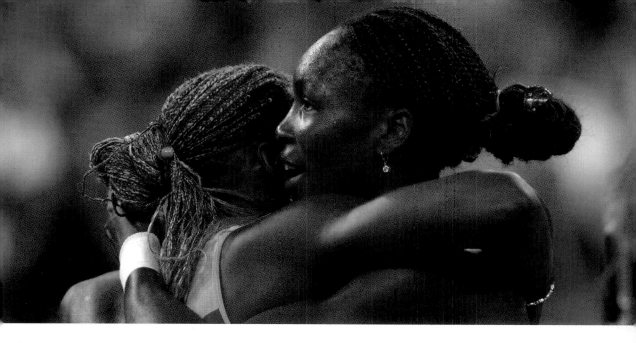

• • •

That 2001 episode in Indian Wells brought Serena and Venus even closer together, perhaps reinforcing the idea that it was the sisters united against what their father called 'the lily-white tennis world'. Within six months, there was another showpiece occasion for the sisters at an American tournament. This time, both of them played, and there was a celebratory feel to their match at the US Open in New York City.

While Serena and Venus had played each other on the tour a handful of times before, including in a tour-level final in Miami in 1999, the conclusion of the 2001 US Open was on a different scale. It was primetime; it was also historic. It was the first time that two sisters had contested a Grand Slam final in 117 years, since Maud and Lilian Watson, the daughters of an English vicar, playing in corsets and petticoats, had met at the 1884 Wimbledon Championships, which was the inaugural women's tournament at the All England Club. Lasting just over an hour, the all-Williams final wasn't of the finest quality, with a high number of unforced errors from both rackets. But that was understandable – playing one's sister when there is a Grand Slam title on the line must be a profoundly odd experience, hardly conducive to producing the best tennis.

▲ At the 2001 US Open, Serena and Venus were the first sisters to contest a Grand Slam final since the nineteenth century.

SPEED OF GROUNDSTROKES

Serena can generate
enormous power with
both her forehand and
her backhand.

AVERAGE
SPEED
OF
FOREHAND

73.1 MPH

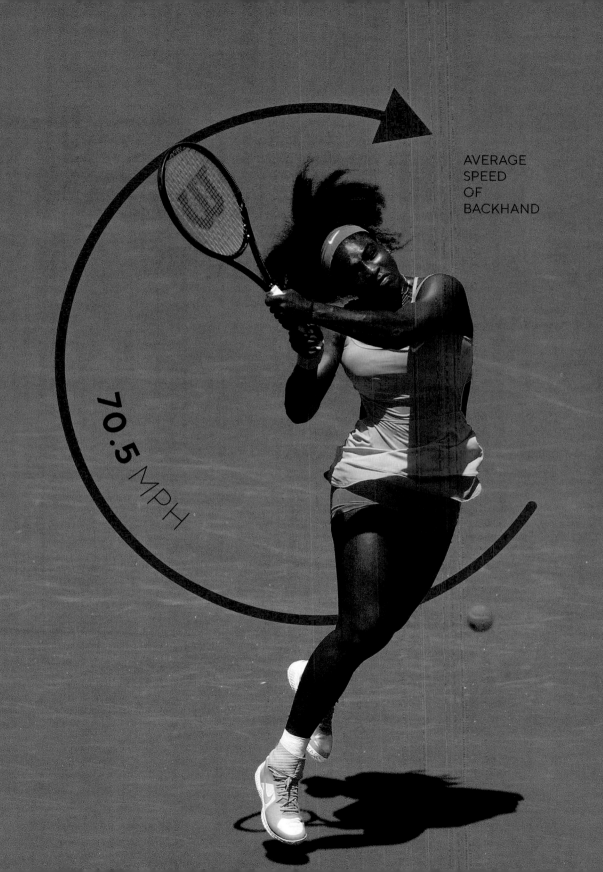

AVERAGE
SPEED
OF
BACKHAND

70.5 MPH

For years, it looked as though Serena and Venus were in their own world on the tour, and they were sometimes criticised for not being more sociable in the locker room. Serena was more concerned with collecting trophies than friendships. Her only real friend on the tour, aside from, in recent years, Caroline Wozniacki, has been Venus. For much of their careers, they shared a home in Florida. And here Serena was, playing her best friend, sister and housemate in the most intense of environments: the final of their home Grand Slam.

Before matches, Richard regularly used to talk strategy with Serena. However, before Serena played Venus the instruction was kept simple: 'Have fun.' But how could either sister have fun in the knowledge that winning the match would inflict the pain of defeat on the other? Understandably, matches between Serena and Venus sometimes had a nervy quality to them, without the fluency and poise of when they played opponents outside the family. Consider how the sisters knew each other's games almost as well as they knew their own – it was extraordinarily

▼ Every major of the Serena Slam, from the 2002 French Open to the 2003 Australian Open, was achieved by beating Venus in the final.

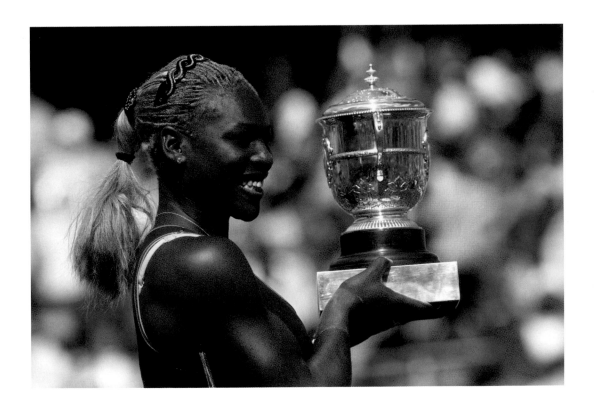

difficult for one to out-manoeuvre the other. Conspiracy theorists around the sport started to suggest – without any evidence whatsoever – that the results of their matches were preordained, that the fans in the stadium or watching on television were watching a contest as scripted as wrestling, determined in advance by their father. According to a report published in the *New York Times*, other players also suggested that the sisters' semi-final at the 2000 Wimbledon Championships, which Venus had won, had been determined beforehand on the whim of their father.

This was ludicrous. Throughout Serena's life, from her childhood on the Compton public courts all the way to the US Open's Arthur Ashe Stadium or Wimbledon's Centre Court, she has always been ferociously competitive. Nothing, not even her love for Venus, would override her desire to win the 2001 US Open and all the other tournaments she entered. Did anyone of sound mind really imagine that Serena would have willingly capitulated in that final in New York, in which she won just six games over the two sets? Consider how competitive the sisters would be in future years at their annual Williams Invitational dance-off. It was also never properly explained why Richard would have made such a demand of his daughters. To what end?

And does anyone genuinely believe that Venus conspired to lose four consecutive Grand Slam finals to her sister? Or that the younger sister only accomplished her Serena Slam, which started at the 2002 French Open and was completed at the 2003 Australian Open, because Venus wasn't playing to her full capacity in the finals? 'The false allegations that our matches were fixed hurt, cut and ripped into us deeply,' Serena observed in 2015.

The reality is her achievement was driven by own brilliance. That and her 'weird revenge-mojo piece'. Heartbroken after an unnamed boyfriend ended their relationship, she decided tennis would be her 'salvation'.

'It's super funny to me now, because I'm past it, but this guy tore my heart in half. Then he ripped up those pieces and stepped on them and backed his car up over them. He left me thinking that I was ugly, that I didn't deserve to be in a loving relationship,' she wrote. 'Heck, I didn't even love me anymore, after So-and-So got done with me.'

▶▶ Serena and Venus in the 2002 Wimbledon final.

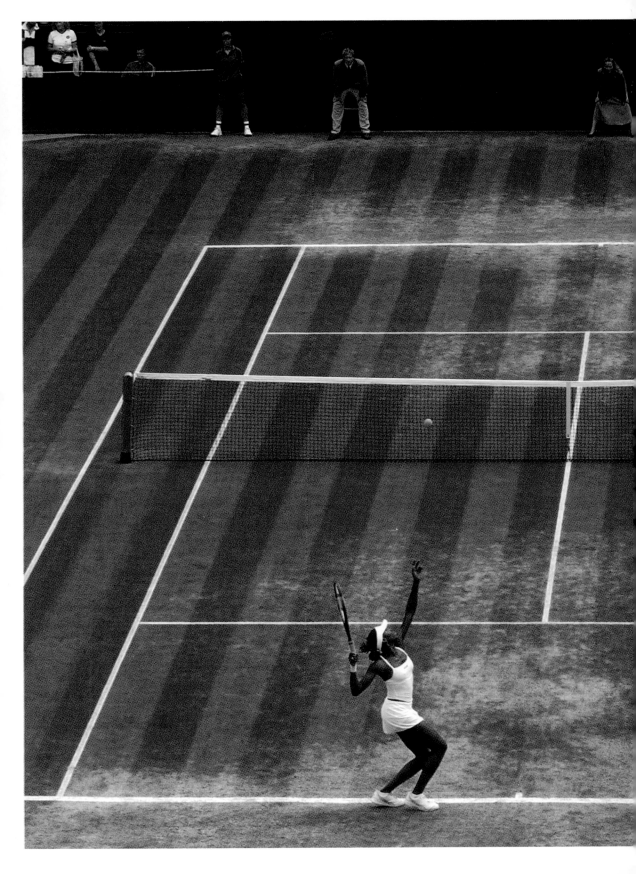

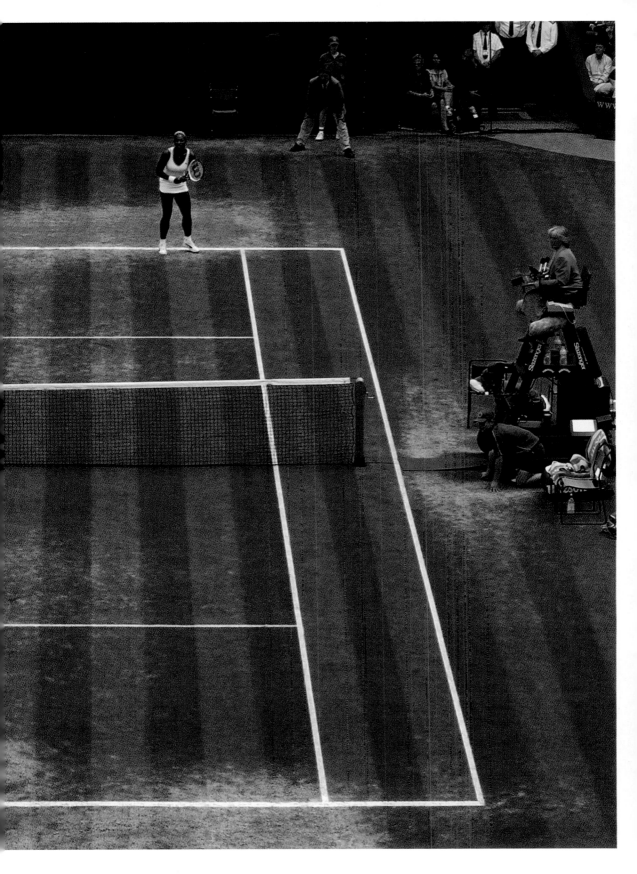

GRAND SLAMS WON AFTER SAVING A MATCH POINT

Serena has won three Grand Slam titles after saving one or more match points:

		MATCH POINT DOWN	FINAL SET SCORE

2003 AUSTRALIAN OPEN
SEMI-FINAL
WILLIAMS VS CLIJSTERS

Serena saved two match points in her semi-final against Kim Clijsters, and went through to defeat Venus in the final.

		MATCH POINT DOWN	FINAL SET SCORE

2005 AUSTRALIAN OPEN
SEMI-FINAL
WILLIAMS VS SHARAPOVA

Serena saved three match points in her semi-final against Maria Sharapova, and went on to beat Lindsay Davenport in the final.

		MATCH POINT DOWN	FINAL SET SCORE

2009 WIMBLEDON
SEMI-FINAL
WILLIAMS VS DEMENTIEVA

Serena saved a match point in her semi-final against Elena Dementieva and went on to defeat Venus in the final.

Serena's motivation was 'to stay in this guy's face, to be a constant reminder of what we had, to rise above his shabby treatment and stand as tall as I possibly could'.

And the best way of doing that would be to win as many Grand Slam titles as possible. To make the sporting news. To put herself up on the billboards.

Absent from the 2002 Australian Open because of injury, Serena began her non-calendar year sweep at the French Open – for her first major in more than two-and-a-half years – and from there she ripped through Wimbledon, the US Open and the following season's Australian Open. All throughout that run, So-and-So was in the margins; written into the match book that she kept, to ensure that she never lost any of that 'revenge mojo' intensity and yet he was very much centre stage in her mind. Perhaps if you read the gossip columns, you may think you have a fair idea of the identity of that man, said to be an American football player. Funny how that 'loser', as Serena thought of him, would send her on that winning spree. This was all about lifting herself out from the 'dirt' that So-and-So had left her lying in. Also heightening emotions at the time was the break-up of the Williams parents' marriage, Richard and Oracene going on to divorce in 2002.

Only once in those four all-Williams finals did Serena drop a set, in Melbourne. The most precarious moment in her Serena Slam – or as she has reimagined it, her 'So-and-So Slam' – had come a round earlier, at the Australian Open, when she had trailed 1–5 in the third set of her semi-final against Clijsters and had staved off a couple of match points.

For Venus in that final, there was also history: she was to become the first woman to lose four Grand Slam finals in a row. Yet with her sister's defeat at the Rod Laver Arena came Serena's triumph: she became only the fifth woman – after Maureen Connolly, Margaret Court, Martina Navratilova and Steffi Graf – to hold all four majors simultaneously.

The 21-year-old from Compton was truly the alpha female of tennis. Halfway through her Serena Slam, at the 2002 Wimbledon Championships, Serena had become the world number one for the first time.

▶▶ Serena won the 2003 Australian Open to complete her first 'Serena Slam'.

A SENSELESS
ACT OF
VIOLENCE

Over fifty-one disturbing minutes in Stanford, California, at a hard court tournament in August 2018 leading up to that summer's US Open, Serena made twenty-five unforced errors in a first-round match against British opponent Jo Konta.

At what was Serena's first competitive appearance since that summer's Wimbledon final, that worked out at roughly one mistake every couple of minutes. Konta regarded it as a privilege to be on the same court as Serena, but the American, for all her stature in the tennis world, could barely keep the ball in that court. Never before, in more than twenty years of playing professional tennis, had Serena experienced such a lopsided defeat.

After taking the opening game, she lost a dozen in a row to go down 6–1, 6–0 to Konta. In the language of the locker room, that's a 'breadstick' and then a 'bagel'. Konta wasn't quite sure how to take her victory; the truth was that Serena had beaten herself. 'I know I can play a zillion times better, but I have so many things on my mind,' she said.

What Serena didn't disclose at the time was how, just ten minutes before walking on to court, she had been sitting in the players' area, scrolling through Instagram on her phone. Amid all the beautiful images on her feed, she had come across a deeply unsettling, unfiltered piece of information and she couldn't shake it out of her mind. How could Serena possibly focus on something as inconsequential as a tennis match when

she had just discovered that the man convicted of killing her oldest half-sister and former personal assistant, Yetunde Price, in 2003, had been released on parole from a Californian prison? His reward for good behaviour in jail.

'No matter what, my sister is not coming back for good behaviour. It's unfair that she'll never have an opportunity to hug me,' Serena said.

Fifteen years after Robert E. Maxfield, known by the gangland moniker of 'Baby Spank', had shot Yetunde dead in her SUV in Compton, Serena was still trying to forgive her killer. She just couldn't quite bring herself to do so. 'The Bible talks about forgiveness. I'm not there. I would like to practise what I preach, and teach Olympia that as well. I want to forgive,' she told *Time*. 'I have to get there. I'll be there. It's hard because all I think about are her kids.' Serena has had difficulty thinking of anything else but the effect that Yetunde's death has had on the three children she left behind – Jeffrey, Justus and Jair – who were all under twelve at the time.

The night that Serena learned of Yetunde's murder, she was already going through an uncertain time, recovering from the first serious injury of her career. The first golden period of Serena's tennis life – culminating with the completion of the Serena Slam at the 2003 Australian Open – couldn't last forever. In fact, it didn't last beyond the next major, the French Open, where she lost in the semi-final to Belgian Justine Henin. While Serena picked up a sixth major at the 2003 Wimbledon Championships, again defeating Venus in the final, she wouldn't play that year's US Open because of a damaged knee. For years, both privately and publicly, she stuck to the line that she had hurt it on the practice court: she was too ashamed to admit the truth – that she had injured herself while dancing in heels in a Los Angeles nightclub. That night out would stop her competing for months, a dark period in her tennis career. She was, in her own brutal self-assessment, a 'dancing fool'. Yet, Yetunde's death would make her own injury problems seem trivial.

It was September 2003, and Serena had spent the day playing at being a movie star, filming the cable television drama *Street Time* on set in Toronto. It was 4 a.m., and Serena was asleep in her hotel room, when

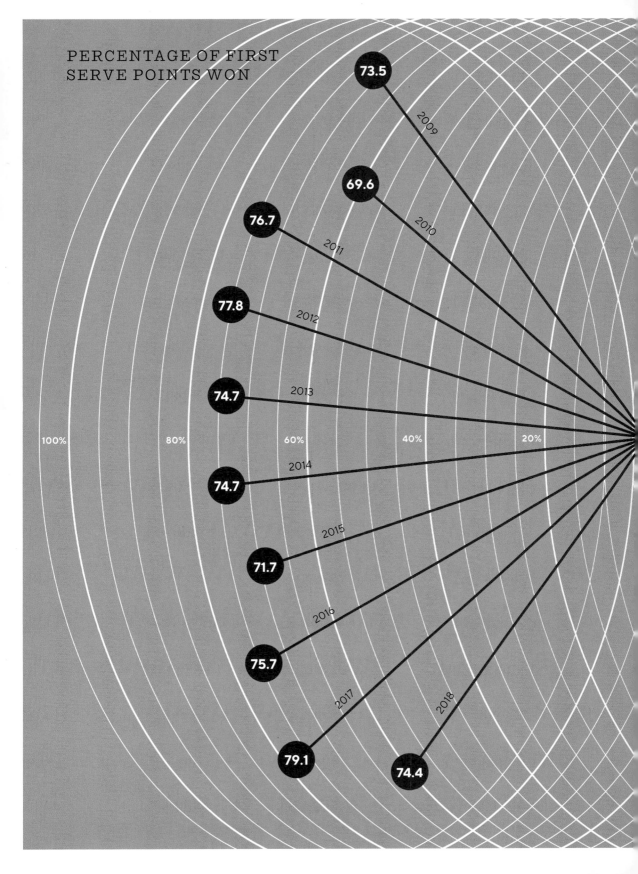

PERCENTAGE OF FIRST
SERVE POINTS WON

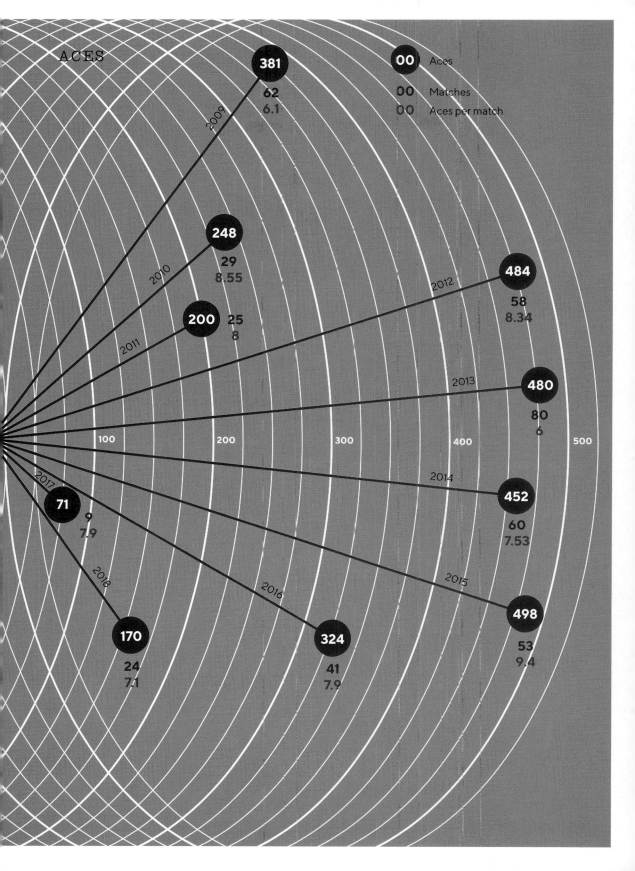

ACES

00	Aces
00	Matches
00	Aces per match

381
62
6.1

2009

248
29
8.55

2010

200
25
8

2011

484
58
8.34

2012

480
80
6

2013

452
60
7.53

2014

100 200 300 400 500

2017

71
9
7.9

2018

170
24
7.1

2016

324
41
7.9

2015

498
53
9.4

her phone rang. It was her mother, calling from California, distressed that Yetunde hadn't returned home from a dinner with friends.

'Have you heard from Tunde? I can't reach her. I think maybe something's happened. Maybe she's been involved in a car accident or shooting,' she told Serena.

Alarmed, Serena couldn't go back to sleep. She dialled Yetunde's home number and a cousin picked up. 'She's gone, Serena. I'm so sorry.' That was when Serena learned that Yetunde had been killed.

For a day or two, Serena couldn't, or wouldn't, accept this 'awful, lurking, dark truth' and wouldn't let go of the possibility that her sister was still alive. Perhaps the authorities had mixed her up with someone else? Maybe she really had been shot but somehow, by some modern miracle, had survived?

In time, however, Serena came to terms with the dark truth of what had happened on the night of 14 September 2003 in Compton, about a mile from the public courts where all the girls in the family had learned to play tennis. Yetunde had been sitting in the passenger seat of a parked SUV with new boyfriend Rolland Wormley, outside a suspected crack house, when she was struck in the back of the head by a round from an AK-47 assault rifle. Maxfield, believed to have been a member of the Southside Crips gang, and perhaps under instructions to protect the house, fired around a dozen rounds into the vehicle. It is thought that the intended target was Wormley, who was on parole and was reportedly a member of another gang. Wormley, though, was unharmed in the attack.

Even those who were well acquainted with the Williams' backstory were startled when the news broke of Yetunde's shooting, and not just because of the horror and pain that the tennis player and her family were going through. It was also a stark reminder of how Serena, having made it from the ganglands of Compton to the gilded world of professional tennis, still wasn't insulated from the violence and gun crime of her old neighbourhood. Yetunde had chosen to live near their childhood home, despite the change in family circumstances that would have enabled her, if she had wanted, to move somewhere less troubled by gang violence.

Yetunde, who was a decade older than Serena, and just thirty-one

when she died, had always been much more than a sister to Serena. 'Tunde and I were so close; she changed my diapers.' After Serena and Venus established themselves within the tennis elite, Yetunde had acted as their personal assistant for a while. Yetunde's role was to arrange their diaries, ensuring they were in the right place at the right time for their playing, sponsorship and media appearances, and also to help with their correspondence. On Serena's part, maybe she just wanted a reason to have Yetunde with her; the half-sisters spoke every day during that period.

Yetunde was no longer part of her younger sister's team at the time of her death; she had trained as a nurse and also co-owned a hair salon with a friend in Lakewood, near Compton, called Headed Your Way. Serena and Yetunde had remained close though – when Serena had a knee operation in 2003, Yetunde visited her almost every day in hospital.

Exacerbating the family's agony and suffering at Yetunde's death was the legal process, which was long and turbulent. It took two-and-a-half years, and three trials, for Maxfield to be convicted and for Yetunde's family to feel as though they had some kind of justice. The first two trials, for murder, had been inconclusive, with hung juries, but just before the

▲ Serena with her sister Yetunde, just two months before Yetunde was killed.

MOVEMENT

Average metres moved per point - for Serena
and a selection of her rivals at the 2018 US Open.

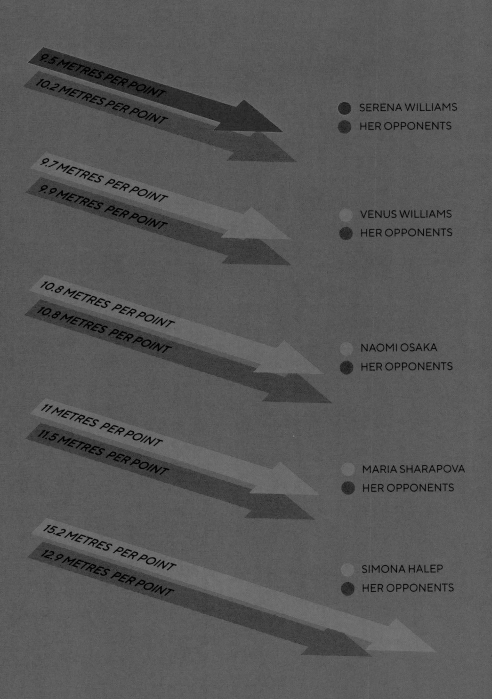

9.5 METRES PER POINT

10.2 METRES PER POINT

- SERENA WILLIAMS
- HER OPPONENTS

9.7 METRES PER POINT

9.9 METRES PER POINT

- VENUS WILLIAMS
- HER OPPONENTS

10.8 METRES PER POINT

10.8 METRES PER POINT

- NAOMI OSAKA
- HER OPPONENTS

11 METRES PER POINT

11.5 METRES PER POINT

- MARIA SHARAPOVA
- HER OPPONENTS

15.2 METRES PER POINT

12.9 METRES PER POINT

- SIMONA HALEP
- HER OPPONENTS

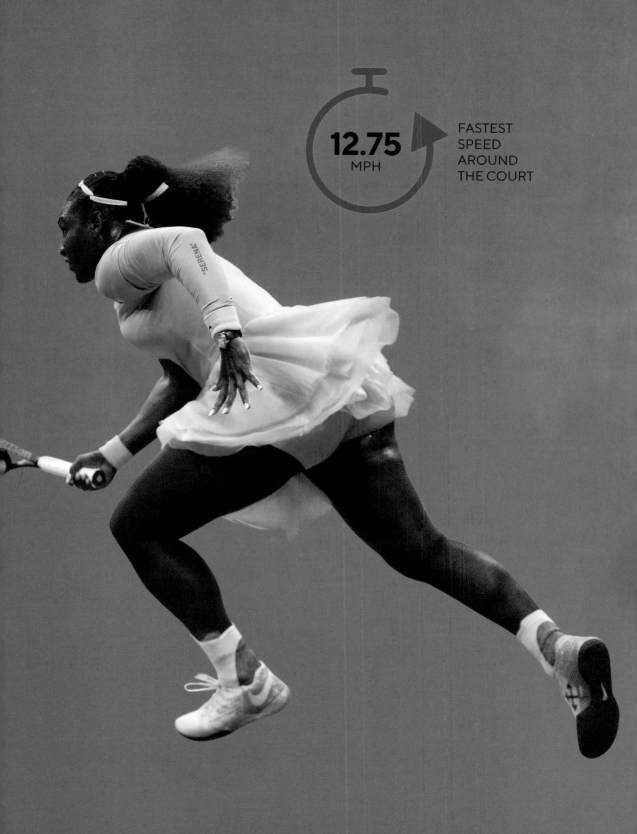

12.75
MPH

FASTEST
SPEED
AROUND
THE COURT

third trial was about to begin, Maxfield offered a plea of 'no contest' to the lesser charge of voluntary manslaughter (by pleading 'no contest', he didn't admit to the crime, but the legal consequences were similar to those if he had confessed his guilt). Serena had originally intended not to speak at the sentencing hearing in court at Compton, because she thought she would find it too emotional, but when the moment came, she felt compelled to say something. This wasn't so much an opportunity to address the court, and to have the court record the family's pain, but a chance for her to speak directly to Maxfield. To let him know, in open court and in the plainest terms, how this gangland shooting had been 'unfair' to the family. Serena said to Maxfield: 'Our family has always been positive, and we always try to help people.'

A clear example of that was seen in 2016. The wealth that Serena has generated with her tennis racket has enabled her to live where she pleases – over the course of her career, she has owned homes in Florida, Los Angeles, San Francisco and Paris – but she will always have a link to the city of Compton. That's where she grew up, and where she learned how to strike a tennis ball. That's also where, in 2016, she and Venus opened the Yetunde Price Resource Center, to honour their sister's life and memory and to help those directly or indirectly affected by violence. The Center is 'committed to helping communities heal'.

'Yetunde was every bit the older sister – nurturing and loving and always making sure others had before she did,' reads a tribute on the Center's website. 'Her compassion continued into adulthood as the mother of three and the caretaker of so many through her work and nature. When Yetunde was tragically killed by an act of senseless violence in 2003, she left behind three children, siblings, parents, and a community that mourned her.'

● ● ●

In some ways, that knee injury proved a blessing: it meant that Serena had a reason, beyond the horror and pain of losing her sister, not to return to the tennis tour. For some time, Serena wasn't strong enough to even

'Frankly, I don't know what I would have done if I hadn't had that knee surgery to hide behind.'

think about picking up a racket and going back to the practice court. And while she worked on her physical conditioning, and it appeared she was doing all the things that an athlete rehabbing from an injury is supposed to do, she knew in her own mind that she wasn't truly dedicated to making her way back to the circuit. 'My heart wasn't in it, and my head wasn't even close,' she wrote in her autobiography.

Even when she was away from the tour, free from the pressures, stresses and scrutiny of competition, Serena didn't feel as though she grieved properly for her sister. 'I went through the motions of grieving, but I was still too numb and raw to really grieve. I cried, but the tears didn't really take me anywhere.'

In her own words, life was a 'blur' for some weeks. Winning Wimbledon would turn out to be the final act of her 2003 season. 'Frankly, I don't know what I would have done if I hadn't had that knee surgery to hide behind. It was an easy excuse to stay on the sidelines, because God knows I wasn't ready to get back out there and play tennis, but at the same time I didn't think I could go on not playing, if I was physically able.'

She was also absent from the opening Grand Slam of 2004, the Australian Open, and didn't compete at any level of tournament until March of that year, when she returned at the hard court event in Miami. Astonishingly, she would win that tournament, which is just as important as Indian Wells, but there was something different about her. Once, Serena had been fuelled by the desire to dominate the women's game, to be recognised as the alpha female of the tennis world. While she was still operating at a high level – which enabled her to win that title in Miami, even demolishing Russia's Elena Dementieva for the loss of

▶▶ Serena and Maria Sharapova in the 2004 Wimbledon final.

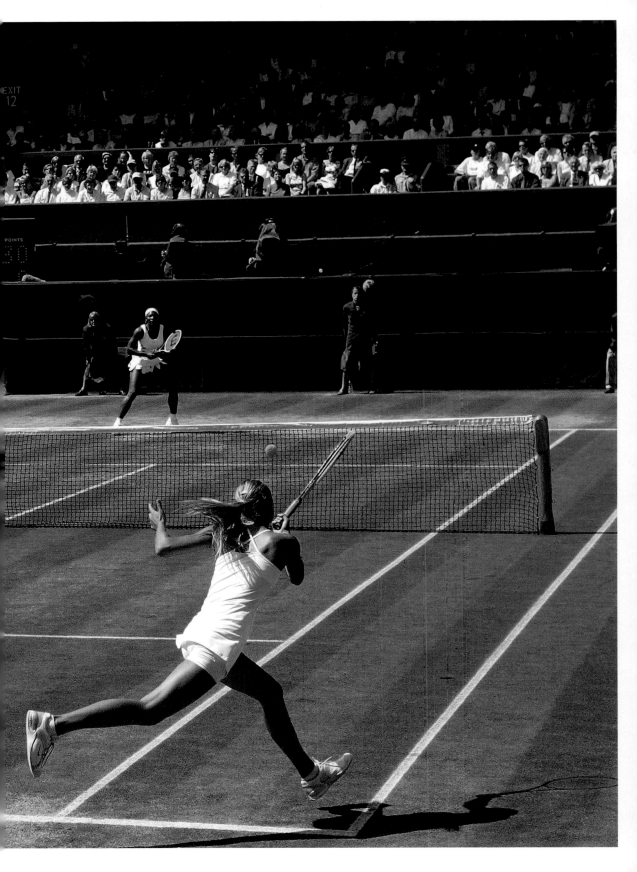

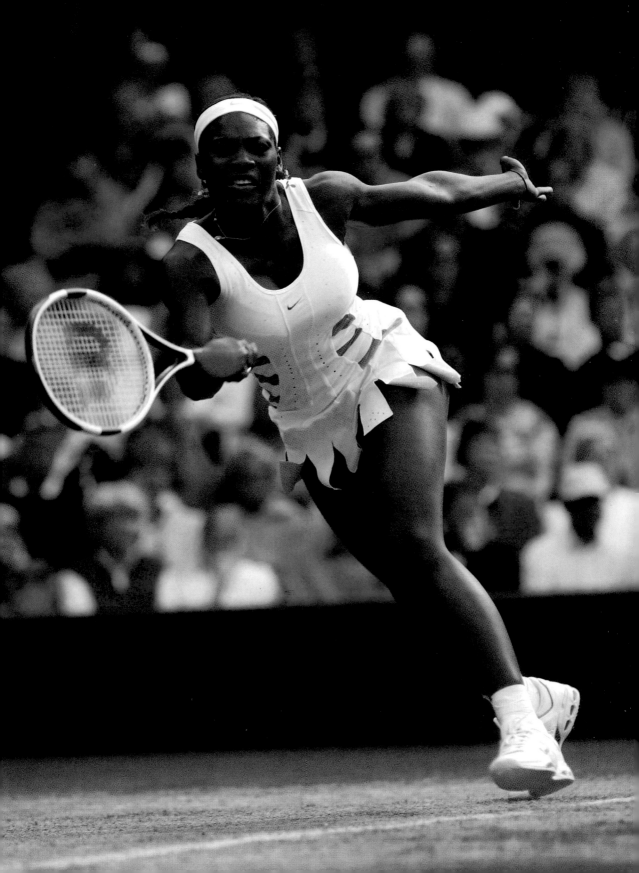

just two games in the final – she couldn't escape the sense she had lost some of her drive. Before, she had built her life around the goal of winning as many tennis matches and titles as she could; now just being on court, as well as the routine of practice and workouts, served a different purpose. An hour on the tennis court was an hour not thinking about her sister's passing.

While Serena has not always been enamoured with playing on the Wimbledon lawns – the bounce hasn't always been to her liking – the All England Club was becoming a productive tournament for her. Having made her Grand Slam return at the French Open, where she lost in the quarter-final to fellow American Jennifer Capriati, Serena reached the Wimbledon final, the first time in twelve months she had played for a Grand Slam title. Only Maria Sharapova, a seventeen-year-old Russian appearing in her first Grand Slam final, stood between Serena and a third successive Wimbledon win.

To the surprise of almost everyone at the All England Club, and those watching around the world, it was Sharapova who ended up receiving the Venus Rosewater Dish and wearing a gown to that weekend's Champions' Dinner. Serena would win just five games in a 6–1, 6–4 defeat. According to Sharapova, when she went backstage after the on-court trophy presentations, she heard Serena sobbing in the locker room. 'Guttural sobs, the sort that make you heave for air, the sort that scare you. It went on and on,' Sharapova wrote in her 2017 memoir, *Unstoppable*, though this account does not tally with Serena's own recollection of the day – '100 per cent hearsay' was her review of the passages she had read.

If that was an unfortunate end to Serena's Wimbledon, her run at that season's US Open was so controversial that it changed tennis forever. Or at least it changed how the sport is officiated. Walking out on court in knee-high black boots, a denim miniskirt and a black tank top, the former champion was soon cloaked in controversy, though this was not trouble of her own making.

A number of line calls went against her during her quarter-final defeat to Capriati. In the days before the Hawk-Eye, line-calling technology was

◀ Wimbledon has been a productive tournament for Serena.

WINNING PERCENTAGE
BY SURFACE

Serena's winning percentages on hard, clay, grass and carpet,
with a selection of other players' numbers for comparison.

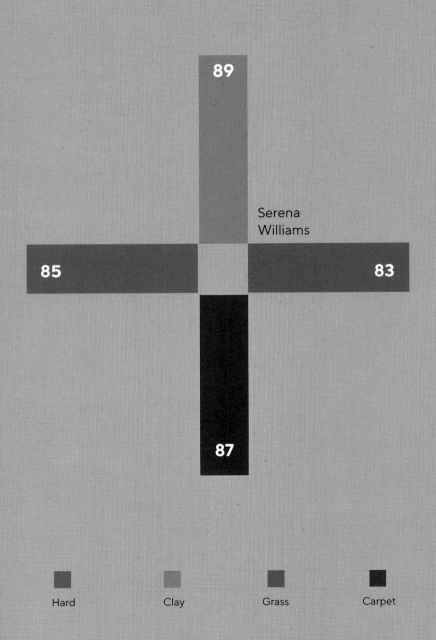

89

Serena
Williams

85

83

87

Hard Clay Grass Carpet

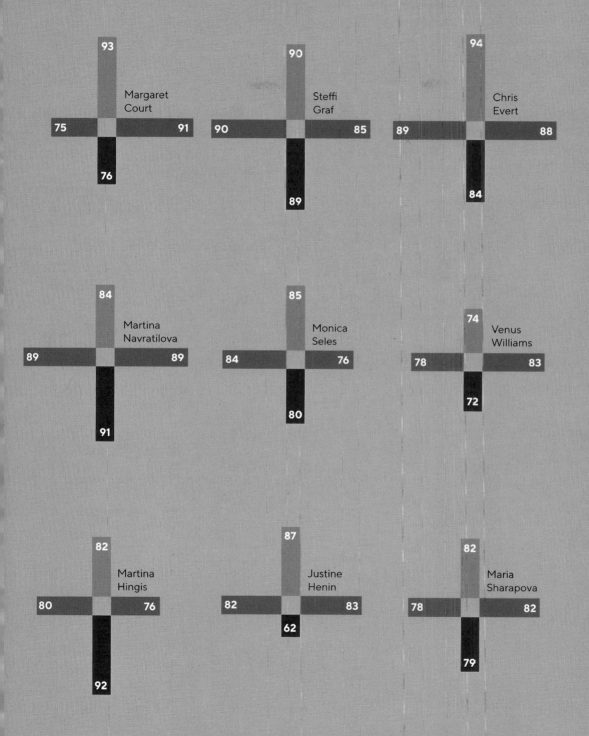

'I guess I want people to understand that our family is so important and a loss like that was devastating.'

introduced to the sport, Serena had no way of challenging or appealing those errors. The most galling of these was when the Portuguese umpire Mariana Alves made an incorrect overrule, which John McEnroe described as 'a disgusting, brutal call', and one that made him 'feel a lot better about those pyrotechnics I put those umpires through'. Such was the consequent hullabaloo, the United States Tennis Association apologised to Serena. More significantly for the wider sport, that match helped persuade administrators that it was time they turned to Hawk-Eye to avoid such human errors. It was also a foretaste of how Serena's most controversial and explosive moments would tend to happen in New York City, at her home Grand Slam.

Of all Serena's Grand Slam titles, one of the most emotional was her run at the 2005 Australian Open, her first title after her sister's murder. After saving three match points against Sharapova in the semi-final, she defeated Lindsay Davenport in the all-American final at Melbourne Park, and then dedicated her victory to Yetunde's memory.

'I guess I want people to understand that our family is so important, and that a loss like that was devastating, so to come back and win like that was key,' Serena said of her seventh singles major, and her first Grand Slam in a year-and-a-half, which ended a blank run since the 2003 Wimbledon title.

Yet, for all the joy that she must have felt in the moment, the public triumph of winning the Australian Open hid what was really going on in Serena's world. Perhaps she wasn't fully cognizant of what was happening to her herself – certainly her family and friends seemed to be unaware – that she was sliding into depression.

▶ Serena dedicated her 2005 Australian Open title to Yetunde's memory.

YEAR-END RANKINGS

Serena has finished a season as number one five times,
including three consecutive years from 2013–15.

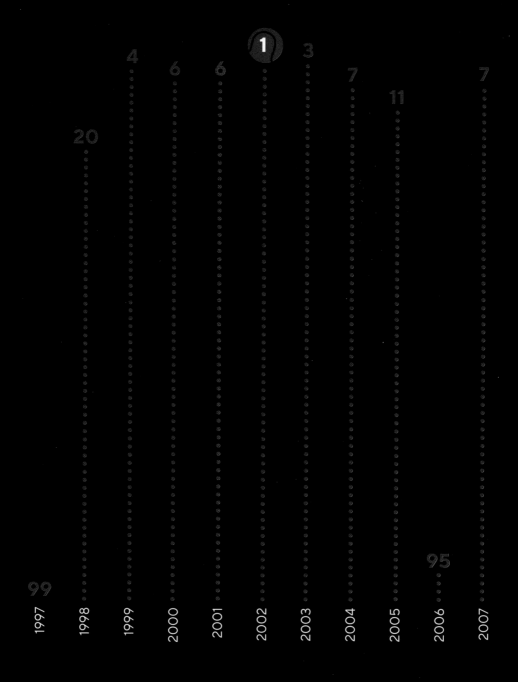

99 20 4 6 6 1 3 7 11 95 7

1997 1998 1999 2000 2001 2002 2003 2004 2005 2006 2007

Serena has won the WTA Tour Finals five times,
in 2001, 2009, 2012, 2013 and 2014. She only trails
Martina Navratilova, who won the title eight times.

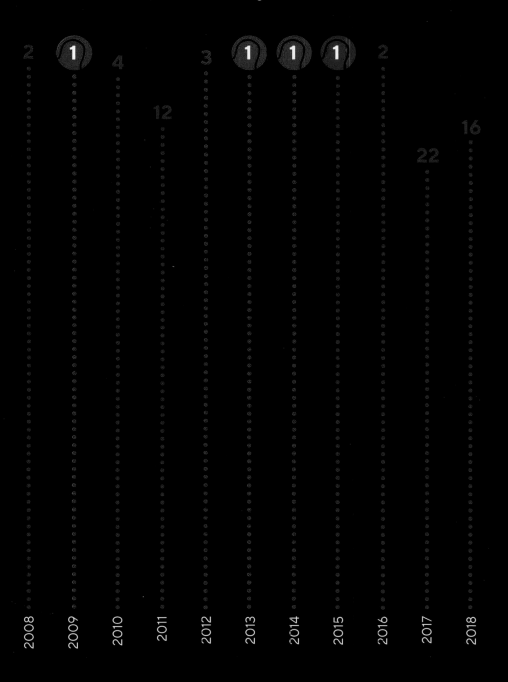

2 1 4 3 1 1 1 2 16
 22
 12

2008 2009 2010 2011 2012 2013 2014 2015 2016 2017 2018

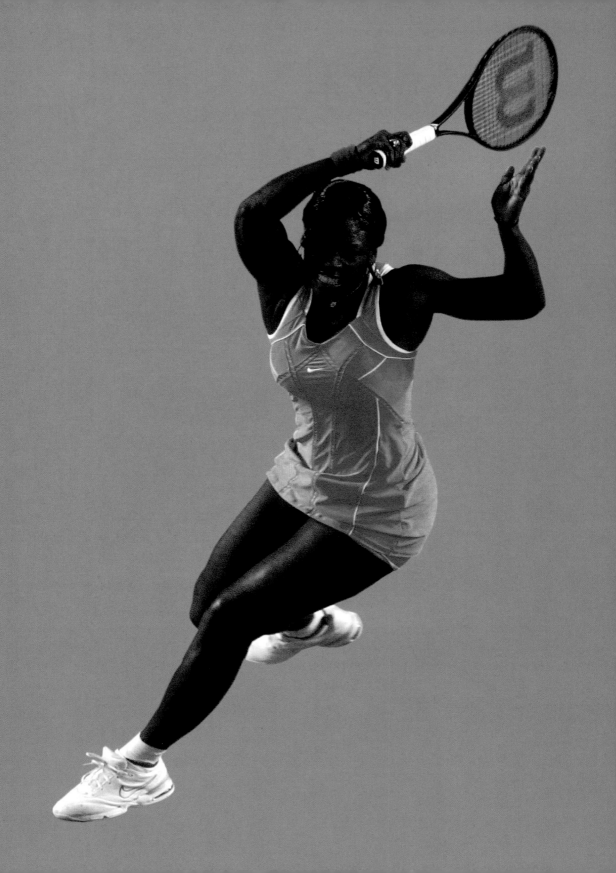

4

THE MAKING OF SERENA VERSION 2.0

They say that playing on the centre court at a Grand Slam exposes your emotions to the world like nothing else.

And yet no one, not even the television cameramen looking for their close-up shots, the photographers collected around the Rod Laver Arena or those sitting in Serena's guest box, noticed that she was crying in the middle of a match. She was both desperate and distraught, and yet everyone at the Australian Open missed this very public breakdown. It also escaped the tens of millions around the globe watching the television broadcast. While Serena's cheeks were wet, it was assumed, on a warm night at Melbourne Park, that it was just sweat pouring off her face.

It was the third round of the 2006 Australian Open, and Serena was losing to Slovakian Daniela Hantuchová, against whom Serena had never previously even dropped a set. The prospect of defeat wasn't what disturbed her – rather it was the realisation that as someone who had dedicated her life to tennis, and who prided herself as always aspiring to excellence, she now found herself not caring about the outcome on one of the biggest stages in tennis. For probably the first time, the defending champion didn't want to be out there on court. Somehow, Serena resisted the temptation to drop her racket and disappear down the tunnel.

▶ Serena felt 'completely lost', 'beaten and confused' in her third round at the 2006 Australian Open.

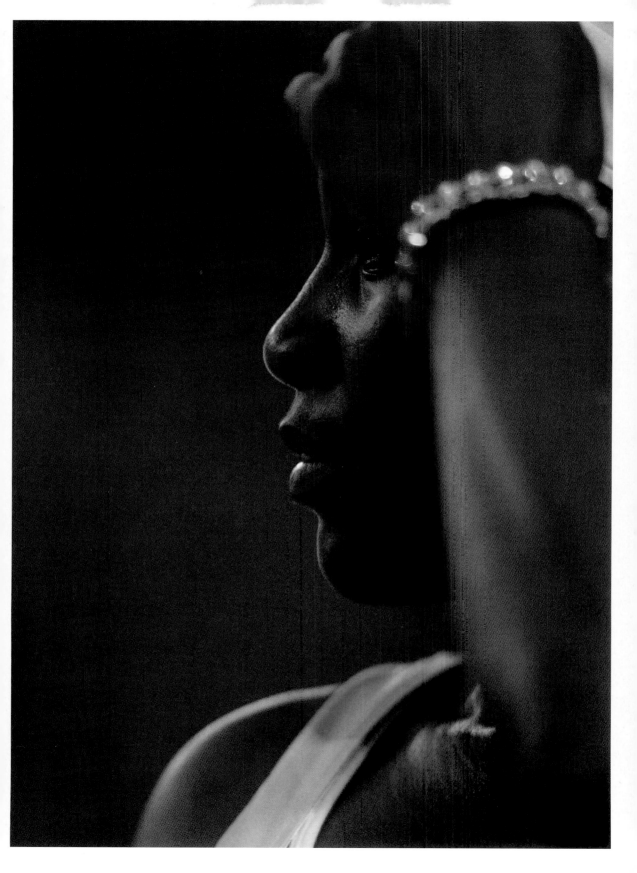

'I didn't know it at the time, but I was slipping into a depression.'

One of the greatest competitors in tennis history, she wasn't performing with anything like her usual ferocity. Not that anyone seemed to notice. She went through the motions of playing points; she didn't ever stop running and she didn't deliberately put the ball into the bottom of the net or three feet beyond the baseline. Serena was to write in her autobiography, *My Life: Queen of the Court*, that she did so knowing that she really didn't care whether she won or lost those points – or the match. All she wanted was to get off that hard court. Afterwards, she would say that she had no feel for the ball: the truth, which she wouldn't disclose until years later, was that she felt numb to the result. As she left the stadium, she was 'completely lost', 'beaten and confused'.

Going into the tournament, Serena had hoped to re-energise her career, and to move on from her disheartening 2005. Aside from winning the Australian Open, it had been a mediocre year for the player (Venus chipped in during 2005, winning that season's Wimbledon title), but this was worse, much worse. At least in 2005, Serena had felt engaged.

For those close to the player though, what happened next was more upsetting. Beaten by Hantuchová in straight sets, Serena returned to Los Angeles, where she went into hiding. Weeks went by, then months, during which she hardly left her apartment, let alone drove to the practice courts or the gym or led the full and active life she had had before.

This seclusion extended to her family – while Serena had always been close to her mother, speaking with her once a day, she didn't call her for a month-and-a-half, and she had no contact with either her sisters or her father. Like Serena, Venus had had a dismal start to the 2006 season – she lost in the first round of the Australian Open, to Bulgaria's Tsvetana Pironkova, and then, because of injury, didn't compete for another four

months, until May, when she played in a tournament in Warsaw. This could have been a time for Serena and Venus to support each other during their absences from the tour, yet Serena shut out her family. She shut herself away from the world.

Serena was to comment that she felt as though she had 'lapsed into serious downhill mode' after winning the 2005 Australian Open. 'Looking back, I think my head wasn't in the game,' she has written of the remainder of that season: she didn't play in another final, let alone win another title. 'It was like every competitive bone in my body was broken – only I didn't have the self-awareness or strength of character to see that anything was wrong.

'I didn't know it at the time, but I was slipping into a depression. I don't think it was what a psychologist would have called a clinical depression, but it was an aching sadness, an allover weariness, a sudden disinterest in the world around me – in tennis above all. Call it what you will, although at first I didn't call it anything. I tried to either ignore it or power past. I just kept playing and playing. And struggling and struggling.'

That's something else that has sometimes been lost in the discussions about Serena, the recognition that even someone with her talents, accomplishments, wealth and fame can be vulnerable. Being good at tennis doesn't protect you from the fog of depression.

It's worth pausing here to rewind and reflect on something Serena said in the moments after losing the 2004 Wimbledon final to Maria Sharapova (if you buy into the Russian's account of the day, this would have been soon after Serena had been sobbing backstage). Asked how, as a 'tennis superstar', she might respond to the challenge from Sharapova, Serena replied: 'A tennis superstar? I'm not a tennis superstar? I'm a superstar. Period. Like Britney Spears.' In the years that followed, all the way up to the 2006 Australian Open and beyond, those comments were repeatedly offered up as an example of Serena's arrogance, her supposed belief that she had come to transcend tennis. What is forgotten is that, just seconds later, she said she was 'kidding'. It was a joke, an off the cuff comment, one which would come back to haunt her.

Officially, the reason she gave for her long absence from the sport was

▶▶ Serena had been hoping to re-energise her career at the 2006 Australian Open.

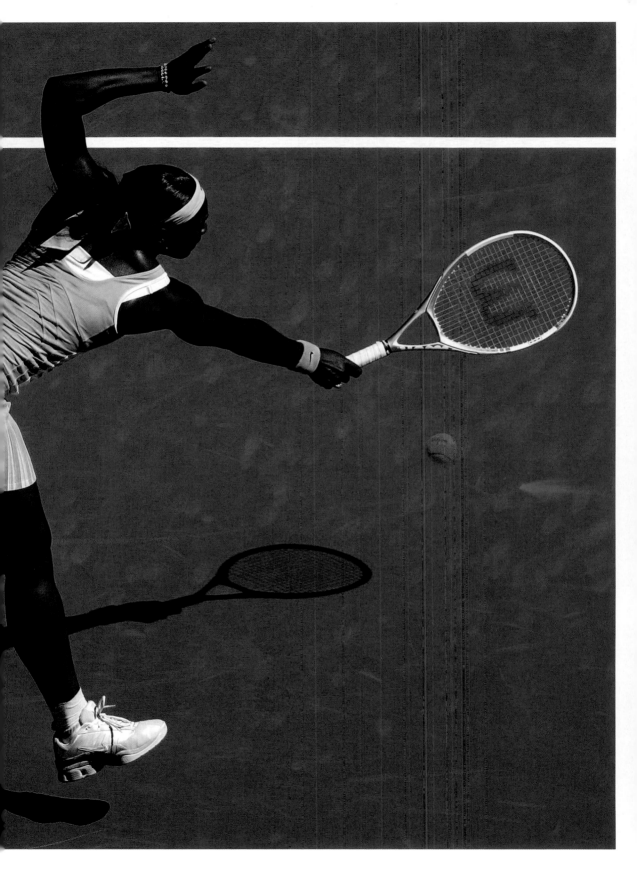

that she had a sore knee. She was missing for six months, between the 2006 Australian Open and that year's Cincinnati tournament during the summer hard court swing in North America. So, when Chris Evert wrote an open letter to Serena, in the May 2006 issue of *Tennis* magazine, accusing her of wasting her talent, the former world number one and winner of eighteen Grand Slams couldn't have known about the mental distress and anguish that her fellow American was going through. Evert's motivation, however, was a genuine concern about Serena's priorities – she was worried that she appeared to be more interested in pursuing her off-court ambitions of acting and designing clothes than in dedicating her life to tennis.

'In the short term you may be happy with the various things going on in your life, but I wonder whether twenty years from now you might reflect on your career and regret not putting one hundred per cent of yourself into tennis,' wrote Evert. 'Because, whether you want to admit it or not, these distractions are tarnishing your legacy. Your other accomplishments just can't measure up to what you can do with a racket in your hand. Just remember you have an opportunity of the rarest kind – to be the greatest ever.'

Also expressing her doubts about Serena's tennis future was another former tennis great, Czech–American Martina Navratilova, in an interview with the *Miami Herald* in 2006. Like Evert's, Navratilova's remarks were born out of a genuine concern that Serena would end up looking back at her tennis career with considerable regret. 'Serena should be in her physical prime, but she is wasting time you cannot ever get back. She had the opportunity to be the greatest in history. Instead, she'll be a supernova who burst on to the scene, and then she was gone,' said Navratilova, who won eighteen major singles titles, putting her level with Evert. 'Serena has a gift, and she's not using it. What you really regret are the things you didn't do. Will she get it together, or will she fall so low she'll need wild-card invitations? She may find by then that her head will be there, but her body won't. It's a sad situation.'

Richard had always encouraged both Venus and Serena to have interests outside tennis as he didn't want 'a couple of gum-chewing

SERENA THE ACTRESS

Credits by year on IMDb –
Internet Movie Database

2002 2003 2004 2005 2006 2007 2008 2009 2010 2011 2012 2013 2014 2015 2016 2017 2018

illiterates' on his hands – and Serena, the youngest, really did imagine she could be an actress as well as a champion tennis player. In reality, the problem wasn't that she was having her head turned by Hollywood and concentrating on matters other than tennis, but rather that she didn't have enough to do in the empty weeks and months that followed her Australian Open defeat.

The Williams family were completely unaware that Serena had been having therapy since 2005 – that was something she had kept from them, along with her depression. When one session a week with her therapist suddenly wasn't sufficient, she increased it to two. And while it became apparent, over the course of those sessions, that her depression had been brought on, in part, by the death of her sister, Yetunde, there were

▲ In 2004, Serena appeared as a guest star in an episode of *Law and Order*.

DOUBLE BAGELS

Serena has won seven matches 6-0, 6-0 – known as a double bagel – at tour level.

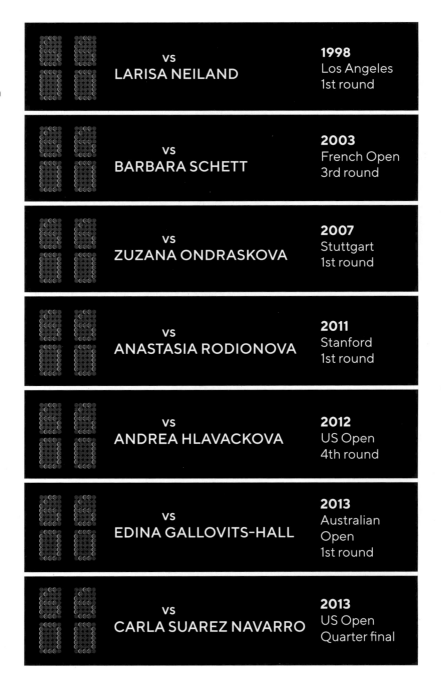

vs
LARISA NEILAND

1998
Los Angeles
1st round

vs
BARBARA SCHETT

2003
French Open
3rd round

vs
ZUZANA ONDRASKOVA

2007
Stuttgart
1st round

vs
ANASTASIA RODIONOVA

2011
Stanford
1st round

vs
ANDREA HLAVACKOVA

2012
US Open
4th round

vs
EDINA GALLOVITS-HALL

2013
Australian
Open
1st round

vs
CARLA SUAREZ NAVARRO

2013
US Open
Quarter final

In all, Serena had played just four tournaments in 2006.

other factors at play. For the first time in her life, she felt as though she no longer liked tennis.

'I've read that in times of stress and duress we start to resent what we love the most, and I suspect that's what happened here. It's like tennis had become a job for me, instead of a passion, a joy, a sweet release,' she disclosed in *My Life: Queen of the Court*. 'At a time in my life when I needed something to lift me up and out of the fog that found me after my sister's passing, all I could do was keep playing tennis, which was all I could ever do. And now, for the first time, tennis couldn't solve anything for me.'

Until that point, Serena's life, like her sister Venus's, had been 'tennis, tennis, tennis'. 'I desperately wanted something more.' Talking to her therapist, she felt as though her unhappiness could be explained by her desire to always make others happy. Weeks passed with Serena in self-imposed exile in Los Angeles, not talking to anyone. So her family drove into town, for what amounted to an intervention. The result was that Serena started seeing her therapist on a daily basis. She wouldn't agree to take any medication, however, for fear that it might disturb her already delicate state of mind.

After January's Australian Open, Serena didn't play again for six months, missing the French Open and Wimbledon. Within the locker room and the tennis media it was assumed that Serena's body was taking longer than expected to repair itself, as she had given no indication that her troubles were mental rather than physical. Meanwhile, tennis was moving on without her. Serena dropped out of the top hundred, the first time her ranking had been that low since 1997, the year she turned sixteen. Her ranking dropped to 140, where she found herself among the grinders, the has-beens and the dreamers.

Then, suddenly and quite unexpectedly, in her own words, 'a weird and wonderful thing happened'. 'The switch flipped in a positive direction. It flipped to where I chose tennis. This was a first for me – and a real breakthrough.' Serena was in her mid-twenties; she would turn twenty-five in September that year. She had won seven Grand Slam singles titles. She had been the world number one, including finishing 2002 at the top of the leaderboard. She had been spoken of as one of the all-time greats. As an African American at the top of the modern game, she was a tennis pioneer. And yet this was the first time it felt as though she was choosing tennis. Before, her father had made that choice for her – or it had seemed as though tennis had somehow selected her – but now she was the one doing the choosing, and it gave her a fresh energy. She had committed to this tennis life.

Yet, six months is a long time to take out in the life of a professional athlete. Making her return, Williams felt as though she had been away from tennis for so long that she was coming back as 'Serena version 2.0'. While she was still coached by her father, and there were no great technical or tactical adjustments to speak of, this new Serena was refreshed, energised and dedicated to becoming the best possible tennis player. The relaunch took place during the North American hard court swing, culminating with the US Open in New York, and while it wasn't the most spectacular comeback that the sport has ever seen, it also wasn't a disappointment either. At her first event, she made the semi-finals in Cincinnati, while she then reached the last four in Los Angeles, before progressing into the fourth round of the US Open, where she was beaten in three sets by French woman Amelie Mauresmo. A sign of where Serena had dropped to in her career was that the former world number one now needed a wild card into the US Open because her low ranking meant that she couldn't gain automatic entry into the draw.

In all, Serena had played just four tournaments in 2006, resulting in her ranking spiralling down to its lowest level in almost a decade; and she had had her motivation questioned by two legends of the game – all while, unbeknown to anyone on the tour, she had been trying to lift herself out of her depression. Yet she was back, and she was also just

▶▶ Serena was ranked eighty-one in the world when she won the 2007 Australian Open.

TOURNAMENTS PLAYED PER TITLE WON

Serena averages one title for every 3.01 tournaments she plays.

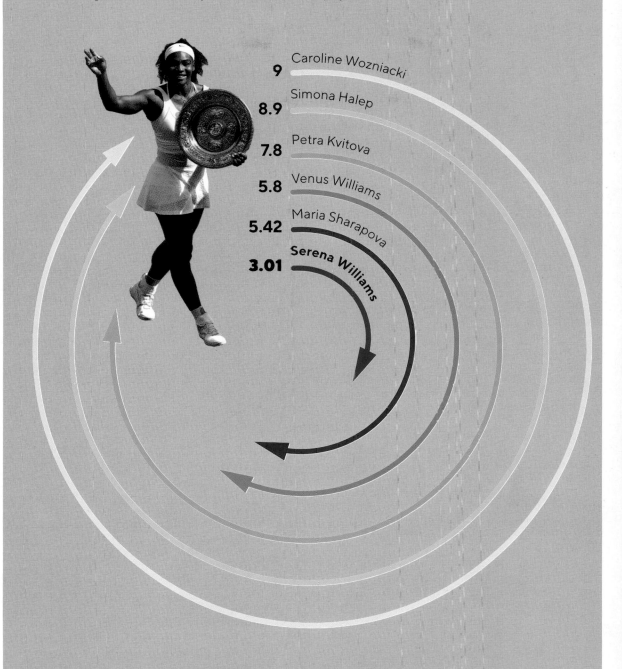

9 Caroline Wozniacki

8.9 Simona Halep

7.8 Petra Kvitova

5.8 Venus Williams

5.42 Maria Sharapova

3.01 Serena Williams

months away from what would be, arguably, the most improbable of all her Grand Slam triumphs.

● ● ●

'Moo,' thought Serena.

It was the week leading into the 2007 Australian Open, and she couldn't help but notice the current media obsession with her hips, thighs and bottom, a story that was being given a lot of column inches and airtime by Melbourne's newspapers and TV networks. 'The general consensus,' she would recall, 'was that I was a big fat cow.' In the face of such scrutiny and negativity about her body, what else could she do but smile and laugh to the world? The only other alternative was to cry, and she didn't want to let the media or, indeed, any of her other critics know that they were getting to her.

That wasn't the first time that her body had become the subject of intense discussion, and it certainly wouldn't be the last. Inside and outside tennis, it can often seem as though everyone has an opinion on Serena's body, just as they might debate another player's backhand or the quality of their second serve. Maria Sharapova, for one, expressed her thoughts in the pages of her 2017 autobiography *Unstoppable*, in which she wrote that it was Serena's 'thick arms and thick legs' that made her 'so intimidating and so strong'.

One attack on Serena came from Shamil Tarpischev, then president of the Russian Tennis Federation, who in 2014 referred to both Serena and her older sister, Venus, as 'the Williams brothers'. Yet she also had her supporters: in 2015, the author J.K. Rowling was so outraged by a troll commenting that Serena was built like a man that she responded by posting a couple of images of the tennis player in a red dress. 'Yeah,' wrote Rowling. 'My husband looks just like this in a dress. You're an idiot.'

In an open letter to her own mother, which Serena posted on Reddit and Instagram, in September 2017, shortly after becoming a parent herself, she gave an insight into how it felt to have had her body picked over and critiqued for years. 'I was looking at my daughter (OMG, yes, I

have a daughter) and she has my arms and legs. My exact same strong, muscular, powerful, sensational arms and body. I don't know how I would react if she has to go through what I've gone through since I was fifteen.

'I've been called a man because I appeared outwardly strong. It has been said that I use drugs (no, I have always had far too much integrity to behave dishonestly in order to gain an advantage). It has been said I don't belong in women's sport – that I belong in men's. (No, I just work hard, and I was born with this badass body and I'm proud of it.)'

Yet, of all the times that Serena's physique was scrutinised in public, the most sustained and most insidious came on the eve of the 2007 Australian Open. Suddenly she was attracting criticism of a totally different kind: for supposedly lacking the strength and physical conditioning to compete.

Two years had passed since Serena had won a Grand Slam. Worse than that, two years had passed since she had appeared in a Grand Slam final. In 2007, she was ranked eighty-one in the world, and the media kept

▲ Serena's victory at the 2007 Australian Open was her first Grand Slam title for two years.

LAUREUS SPORTSWOMAN OF THE YEAR

Serena has won the award a record 4 times.

saying how the extra weight she was carrying meant she wouldn't triumph again in Melbourne (which, you suspect, was what some other players would have been saying privately). She has joked that the most strenuous thing she had done since her last appearance was shopping on Rodeo Drive, while – in another break from her usually strict fitness regime and diet – she had spent a lot of time frequenting Stan's Donuts in Los Angeles. After an early loss during a small warm-up tournament in Hobart, Tasmania, where she was beaten in the quarter-finals by Austrian Sybille Bammer, what possible hope did she have in Melbourne? It didn't help Serena's mood when an executive from Nike had a quiet word before the Australian Open, in which he suggested that she needed to have a good tournament otherwise she might not hang on to her clothing sponsorship contract.

History was also against Serena as she sought an eighth Grand Slam title, and a third triumph at Melbourne Park. An unseeded woman hadn't won the Australian Open since Chris O'Neil was the champion in 1978. But somehow, in perhaps the most improbable fortnight of her career, which included coming back from a set down in both her third-round match with Russian Nadia Petrova and her quarter-final against Israel's Shahar Pe'er, she came through to win. The tournament is mostly remembered for the ferocity of her tennis in the final, when she demolished Sharapova for the loss of just three games. Sharapova thought her opponent had been 'flawless'. The greatest error she made was when she fired a ball directly at Serena, who appeared to mouth in response: 'You're going to pay for that.'

▸ The 2007 Australian Open was the most improbable fortnight of Serena's career.

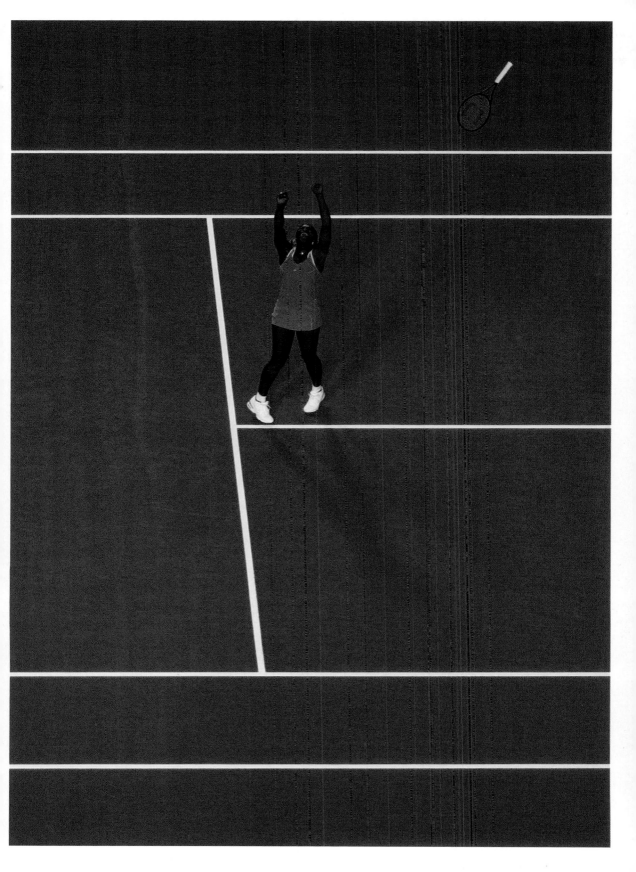

Serena wasn't simply motivated by a desire to go back to winning majors again, however. She was also inspired by the memory of her late sister and had written 'Yetunde' on a piece of paper which she took on to court. 'Every changeover I looked at it and I thought about how happy she would have been, how much she always supported me. I thought about what an amazing sister she was to me. I said, "Serena, this has to be motivating". This had to be more than enough to motivate me, and I think it was.' In her champion's address, an emotional Serena would dedicate her win to Yetunde.

Another considerable factor was the desire to prove something to those who saw her just as 'a big fat cow'. 'I felt that people said I wasn't fit because I'm larger in some areas than other girls,' she said in the press.

LOWEST RANKED GRAND SLAM SINGLES CHAMPIONS

At the 2007 Australian Open, Serena became the lowest ranked women's Grand Slam singles champion since 1978.

MARK EDMONDSON	EVONNE GOOLAGONG	CHRIS O'NEIL
212	**-**	**111**
1976 AUSTRALIAN OPEN	1977 AUSTRALIAN OPEN	1978 AUSTRALIAN OPEN
	Unranked	

'I don't have a flat chest. If I lost twenty pounds, I'm still going to have these knockers – forgive me – and I'm still going to have this ass. It's just the way it is.'

Writing on her blog a few months later, she addressed her fanbase, thanking them for their support. 'One day you are on top of the world, and the next day you are fighting to hold on physically and mentally. You grasp on to a small string that's holding you between sanity and insanity... Groping in the dark trying to find the light that can lead you out of the dark tunnel... Then and only then you find... the true people that are your friends... the ones that are willing to be there for you whether or not you are extremely successful or just normal.'

GORAN IVANISEVIC

KIM CLIJSTERS

125

81

—

2001
WIMBLEDON

2007
AUSTRALIAN
OPEN

2009
US OPEN
Unranked

5

'ON HER DEATH BED'

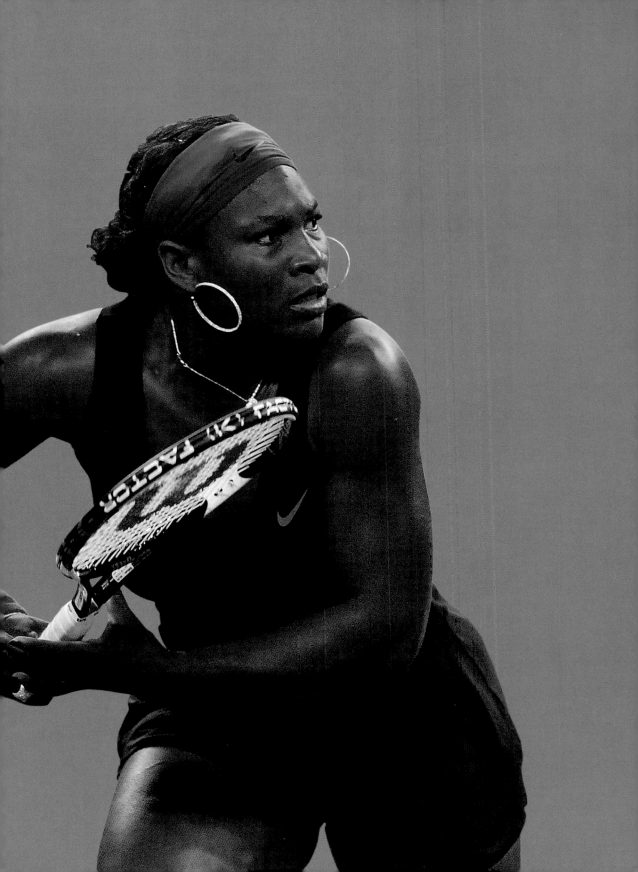

Who, you might well ask, is the real Serena? There isn't one answer to that question, but several - in interviews with the media, Serena speaks openly of her multiple personalities.

The mellow version of Serena is the one she likes to call 'Summer', who is apparently 'an assistant who lives inside my body', and a sweet girl who writes thank-you notes. 'Megan', meanwhile, is 'a bad girl who likes to have a lot of fun', while 'Psycho Serena' is 'a girl who gets really crazy on the tennis court and just really fights hard, just takes it a little too far sometimes'. If there's one version of her that you don't want to upset though, it's 'Laquanda': 'She's not nasty, she's just real and keeps it real. And you definitely don't want to cross her. If you cross her, then she snaps. I don't speak to her very often. I never try to see her. She's nuts.'

Every so often, Laquanda comes out to play, and it can get ugly fast. Probably never more so than during Serena's semi-final against Belgian Kim Clijsters at the 2009 US Open, when the American was dropping f-bombs on primetime US television, while threatening to stuff a tennis ball down a line judge's throat. The watching John McEnroe, known for his own very public court meltdowns, thought 'all hell broke loose' on that wild night. It doesn't take much to identify the moment on the Arthur Ashe Stadium when 'Psycho Serena' flipped to 'Laquanda', behaviour that ultimately resulted in the largest one-off fine in the history of the Grand

▶ Serena during the 2009 US Open semi-final.

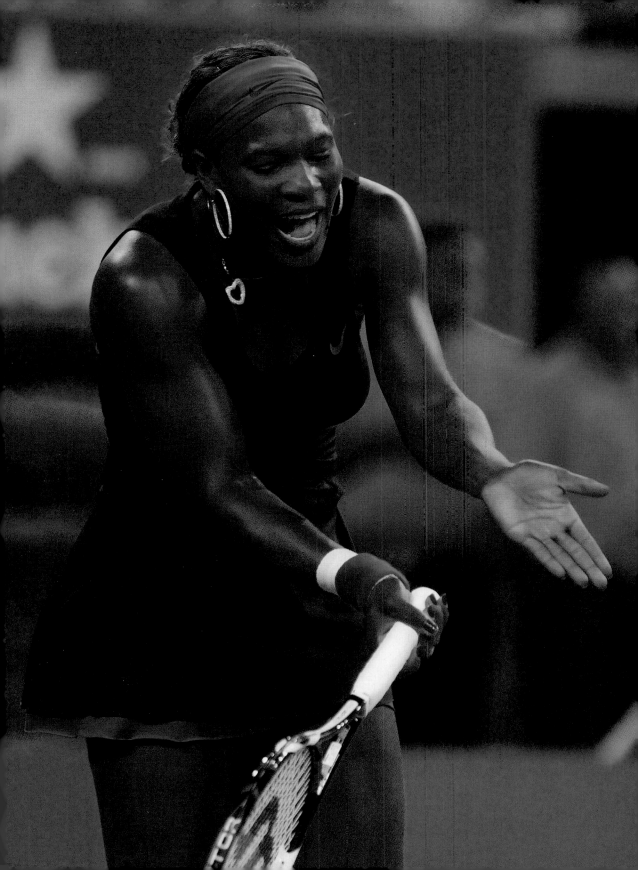

TIMELINE OF GRAND SLAM APPEARANCES

	1998	1999	2000	2001	2002	2003	2004	2005	2006	2007
AUSTRALIAN OPEN	●	●	●	●	○	●	○	●	●	●
FRENCH OPEN	●	●	○	●	●	●	●	○	○	●
WIMBLEDON	●	○	●	●	●	●	●	●	○	●
US OPEN	●	●	●	●	●	○	●	●	●	●

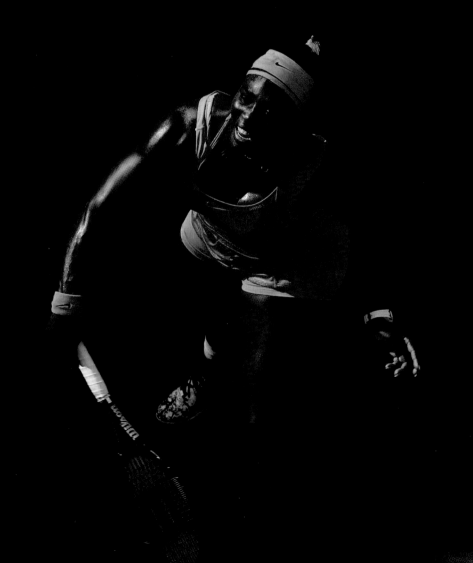

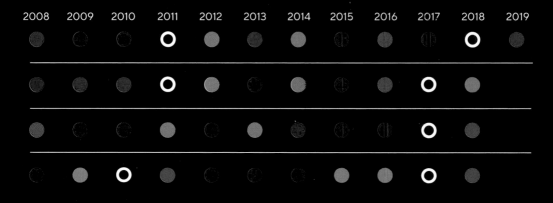

| 2008 | 2009 | 2010 | 2011 | 2012 | 2013 | 2014 | 2015 | 2016 | 2017 | 2018 | 2019 |

○ CHAMPION ◐ QUARTER-FINAL ◑ 2nd ROUND

◉ RUNNER-UP ◉ 4th ROUND ◉ 1st ROUND

◉ SEMI-FINAL ◉ 3rd ROUND ○ DID NOT PLAY

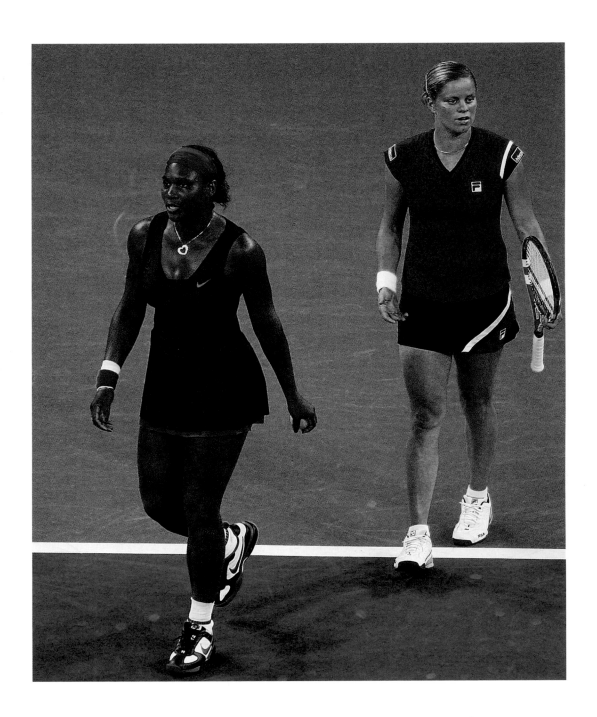

Slams. Serving to stay in the match, she was called for a foot fault, which made the stadium gasp, and which left the defending champion very cross indeed. Almost immediately, she tore into the line judge, Shino Tsurubuchi. It was clear in her mind that her foot must have been behind the baseline when she hit the serve. In her analysis, she never foot faulted and now this, at the crucial stage of a match deep into her home Grand Slam. Enraged, Serena approached the line judge, jabbing her finger and telling the official, in what must have been a first, that she was going to shove a tennis ball down her throat. 'I swear to God, I'm f---- going to take this f---- ball and shove it down your f---- throat, you hear that? I swear to God.'

In an interview with *Sports Illustrated*, the line judge would report Serena 'said a bad word, a very bad word'. The problem was that Serena had said that 'very bad word' more than once, and those words had been accompanied by apparent threats.

Much was made of the size of the bespectacled line judge, who at just five feet tall was considerably smaller than the tennis player, and who later confessed to being 'a little' scared: 'If you look at the people behind me in the stands, they were scared,' she added.

With that foot fault called on a second serve, Serena was suddenly match point down, but that point would never be played. When the line judge ran over to the umpire and whispered what Serena had said, the contest was over. After conferring with the tournament referee and the WTA supervisor, the umpire punished Serena with a point penalty, which meant that it was game, set and match Clijsters. She looked distinctly uncomfortable at going through to the final against Denmark's Caroline Wozniacki in such unusual circumstances.

Naturally, that wasn't the end of the matter. Within hours, the tournament fined Serena $10,000. Over the coming months, the Grand Slam Committee investigated the incident, before concluding that the American was guilty of a major offence – that's something that goes way beyond the relatively mild misdemeanours of trashing rackets, smacking tennis balls out of the stadium in anger or cussing to yourself over duffing a shot. According to the rulebook, she had behaved in a way that was

◄ Serena was judged to have committed a major offence at the 2009 US Open.

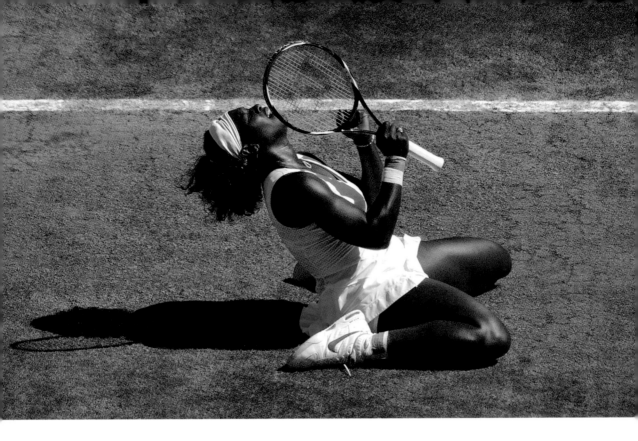

▲ Serena celebrates
after beating Venus in
the 2009 Wimbledon
final.

'flagrant and particularly injurious to the success of a Grand Slam, or is
singularly egregious'.

One part of the punishment was financial, but the other had far more
serious implications – the threat of a ban from the majors. In the end, she
was fined a further $82,500 and put on probation for two years at the
Grand Slams. This meant that if Serena were to commit another offence,
she would be suspended from the next US Open, and her fine would be
increased to $175,000. Some commentators regarded that punishment
as being too lenient, arguing that she should have missed the next Grand
Slam, the 2010 Australian Open, or the next US Open in 2010 as a
consequence for her actions.

It seemed everyone had a view on the episode, with some fans
apparently telling Serena that they had only started watching tennis
because of her tirade. 'A lot of people say that it was the coolest thing
they've ever seen,' she said. 'I think that's a little bit ridiculous. But they
say that after I did that, they now watch tennis, and I'm like, "cool". It was
what it was.'

There were other consequences for Serena, however: she was spoken to by the elder Jehovah's Witnesses. 'They had to have a talk with me,' she told the *New York Times*. 'And I knew it was coming. I just felt really bad, though, because it's like, that's not who I am. They just talk to you. They show you Scriptures. It's almost like a reprimand, but it's not bad because in the Bible it says God loves you, and if someone reprimands you, they love you.'

Amid all the fury at Serena's language and behaviour, what almost went undiscussed was the pressure that she would have been putting on herself to win the tournament, which would have taken her level with her idol and fellow American Billie Jean King on twelve singles majors. Since Serena's astonishing victory at the 2007 Australian Open, she had won three more Grand Slams, at the 2008 US Open, the 2009 Australian Open and 2009 Wimbledon, taking her to eleven in total. You can appreciate why she jumped up and down after winning the 2008 US Open – just a couple of years after dropping out of the top hundred, that victory over Serbia's Jelena Janković took her back to world number one for the first time in five seasons.

In another significant development, Chris Evert disclosed that she perhaps shouldn't have written that open letter, in 2006, to *Tennis* magazine, in which she questioned whether Serena was more interested in being an actress and clothes designer than a tennis player. 'It's opened my eyes not to be judgmental and to each his own. Whatever makes you happy. By having other interests, maybe you won't get burned out so quickly,' she commented.

Watching his daughter win another major at the 2008 US Open, Richard felt as though Serena was fighting like 'a cross between a pit bull, a young Mike Tyson and an alligator', and she showed more of that spirit at the 2009 Australian Open. Such was her domination of Dinara Safina – Serena gave up just three games in the final – that the Russian admitted to feeling like a ball kid on the court, just running after shots and playing fetch.

'Are you looking at my titles?' read the provocative slogan on the Nike T-shirt Serena wore around the All England Club, after beating her sister,

GRAND SLAM WINS

Serena has won more singles matches at the Grand Slams than any
other woman (figures correct after the 2019 Australian Open).

Wins and defeats in Grand Slam matches

SERENA WILLIAMS	STEFFI GRAF	MARTINA NAVRATILOVA	CHRIS EVERT
335-46	278-32	305-49	296-37

Player overall winning percentage

88%	90%	86%	89%

Winning percentage by Grand Slam

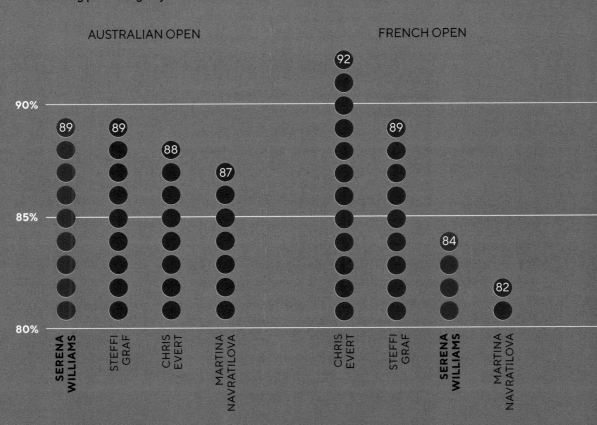

AUSTRALIAN OPEN

FRENCH OPEN

90%

85%

80%

SERENA WILLIAMS — 89
STEFFI GRAF — 89
CHRIS EVERT — 88
MARTINA NAVRATILOVA — 87

CHRIS EVERT — 92
STEFFI GRAF — 89
SERENA WILLIAMS — 84
MARTINA NAVRATILOVA — 82

Wins and defeats by Grand Slam

	AUSTRALIAN OPEN	FRENCH OPEN	WIMBLEDON	US OPEN
SERENA WILLIAMS	85-11	63-12	92-11	95-12
STEFFI GRAF	47-6	84-10	74-7	73-9
MARTINA NAVRATILOVA	45-7	51-11	120-14	89-17
CHRIS EVERT	29-4	72-6	94-15	101-12

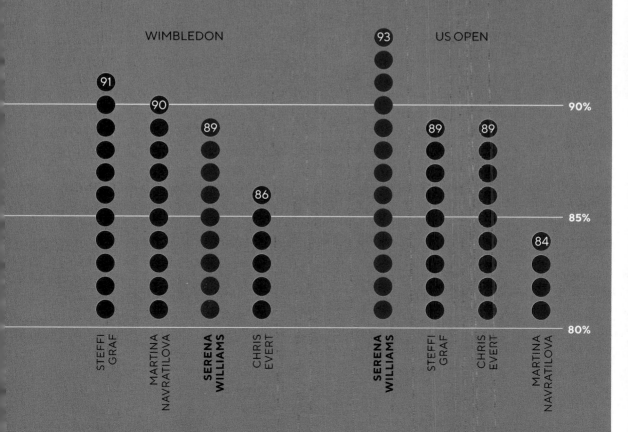

RIVALRIES

The numbers behind some of Serena's most important rivalries, and the few players with a winning record against her.

Winning percentage in some of her key rivalries

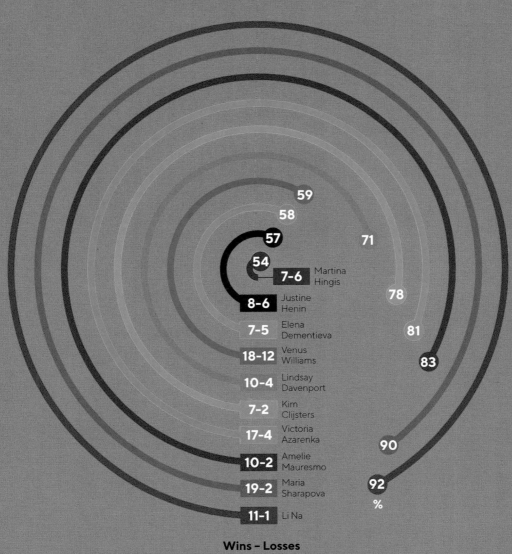

59
58
57
54
7-6 Martina Hingis
71
8-6 Justine Henin
78
7-5 Elena Dementieva
81
18-12 Venus Williams
83
10-4 Lindsay Davenport
7-2 Kim Clijsters
17-4 Victoria Azarenka
90
10-2 Amelie Mauresmo
19-2 Maria Sharapova
92
11-1 Li Na
%

Wins – Losses

Players with a winning record against Serena

57

100

100

%

3-4 Sybille Bammer

0-2 Arantxa Sanchez-Vicario

0-2 Naomi Osaka

Wins – Losses

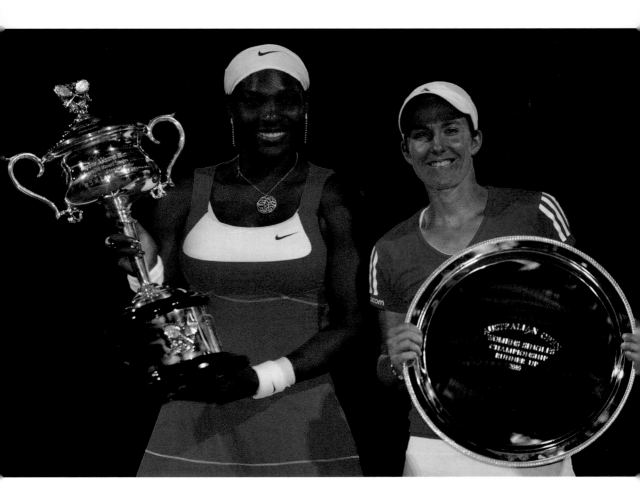

▲ The controversy of the 2009 US Open didn't stop Serena from winning the next Grand Slam, the 2010 Australian Open.

Venus, in the 2009 Wimbledon final. The sport was indeed counting her titles, as that was the third occasion that she had won Wimbledon, and all three of her titles had come through defeating her sibling in the final, although she lost to Venus in 2008.

While discussions about Serena's language at the 2009 US Open continued for months, that controversy seemed hardly to affect her performance at the next major, the 2010 Australian Open, the tournament that some critics considered she should have been barred from. One of Serena's most important and most compelling rivalries was

with Justine Henin, resulting in a battle between the American's powerball tennis and the Belgian's guile and exquisite single-handed backhand. By beating Henin in the Melbourne final, Serena had won her twelfth major, and gained parity with her idol, King. Victory over Russia's Vera Zvonareva in that season's Wimbledon final, for her thirteenth major, was 'kind of cool', as she put it; it placed her ahead of King, provoking further debate about how high she could go on the leaderboard. Now there were only five women ahead of Serena on the all-time list of Grand Slam tite wins for the amateur and professional eras: Margaret Court on twenty-four, Steffi Graf had twenty-three (and the record for the Open Era), Helen Wills Moody was on nineteen and Evert and Navratilova were level on eighteen apiece.

As she walked into Wimbledon's post-tournament party, the Champions' Dinner, Serena was in a good place, a happy place; yet, as we have seen, nothing is ever straightforward in this woman's life. Within days, she would have an accident that would keep her away from competitive tennis for almost a year, leading her to miss three Grand Slams in the process; she only returned for the 2011 grass court season. Even more seriously, that calamity would lead to medical complications that would leave her on what was almost to be her death bed.

● ● ●

It was a pedicure that changed Serena's life. In fact, it was a pedicure that almost ended her life. Days after winning the 2010 Wimbledon title, Serena was in Munich, getting ready to go out to a restaurant. She had been planning on wearing boots, but then, wanting to avoid chipping the fresh polish on her toenails, at the last moment switched to a pair of open-toe sandals.

'You ever see that movie *Sliding Doors* with Gwyneth Paltrow?' she has commented, referring to the fact that one choice can change the direction of your life. The irony, given what followed, was that when making the decision about which shoes to wear that night, she had said to herself: 'Man, I don't want to mess up my toes.'

Serena has won six majors without dropping a set, tying an Open Era record with Martina Navratilova.

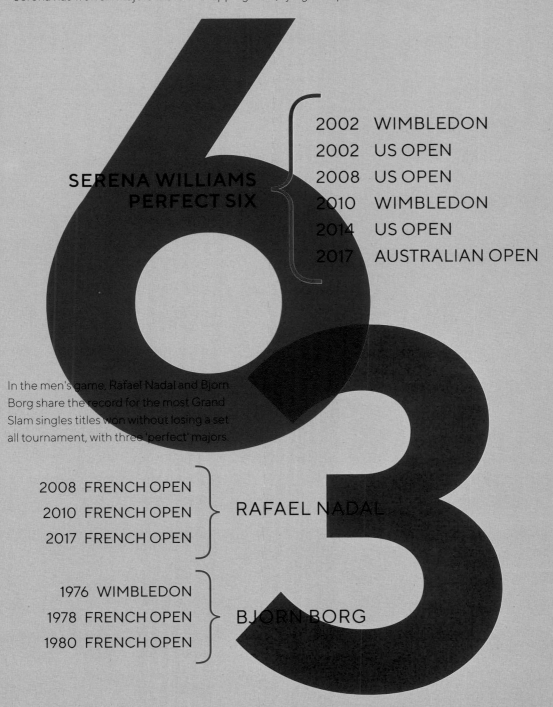

**SERENA WILLIAMS
PERFECT SIX**

2002	WIMBLEDON
2002	US OPEN
2008	US OPEN
2010	WIMBLEDON
2014	US OPEN
2017	AUSTRALIAN OPEN

In the men's game, Rafael Nadal and Bjorn Borg share the record for the most Grand Slam singles titles won without losing a set all tournament, with three 'perfect' majors.

2008	FRENCH OPEN
2010	FRENCH OPEN
2017	FRENCH OPEN

RAFAEL NADAL

1976	WIMBLEDON
1978	FRENCH OPEN
1980	FRENCH OPEN

BJORN BORG

'It could possibly have been career-ending, but for the grace of God I got there [to the hospital] in time...'

As she left the restaurant, however, Serena stepped on something sharp, most probably broken glass. Immediately in pain, and bleeding so heavily that she left a large puddle of blood on the floor, she fainted. For the second time in her career – the first when she hurt her knee while dancing in heels in a Los Angeles nightclub – a freak accident was to impact on Serena's health, and subsequently her mental wellbeing.

While there have been some suggestions that what she stepped on was a broken beer bottle, she is not entirely sure, her memories of the night affected by shock, the blood and fainting. Whatever she trod on, the resulting damage left her with a droopy toe. One operation wasn't enough, the injury so severe that she ended up having two surgeries, with the second leading to the most testing time of her life to that point, aside from the period after her sister's death. Having to spend twenty weeks with her foot in a cast, which prevented her from training, was torturous for Serena.

Some days, she felt a little 'depressed', to the extent that she didn't leave her bed. Miserable to be around, she cried a lot. 'So much stuff happened to me and I just couldn't understand why, or what I had done to deserve this. But I just think it was a series of unfortunate events,' Serena has said. 'As the Bible says, there are unforeseen occurrences and unforeseen things that can take place.'

Such a long period of inactivity didn't just have a damaging effect on her mind; it also caused a pulmonary embolism in her lungs in early 2011, which gave her the 'scariest moment of my life' and was to prove life-threatening. 'A lot of people die from that,' she commented. 'They said it could have gotten a lot more serious a day or two later. It could possibly

▶▶ Serena and Justine Henin during the 2010 Australian Open final.

have been career-ending, but for the grace of God I got there [to the hospital] in time, and I was able to recover from it.' In an interview with *People*, she said she was 'lucky to be alive'.

There was a further complication when Serena was readmitted to hospital with a large haematoma in her stomach that had grown to the size of a grapefruit. Doctors told Serena: 'We can't drain this. We have to surgically remove it.'

One of the most unusual methods for regaining her strength and improving her breathing involved a swimming pool and a water bottle. Under the instruction of her long-term fitness trainer Mackie Shilstone, Serena was treading water in a swimming pool while slowly tipping a bottle of water over her head. She continued until the bottle was empty, then repeated the exercise over again several times. Sensing her discomfort, Shilstone called out to her from the side of the pool, imploring her to rediscover the courage she had shown when recovering from her blood clots and haematoma: 'Why are you afraid of opponents? How can you ever be afraid of an opponent? You just walked away from death.'

Having literally been 'on her death bed', Serena felt as though the episode had given her a new perspective not just on her life, but also on her career as a tennis player. Just months after that near-death experience, the tennis player would be seeking another trophy for her collection. Would she be more calm and gentle on her return to competition? Having prepared with a warm-up, grass court tournament in Eastbourne, Serena played the first Grand Slam of her comeback at that summer's Wimbledon. While she was the defending champion, she had hardly played that year, and few imagined that she would go on to win the title. And so it proved: she lost in the fourth round to Frenchwoman Marion Bartoli (who would go on to win the title two years later).

By the end of summer 2011, Serena was again embroiled in controversy. Playing at the US Open for the first time since 2009, the tournament which had ended so badly for her, Serena reached the final at Flushing Meadows, only once again to draw criticism for the language she used towards officials. Such was the drama, when people in tennis discuss the 2011 US Open, they only mention in passing that Australia's Sam

TIEBREAKS

Serena's career winning percentage in tiebreaks

67 %

Winning percentage by year

Year	Percentage
1997	**50 %**
1998	**50 %**
1999	**100 %**
2000	**57 %**
2001	**50 %**
2002	**92 %**
2003	**100 %**
2004	**57 %**
2005	**13 %**
2006	**0 %**
2007	**75 %**
2008	**71 %**
2009	**50 %**
2010	**83 %**
2011	**60 %**
2012	**60 %**
2013	**57 %**
2014	**100 %**
2015	**78 %**
2016	**80 %**
2017	**100 %**
2018	**100 %**

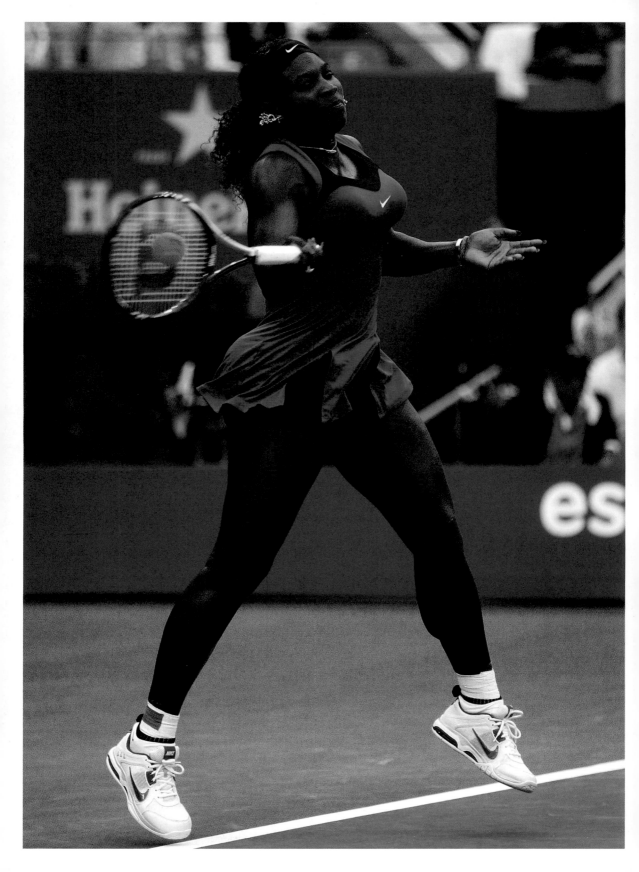

Stosur won her first Grand Slam title that night. This time, Serena lost her composure after being penalised for supposedly distracting Stosur during a point. After having struck what she imagined would be a winner, she called out 'C'mon', but, as the point was still live, the umpire ruled that she had distracted Stosur. The rules were clear, the point Stosur's.

At the next changeover, Serena made her displeasure very clear to umpire Eva Asderaki: 'You're nobody. You're ugly on the inside.' A ninety-second changeover wasn't nearly long enough for her to say everything she wanted to, it seemed, and the next time she sat down between games, she continued her attack: 'You see me walking down the hall, look the other way. We were in America the last time I checked. You're a hater and you're unattractive inside. What a loser.' Afterwards, she said that she couldn't recall her conversation with the umpire: 'I don't even remember what I said. It was just so intense out there. It's the final and I guess I'll see it on YouTube. I was just in the zone.'

That two-year period between the 2009 and 2011 US Opens had proved to be one of the most turbulent and trying times of Serena's tennis career – injury, depression and coming close to death all bookended by controversy at her home Grand Slam. That she had attacked another official while playing in America may be an indication of the pressures and expectations that Serena feels every time she steps out under those lights on the Arthur Ashe Stadium. This time, she was fined a mere $2,000, which the United States Tennis Association said was 'consistent with similar offences at Grand Slam events', and tennis quickly moved on.

Days after the 2011 US Open, Serena turned thirty, which is a particularly significant birthday for a tennis player. Traditionally, tennis players fade away in their thirties, never again showing the power and poise that they had demonstrated in the prime of their teens and twenties. Venus, some fifteen months older than Serena, was still competing on the tour, but she wasn't the same player in her thirties that she had been in her youth. For Serena it was different: once again, Venus's younger sister would go on to demonstrate that she wouldn't be constrained by tennis convention.

◂ Serena during the emotional 2011 US Open final.

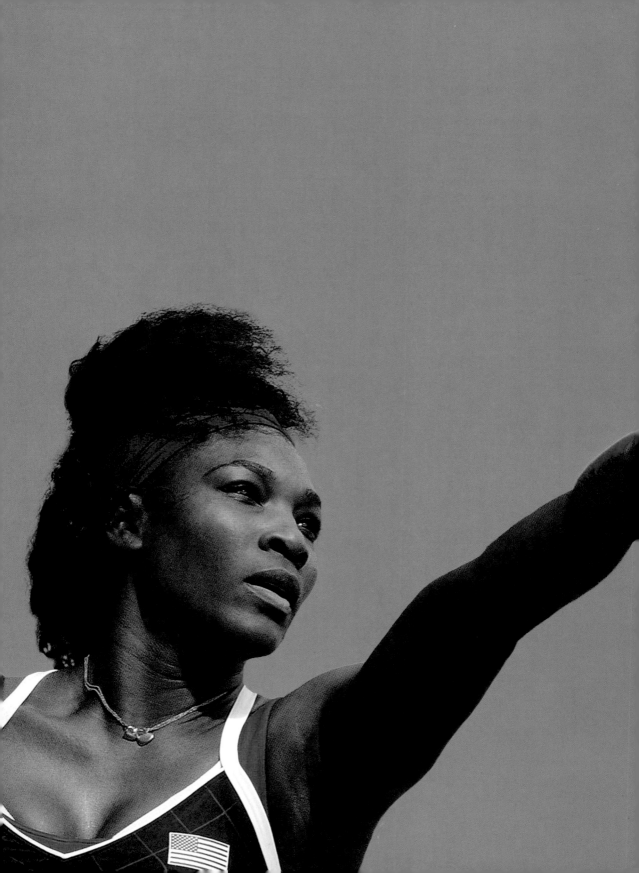

NEW COACH,
NEW BEGINNING

For three days, Serena didn't leave her Paris apartment. She barely even left her bedroom.

Historically, Serena has never been one to easily accept defeat, but her loss in the opening round of the 2012 French Open, to Frenchwoman Virginie Razzano, was the most unsettling, the most discombobulating, the most distressing of all. She had never been beaten in the first round of a Grand Slam, so this, her first, was smeared across her record, just like the clay of Roland-Garros had stained her shoes and socks. Yet that was a mere sidebar to the shock at Serena's apparent mental disintegration on Court Philippe Chatrier, while playing Razzano, who was ranked 111 in the world. For much of the match, Serena – ranked over a hundred places higher, at number five – had appeared tearful, negative, lost and resigned to defeat.

When players lose early at a Grand Slam tournament, they tend to flee town as soon as possible. Why stick around and wallow in misery? For days after such a devastating defeat at the French Open though, a vulnerable, distraught Serena remained just a few miles from Roland-Garros, lying in bed, in her apartment on Paris's Left Bank, staring at the ceiling and repeatedly asking herself a question that she couldn't answer: what next?

▸ Until the 2012 French Open, Serena had never lost in the first round of a Grand Slam.

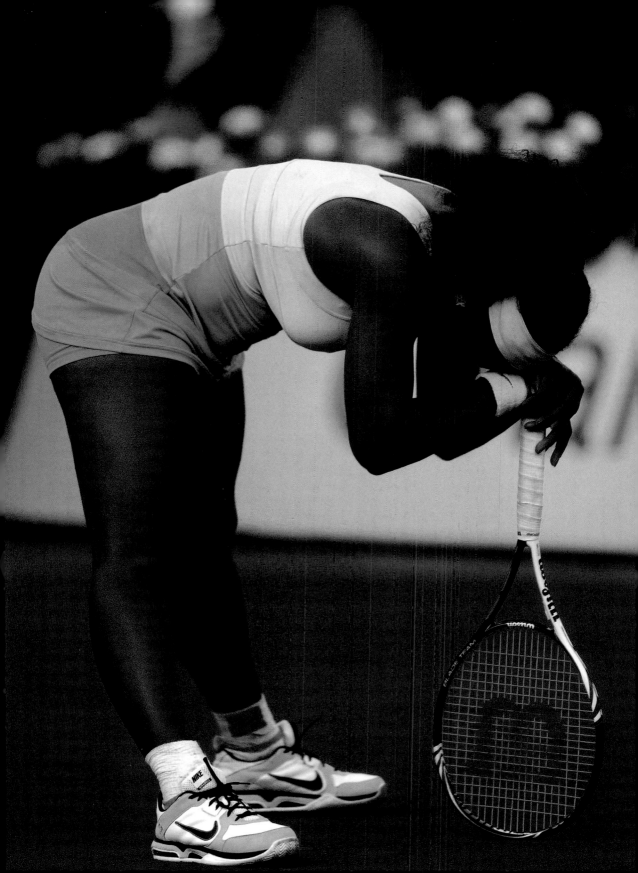

While she barely knew Mouratoglou, there was something about him that intrigued her.

On one of the biggest stages in tennis, against an opponent she should have easily dealt with, Serena knew she had 'come undone'. Hence her devastation. The thought of flying back home to Palm Beach Gardens in Florida wasn't appealing. She came around to the conclusion that she wanted to stay in France to try to fix her game before Wimbledon, which was less than a month away. But how might she rejuvenate her tennis?

As a child, and then as a grown-up woman winning Grand Slam titles, Serena had been coached by her father, Richard. Her mother, Oracene, had also been a guide and mentor throughout her life. Now in her thirties, Serena had never had a coach outside the family, although for years she had employed a German hitting partner, Sascha Bajin. As she pondered the state of her career in her apartment, Serena's thoughts turned to the possibility of hiring an outsider, Patrick Mouratoglou.

In the practice week before the French Open, Serena had found herself repeatedly bumping into the Frenchman in the corridors of Roland-Garros, and while they would say hello and chat for a minute or two, their relationship didn't go much deeper than that. While she barely knew Mouratoglou, there was something about him that intrigued her: she had noticed, over the years, how he had galvanised many of the players he had worked with, including guiding French–Iranian Aravane Rezaï into the top twenty of the women's game, and mentoring Cypriot Marcos Baghdatis, who played in the 2006 Australian Open final and broke into the men's top ten. Perhaps Mouratoglou could help her reboot her tennis life? It was coming up for two full years since she had last won a Grand Slam at the 2010 Wimbledon Championships. Two years without a major, with a significant birthday in between – she had turned thirty in

September 2011 – inevitably triggered discussions about Serena's future in tennis. Would she ever win another slam? Could Mouratoglou offer her the tactical, technical and psychological guidance she needed?

More practically, Mouratoglou had a tennis academy just outside of Paris. Serena texted the coach: 'I need a place to hit.' They ended up talking on the phone and made a plan: Mouratoglou would send a car in the morning to take her to the academy, where he would provide her with a court and a couple of male sparring partners.

Their first practice session didn't go quite as Serena had imagined: Mouratoglou didn't say a word. The coach also didn't hit a ball nor take a racket on to court; instead, he stood where the umpire's chair would be and observed.

Mouratoglou had been aware of how desperately the American had played at Roland-Garros; in his part-time role as a television analyst, he had been in a studio during the match, and he and his colleagues had been shocked at her performance. Mentally, Mouratoglou thought, Serena had been 'unrecognisable': 'Serena was negative and seemed lost out on court; she was in tears at every changeover and gave the impression that she had already lost.' For half an hour on the practice court at the Paris academy, Serena hit groundstroke after groundstroke; the only sound was the popping of the tennis balls leaving her strings. Mouratoglou remained still and silent, just watching, and Serena became increasingly confused as to why he didn't offer her any advice, encouragement or make a single comment. Mouratoglou's silence only ended when Serena, taking her first break of the session, sat on a chair and called out to him: 'Talk to me.'

With hindsight, it might seem that the future success of their player–coach relationship would rest on how Mouratoglou responded to that invitation. His analysis, which he shared with her, was that she was repeatedly off-balance when hitting the ball, her movement awkward, stilted and uneven, caused by stress, he believed.

'I watched your match against Razzano. I can see you're making the same mistakes in practice that I saw you make in your match. You're not respecting the fundamentals. You're waiting for the ball to come to you

GRAND SLAM PROGRESSION

At the 2018 US Open, Serena played in her 31st Grand Slam final.
That was her 69th major – meaning she had reached the final at
44.9 per cent of the Grand Slams she had played.

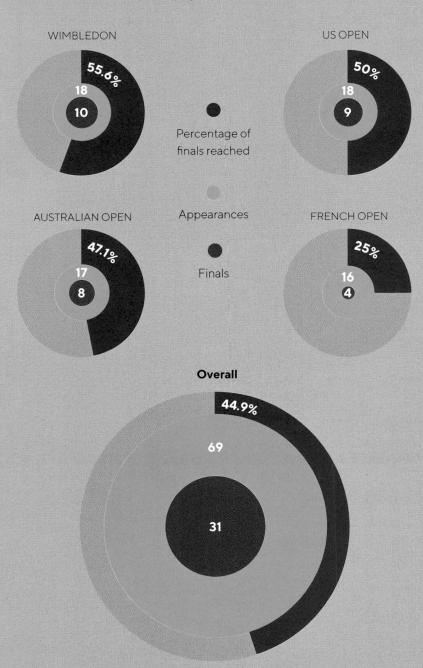

WIMBLEDON
55.6%
18
10

US OPEN
50%
18
9

Percentage of
finals reached

Appearances

Finals

AUSTRALIAN OPEN
47.1%
17
8

FRENCH OPEN
25%
16
4

Overall
44.9%
69
31

Success rate for reaching Grand Slam semi-finals:

Serena has reached the semi-final or better at more than half of the Grand Slams she has played.

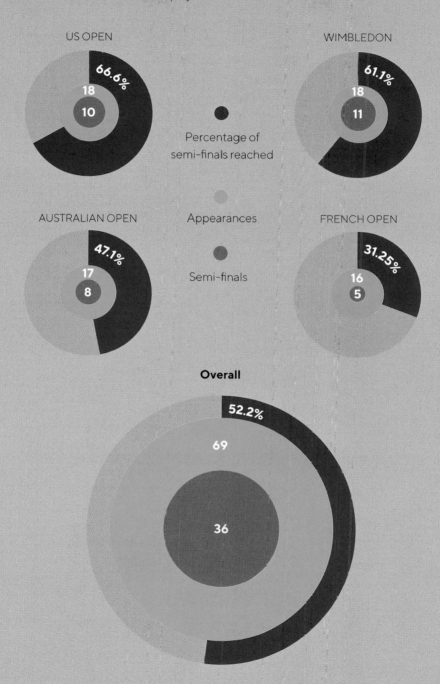

US OPEN
66.6%
18
10

WIMBLEDON
61.1%
18
11

Percentage of semi-finals reached

AUSTRALIAN OPEN
47.1%
17
8

Appearances

Semi-finals

FRENCH OPEN
31.25%
16
5

Overall
52.2%
69
36

instead of moving towards it. And when you hit the ball, you're not balanced. Your feet need to be further apart and your centre of gravity needs to be lower at the moment of contact with the ball to give you better stability.'

As Mouratoglou recalls in his memoir *The Coach*, that was apparently the first time all morning that he saw Serena smile. She replied: 'That's unbelievable. My father also tells me that I don't move up to the ball.'

Mouratoglou offered fresh and yet, at the same time, reassuringly familiar insight. Serena liked the way he operated on the practice court and the way he thought about her game, including some of the more unconventional aspects of it. Throughout her career, others had urged the tennis player to change her open stance, but Mouratoglou suggested that she continue using that technique, since it had already brought her years of success. After a few days practising at the academy, Serena was feeling much better about her tennis. She didn't want her arrangement with Mouratoglou to end.

The one complication was that he was already coaching another player, Grigor Dimitrov, a Bulgarian who at the time was ranked just inside the top one hundred on the men's tour. Dimitrov showed considerable flair and promise, to the extent that he was known as 'Baby Federer'. Mouratoglou indicated that looking after the player would be his priority, but Serena wouldn't be put off. Arriving in London, she met Mouratoglou in a cafe in Wimbledon Village, where she asked him to prepare her for The Championships: 'I haven't won a Grand Slam tournament for a good while. I'm ready to do whatever's necessary to achieve that. I've only ever had one coach: my father. Perhaps the time has come for me to have another look at my game.' More than anything, Serena wanted to wipe the memory of her defeat to Razzano by winning Wimbledon. Mouratoglou agreed, although Dimitrov would remain his main focus.

During that meeting in a Wimbledon café, Serena had told Mouratoglou how much she liked his energy: 'You give me a feeling of strength. When you're in the room, even if you're not doing or saying anything, you have a presence. You exude a feeling of confidence that makes me want to have you by my side.'

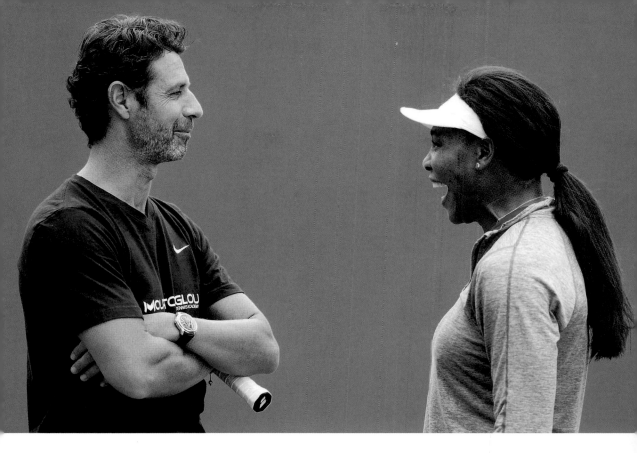

Through tennis – in which he had made a name for himself for his smart analysis and his direct, firm guidance of players – Mouratoglou had developed a confidence and a strength that he would need to call on in those early days with Serena. In the garden party surroundings of the All England Club, there were power games to be played. Mouratoglou would have to assert himself, not just in his relationship with Richard, but with Serena herself.

Early on in the tournament, Mouratoglou didn't care for the way Richard spoke to him, so he told him so, saying that they must treat each other with respect. This was a bold move by Mouratoglou, as a newcomer and the first coach from outside the Williams family, and he was uncertain how Richard would react to his comments. But it seemed as if Richard had been testing him and everything was resolved amicably. The other power game was at the Aorangi Park practice courts; after Serena barely acknowledged Mouratoglou during morning training, he said that he wouldn't tolerate such aloofness.

▲ Serena and her coach Patrick Mouratoglou developed a close bond.

'At the end of the session, when she was sitting on her chair and tapping away at her phone, I hit her sharply on the cap,' Mouratoglou recalled in *The Coach*. 'I have some rules which have to be respected,' he told the player. 'Rule Number One: when you arrive in the morning, you must say hello. Rule Number Two: when I talk to you, you must look at me and you must reply.'

In most other workplaces or industries, that would be a very normal request, but the dynamic between an elite tennis player and a coach, and especially between a serial champion and a new coach, is generally a long way from being normal, the balance of power tipped heavily in favour of the athlete, who can hire and fire at will. Yet, with that intervention, Mouratoglou went some way to setting the tone for their continued working relationship.

In this reinvention of Serena, the most remarkable and immediate development was how she was suddenly serving at an exceptionally high level, arguably higher than ever before – and in no small part that was thanks to the work she did with Mouratoglou. Over seven matches in the Wimbledon fortnight, Serena fired 102 aces into the dark green

▼ Patrick Mouratoglou was Serena's first coach from outside the family.

backstops, a tournament record for the women's tournament, also more than any man that summer (even though they were playing best-of-five-sets matches, so had greater opportunity to post larger numbers). Seventeen of those came in the final against Agnieszka Radwańska, a Pole known as The Professor because of her high-brow, creative tennis. And yet all the creativity in the world isn't going to help you if you can't put your racket on the ball: in one game alone, Serena hit four straight aces, leaving Radwańska a mere spectator.

In winning her fifth Wimbledon title, Serena extended her Grand Slam collection to fourteen; the victory confirmed she had found a coach who would bring the best out of her, and that she was back.

● ● ●

When Patrick Mouratoglou started coaching Serena, he hadn't appreciated there were two Serenas. To his surprise, he had discovered there was a softer, off-court Serena who was 'funny, nice and cares for people, who can be so funny and so capable of self-derision'. Then there was the other Serena, the one on public display, and the one Mouratoglou had already known about: the 'champion with a killer instinct'.

Serena and Mouratoglou sometimes spoke in French, which she had learned because she wanted to address the Paris crowd in their own language after winning the French Open, but when the coach wanted to be sure his player had understood his message, he would switch to English. Winning Wimbledon is certainly one way for a player and coach to get acquainted very fast, but that connection only became stronger in the coming weeks and months, with a series of open and honest conversations, in two languages, but with one purpose: to restore Serena to her role as the dominant force in the women's game. Soon there seemed to be a greater intimacy to a relationship that was transforming the women's game. In media circles it led to persistent rumours – never confirmed and never denied – that the pair were more than just player and coach and were romantically involved for a while. Whatever the truth, the Serena–Mouratoglou partnership was plainly a formidable one in

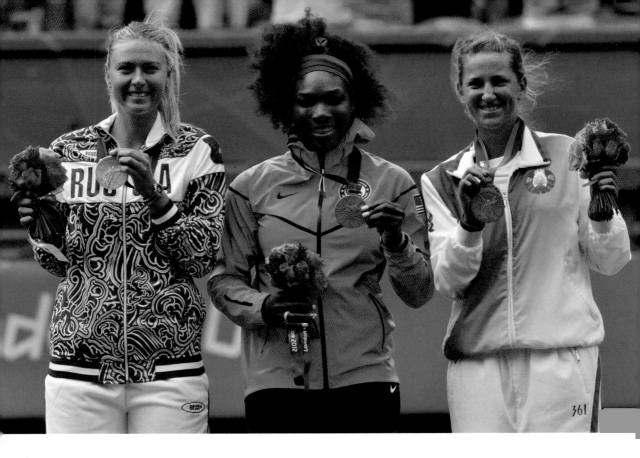

▲ With her run at the 2012 London Games, Serena completed the Career Golden Slam: winning all four majors and an Olympic gold medal.

tennis. In 2013, Serena would achieve the highest season-long winning percentage of her career, while launching herself at the history books, and continuing her attempt to surpass Steffi Graf's Open Era record of twenty-three Grand Slam singles titles, as well as Margaret Court's all-time record of twenty-four majors.

'In order to coach Serena, I needed to understand her, to know how she sees life, tennis, how she sees different situations, what her major beliefs are, what her tennis background is, what her goals, dreams and fears are,' Mouratoglou disclosed. 'When you coach someone, you have to speak the same language, as the same words do not have the same meaning for everyone. "The weather is beautiful" doesn't mean the same thing for someone living in Paris as it does for someone living in Miami. It took me a few months to learn that new language, to be able to communicate with her, to understand her, and to be heard and understood by her.' With Mouratoglou's alliance with Dimitrov coming to an end, in part because the Frenchman had been drawn to the

'When you coach someone, you have to speak the same language.'

prospect of coaching Serena full-time, he was able to focus all his energies on her going forwards.

One quirk of the 2012 summer was that the All England Club hosted two competitions on its lawns: The Championships and then, as a one-off, the Olympic tennis event of the London Games. While the optics were different at the Olympics, with advertising permitted in what is usually a 'clean' Centre Court, and with the white-clothing rule not in play, Serena continued where she had left off: such was her form as an Olympian, she conceded just one game in beating Maria Sharapova in the gold medal match. In doing so, she became only the second woman in history, the first being Steffi Graf, to complete what is known as the Career Golden Slam: winning all four majors, as well as the Olympics. Even the controversy over Serena's celebratory dance after pulverising Sharapova – she performed the Crip Walk, associated with the Crips and Californian gang culture, on the Centre Court grass – couldn't distract from the joy that she took from standing on top of the podium. Such an astonishing start to their player–coach relationship continued in New York, where she overcame Victoria Azarenka to take her fourth US Open title and fifteenth Grand Slam.

In 2013, Serena was close to unplayable: she won seventy-eight matches and lost just four, giving her a season-long winning percentage of 95.1, the highest of her career. She had never been more consistent, and she regained the world number one ranking for the first time since 2010, when her life-threatening blood clots had intervened. The 31-year-old was the oldest player to hold that status.

'Serena has always been able to raise her level above any other player in the big matches, but she needed to get a more solid Plan B,'

PATRICK MOURATOGLOU

Grand Slam, Olympic and WTA Finals titles won since hiring Mouratoglou.

AUSTRALIAN OPEN
2015
2017

2

FRENCH OPEN
2013
2015

3

WTA FINALS
2012
2013
2014

2

1

OLYMPIC GOLD
SINGLES

LONDON GAMES
2012

3

WIMBLEDON
2012
2015
2016

3

US OPEN
2012
2013
2014

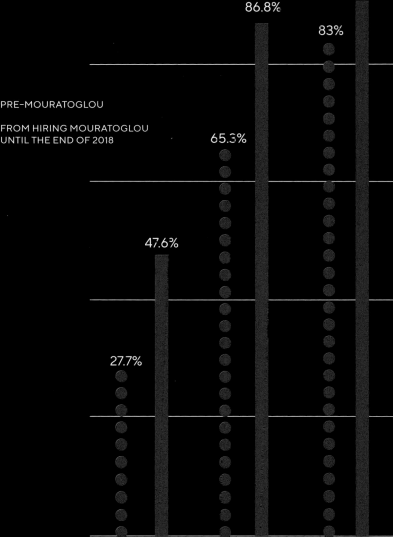

86.8%

83%

PRE-MOURATOGLOU

FROM HIRING MOURATOGLOU
UNTIL THE END OF 2018

65.3%

47.6%

27.7%

CAREER GOLDEN SLAM

Serena is the only woman to have achieved the Career Golden Slam
– winning all four majors and the Olympics – in singles and doubles.
No man has done so in both singles and doubles.

CAREER GOLDEN SLAM FOR SINGLES:

CAREER GOLDEN SLAM FOR DOUBLES:

SERENA HAS FOUR OLYMPIC GOLD MEDALS:

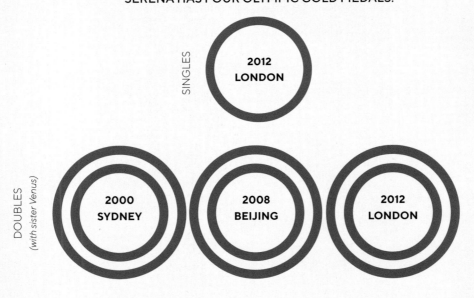

Mouratoglou has said. 'We worked on that, improving her base, her fitness, as well as her ability to hit with more spin, and to give her more options of shots so she has solutions on a bad day.' While the player is celebrated for her firepower and her ability to blast her way through opponents, she is more creative and imaginative that many observers have given her credit for.

Such was her dominance of women's tennis in 2013, winning on good and bad days, and on so-so days, too, she had a streak of thirty-four victories, which was the longest undefeated run of her career. She also scored eleven titles during the year, including two Grand Slams. Perhaps most interestingly, just a year on from losing to Virginie Razzano at Roland-Garros, and the first-round defeat that had made her question her future, Serena was a clay court player transformed: she defeated Sharapova to lift La Coupe Suzanne Lenglen, the women's singles trophy, eleven years after her first French Open triumph in 2002, which took her to sixteen major titles. Just as productive was a trip to the US Open, where for the second year in succession, she beat Azarenka in the final. Now on seventeen Grand Slams, she was just one major short of equalling two all-time greats, Chris Evert and Martina Navratilova – also her one-time critics.

● ● ●

Serena didn't add to her total at the first three Grand Slams of 2014. If the thought of making history, and equalling Evert and Navratilova on eighteen majors, weighed heavily on the fight-mode Serena for a while, she achieved parity at that season's US Open. That killer instinct led her to beat her close friend Caroline Wozniacki there with a loss of just six games. As it turned out, Serena's New York triumph was significant for another reason: she would go on to hold all four Grand Slam titles for the second time in her career. In this Serena Slam Two, which was just as exhilarating as the original, she defeated Sharapova at the 2015 Australian Open for her nineteenth major, before landing her twentieth by beating Czech Lucie Safarova in the final of the French Open, a victory that was

WHEN WAS SERENA AT HER MOST DOMINANT?

Serena was most dominant in 2013 when she won 95.1 per cent of her matches. That was the highest season-long winning percentage since Steffi Graf in 1989, who had 86 victories and two defeats for a success rate of 97.7, and not far off Martina Navratilova's all-time record of 98.9 per cent, which she set in 1983 with 86 wins and just one defeat.

9-5	29-11	41-7	37-8	38-7	56-5	38-3	38-9	21-7	12-4	35-10
64%	73%	85.4%	82%	84%	91.8%	92.7%	80.9%	75%	75%	77.8%
1997	1998	1999	2000	2001	2002	2003	2004	2005	2006	2007

WINS-LOSSES % WINS

2008	2009	2010	2011	2012	2013	2014	2015	2016	2017	2018
44-8 84.6%	50-12 80.6%	25-4 86.2%	22-3 88%	58-4 93.5%	78-4 95.1%	52-8 86.7%	53-3 94.6%	38-6 86.4%	8-1 88.9%	18-6 75%

SINGLES TITLES PER YEAR

Serena's most successful year was 2013, when she
won 11 singles titles.

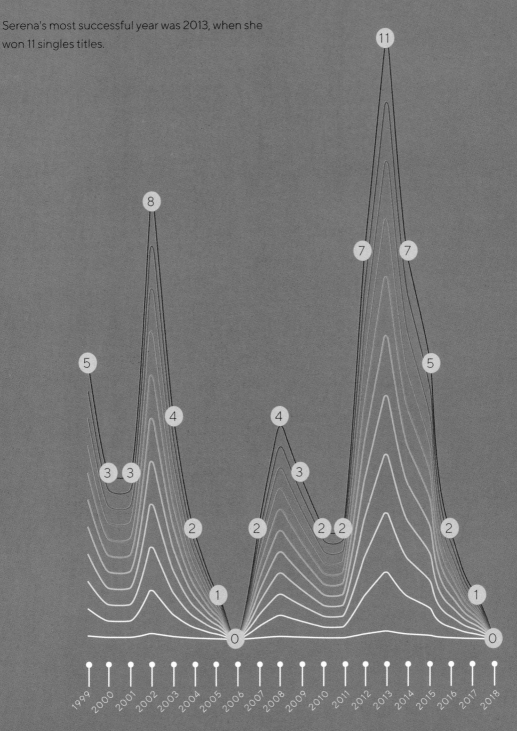

SINGLES TITLES WON

TITLES WON IN 2013

Brisbane
January

Miami
March

Charleston
April

Madrid
May

Rome
May

French Open
June

Bastad
July

Toronto
August

US Open
September

Beijing
October

WTA Finals
October

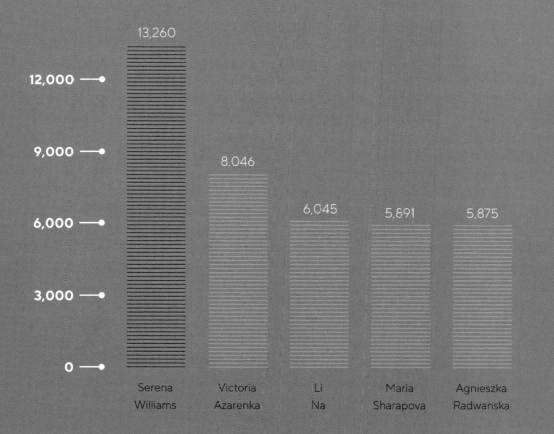

13,260

12,000

9,000

8,046

6,000

6,045

5,891

5,875

3,000

0

Serena Williams

Victoria Azarenka

Li Na

Maria Sharapova

Agnieszka Radwanska

YEAR-END RANKING POINTS, 2013

While the first Serena Slam had been partly
fuelled by a broken heart, and her desire to show
a former boyfriend that she was thriving after
he had dumped her, the second was driven by
something purer - the ambition to dominate
the tennis landscape once more.

even more notable as she had been suffering with flu during the tournament, even skipping practice the day before to retire to her bed.

On the Wimbledon grass, she defeated Spain's Garbiñe Muguruza to complete the Grand Slam circle, and to win her twenty-first major: at the age of thirty-three years and two hundred and eighty-nine days, she was the oldest Grand Slam singles champion of the Open Era. While the first Serena Slam had been partly fuelled by a broken heart, and her desire to show a former boyfriend that she was thriving after he had dumped her, the second was driven by something purer – the ambition to dominate the tennis landscape once more.

Serena receiving the Venus Rosewater Dish didn't completely satisfy the traditionalists, nor did it satisfy her either. Clearly, anyone who holds all four majors simultaneously must have been playing some phenomenal tennis and yet to win all four majors in the same season, for a calendar year Grand Slam, has near-mythical status in tennis, above anything accomplished across two seasons. The last person to do it was Steffi Graf in 1988. Serena hadn't even changed from her Wimbledon whites to her gown for the Champions' Dinner before the debate had shifted across the Atlantic to New York City, and whether she could win the US Open to become the first woman since Graf to sweep through all four Grand Slams.

Graf was very much in Serena's thoughts. When she had first hired Mouratoglou in the summer of 2012, she had only concerned herself with

LONGEST WINNING STREAK

Serena won 34 consecutive matches in 2013, a run which ended
with a fourth-round defeat to Sabine Lisicki at Wimbledon.

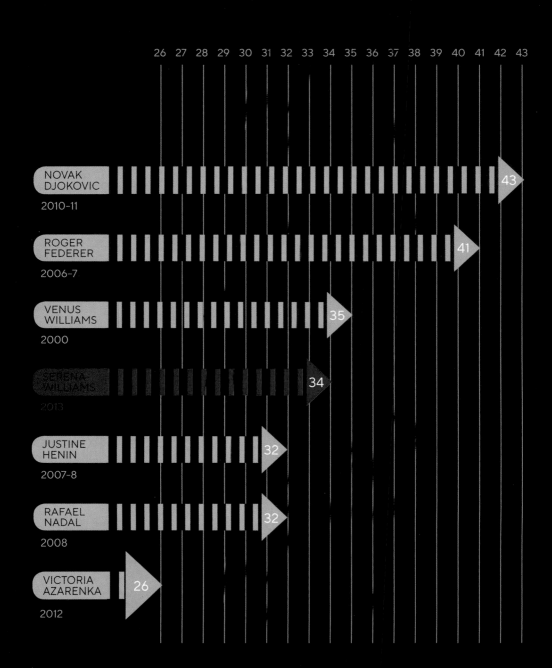

BREAK POINT CONVERSION

In 2013, Serena converted more than half of her break point opportunities.

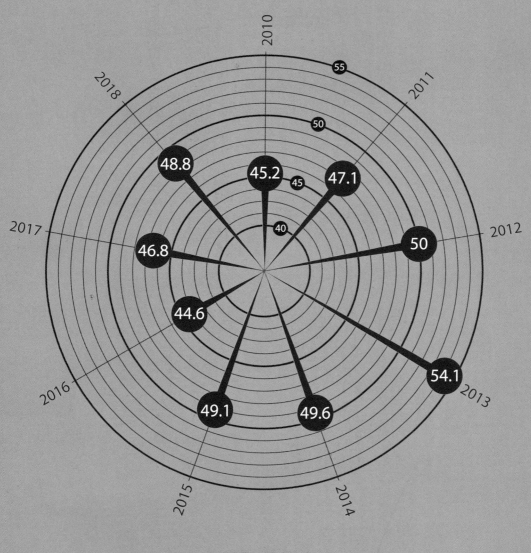

BREAK POINT
CONVERSION
PERCENTAGES

breaking that two-year run without success. 'The project was to win one more Grand Slam,' Mouratoglou has said. But, as Serena accumulated Grand Slams under her new coach's guidance, she become increasingly motivated by wanting to eclipse Graf's Open Era record of twenty-three singles majors. That would only leave Margaret Court's record to beat; she scored a record twenty-four Grand Slams, when playing in the amateur and professional eras. As Mouratoglou observed, to become the undisputed greatest player of all time, the American would have to win more Grand Slam titles than any other woman in history.

As Serena advanced through the US Open draw, it appeared she was moving in on what would have been the most spectacular of victories, with the American set to emulate Graf twice over – with a calendar-year Grand Slam and by equalling the Open Era record for majors. Certainly, no one had imagined that Roberta Vinci, an Italian veteran who had never previously beaten Serena, would be the woman to hijack history at the Arthur Ashe Stadium. In their semi-final, Serena was nervous, and a long way off her best, and Vinci made the most of her opportunity. For all Vinci's apologies afterwards – she recognised that New Yorkers as well as the watching global tennis public had wanted to see history being made – there was nothing diffident or reverential about her tennis. When she won, this was immediately described as the greatest upset in Grand Slam history. Even with the passing of the years, that analysis still stands. Serena had been so close to tennis immortality.

Even with that New York defeat, it had been a memorable year for Serena in the United States. She had ended her boycott of the Indian Wells tournament. But, for weeks after losing to Vinci, she didn't think much about her act of forgiveness, or of the three majors she did win in 2015. Instead she was distraught about the calendar year Grand Slam that had got away.

'She was depressed,' Mouratoglou has said. 'The reaction was quite strong. She was really, really affected, which I think is normal when you are Serena. She does everything with a hundred per cent of her heart so is more disappointed when she doesn't reach her goal. She has a level of expectation that is much higher than anyone else's.'

7

INSIDE THE COURT OF SERENA WILLIAMS

Think of Serena as an accidental royal courtier.

Growing up in Compton, California, Serena could never have imagined that years later she would be mentoring, let alone dressing, a member of the British royal family – and a duchess, no less – on how to handle being tailed by the paparazzi and how to cope with being picked over by the international media, while urging her – etiquette be damned – to 'stop being so nice'. But when her close friend, the actress Meghan Markle, became Prince Harry's girlfriend, and subsequently his wife, and experienced press attention on a previously unknown level, the tennis player found herself, however improbably, an unofficial adviser to the newest member of the British monarchy.

For years after Serena and Meghan met at a Super Bowl party in Miami in 2010, Serena was the one with the higher global profile. At the time Markle noted on her now defunct lifestyle blog, *The Tig*, how they had 'hit it off immediately', and had 'chatted not about tennis nor acting but about good, old-fashioned girly stuff'. Serena was in pursuit of tennis greatness; Markle was in the popular TV show *Suits* and, while famous, she was nowhere near the level of her friend. Then, in 2018, Markle was transformed from TV actress to royalty when, on her marriage to Prince

▶ Serena and her husband Alexis Ohanian arrive for Prince Harry and Meghan Markle's wedding.

AGE WHEN WINNING GRAND SLAMS

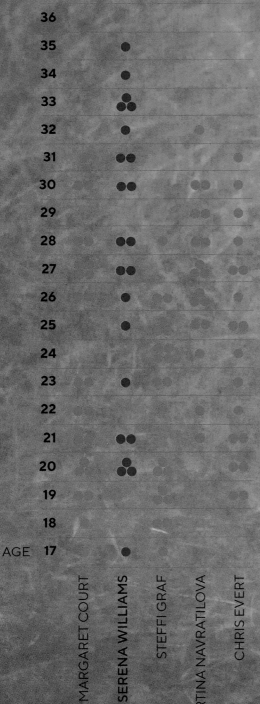

36
35
34
33
32
31
30
29
28
27
26
25
24
23
22
21
20
19
18
AGE 17

MARGARET COURT
SERENA WILLIAMS
STEFFI GRAF
MARTINA NAVRATILOVA
CHRIS EVERT

● = number
of Grand
Slams won

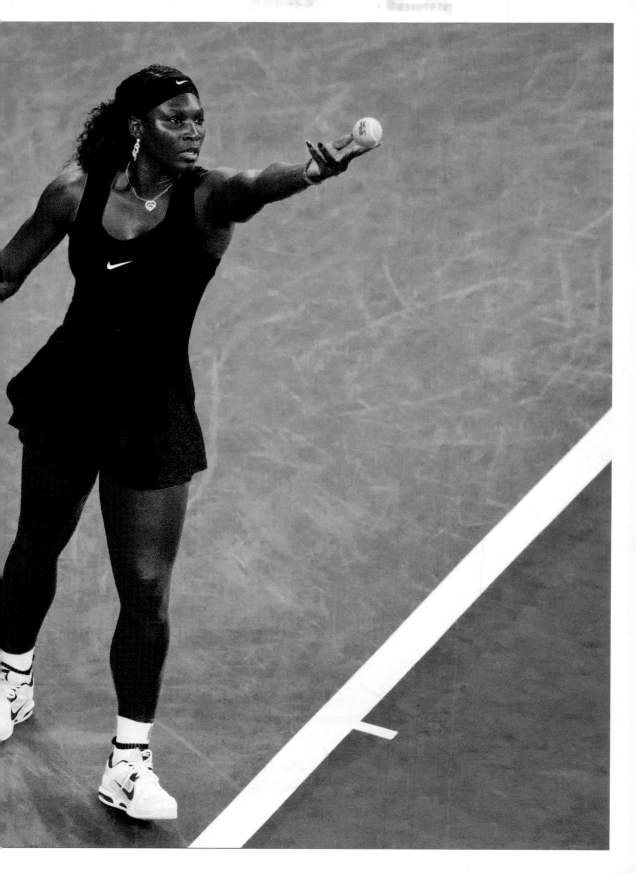

Harry, she became the Duchess of Sussex and, thereby, one of the most famous women in the world. Understandably, that took some adjustment, and her friend Serena, more accustomed to life under the media spotlight, was on hand, telling her: 'You've got to be who you are, Meghan. You can't hide.'

As the first of the pair to become a mother, Serena's calls and text messages to the duchess have also included the odd piece of parenting advice. It was Serena who hosted Markle's baby shower in New York in February 2019. This is not, however, a one-sided relationship: in return, Markle is believed to have helped and counselled Serena during some of the most trying times in her own life, including the fall-out following the controversial defeat to Japan's Naomi Osaka in the 2018 US Open final. As Serena has disclosed, she and Markle have been heavily reliant on each other's support and friendship.

Some might suspect an element of publicity and self-promotion in a celebrity friendship, but there is no doubting the closeness of the bond between a black icon of tennis and the first woman with African-American heritage to marry into the British royal family. Their relationship also gives an insight into Serena outside the sport, into how someone so competitive and hardened on the tennis court can be so warm to her friends. In the days before the 2018 French Open, which was the first Grand Slam since she returned from maternity leave, and so the first chance for her to equal Margaret Court's all-time record of twenty-four major singles titles, you might have expected her to have been in Rome for an important warm-up tournament on the clay courts of the Foro Italico. Instead, she chose to support her friend, attending Markle's wedding to Prince Harry at St George's Chapel in Windsor, where she sensed she was 'watching history' from her pew.

'It was really exciting to see so much African-American culture impacted in the wedding, and I was really happy that Meghan wanted to incorporate that. I think it was just a whole cultural shift and change. It was seeing how far African Americans have come,' Serena later reflected during a news conference at the French Open. 'I thought it was an incredibly inspiring and beautiful and really motivating thing.'

For her part, Markle may also feel as though she is 'watching history' when she supports Serena at Grand Slams. That particular summer, she would sit in the Royal Box on Wimbledon's Centre Court as her friend took another swing at the record books, playing against Germany's Angelique Kerber for the Venus Rosewater Dish.

Serena's influence has extended far beyond that of any other past or current champion and, like Markle, she has used that platform to speak up for the causes and charities she believes in, such as the Yetunde Price

▼ Serena on The Late Show with David Letterman.

...when she says you have to 'know your lane' and that 'my core is tennis', she is undoubtedly speaking the truth.

Resource Center in her sister's memory. Culturally, she has been the most influential of all tennis players. In part, that has been the result of her background – Compton wasn't previously known for producing tennis champions – but also because of her willingness to embrace opportunities, leading her to make appearances in films and TV shows, as well as in music videos, and also to develop her own fashion line. At the 2019 Academy Awards, she did a presenting segment, in which she made a short speech about love, dreams and ambitions. Other athletes may well have declined such invitations, not wanting any distractions from their sport (though they might not have been asked in the first place). With Serena, though, tennis has never been enough. Still, when she says you have to 'know your lane' and that 'my core is tennis', she is undoubtedly speaking the truth. Everything starts and ends with tennis. Yet her worldview extends beyond the baseline. Serena wants to be the greatest tennis player in history and she also wants so much more.

As Chris Evert and others have come to appreciate, you can play tennis at the highest level, while acting, training to be a nail technician and designing clothes. Such an energetic, all-encompassing approach to life is also how Serena ended up dancing, seemingly without inhibition, in a music video for the American singer Beyoncé. 'She told me that she just wants me to dance, just be really free and just dance like nobody's looking and go all out. So that wasn't easy in the beginning, but then it got easier,' Serena has disclosed. By 2015, Serena's celebrity was such that she hit what *Sports Illustrated* called 'this rare sweet spot', where the 'exotic became the norm'. American businesswoman Martha Stewart was calling her 'the most powerful woman I know', while broadcaster and actor

Oprah Winfrey and President Barack Obama were enthusing about her tennis and author J.K. Rowling was mocking one of Serena's trolls on Twitter.

Before she became a mother herself, Serena found herself reading bedtime stories to the children of Sheryl Sandberg, the chief operating officer of Facebook and author of *Lean In*, a book about women's leaders. After reading Sandberg's book, Serena stated publicly that the COO was the celebrity with whom she would most like to have dinner. From that one line came a real dinner invitation from Sandberg, and the start of a true friendship.

When they met for the first time at a seafood restaurant in Florida, the tennis player kept asking questions and Sandberg is said to have been taken aback by Serena's curiosity, and 'smart' conversation. She seemingly wanted to discover all she could about technology. Athletes have a reputation for having a narrow outlook on the world, but that wasn't how Sandberg found Serena, and it was on her suggestion that, in 2017, Serena joined the board of a consumer survey start-up, SurveyMonkey. Similarly, Stewart has said of Serena: 'She asked me lots of questions. She likes to hang out with success. She likes to hang out with people who are not going to pander (to her).'

Just months after that dinner, Sandberg's husband, Dave Goldberg, died while they were on holiday. A grieving Sandberg was touched by the support she received from the tennis player. 'I just kept getting these messages from Serena, literally every couple of days, for months. Texts, messages, voice mails. She would write, "You have all my strength" or "You are the strongest woman I know. You will get through this." For Serena Williams to say, "You have all my strength", God, when you're like where I was after Dave died, that feels like a lot of strength. I would get that text and look at it, and would feel pretty emotional. I would feel like she was carrying me.'

Grief is something that Serena knows all too well. She drew on that experience, speaking to Sandberg and her children about the death of her sister, Yetunde.

● ● ●

WHO IS THE GOAT?

Who is the greatest of all time, Serena Williams or Roger Federer?

	FEDERER
GRAND SLAM SINGLES TITLES	20
TOTAL SINGLES TITLES	**101**
HIGHEST NUMBER OF TITLES WON IN ONE SEASON	**12**
CAREER WINNING PERCENTAGE	82
TOTAL WEEKS AS WORLD NUMBER ONE	310
LONGEST STREAK, IN WEEKS, AT WORLD NUMBER ONE	**237**
SEASONS AS THE YEAR-END NUMBER ONE	**5**
OLYMPIC GOLD MEDALS	1
DAVIS/FED CUP TITLES	**1**
GRAND SLAM DOUBLES TITLES	0
GRAND SLAM MIXED DOUBLES TITLES	0

WILLIAMS

23

72

11

85

319

186

5

4

1

14

2

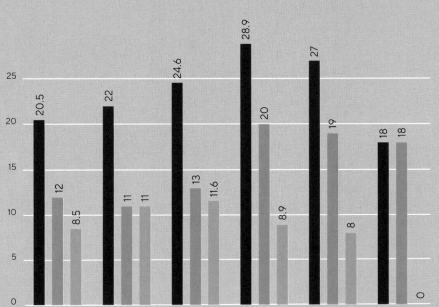

● TOTAL EARNINGS
● ENDORSEMENT AND APPEARANCE FEES
● PRIZE MONEY

For someone of Serena's stature, prize money is just the start of the financial reward. With more than $80 million in career winnings, Serena is top of the all-time leaderboard, and has won more than double the next woman on the list, her elder sister, Venus. But she has earned a multiple of that number from her endorsement contracts – in 2019, she appeared in a prominent advert for her clothing supplier, Nike, in which she implored women to 'dream crazier' – as well as from sponsorship deals, appearance fees and other business arrangements In 2018, Serena was estimated by *Forbes* magazine to have earned $18.1 million in the twelve months from June 2017 to June 2018, of which only $62,000 came from prize money, the rest from off-court deals and appearance fees. For a third successive year, she was the highest-earning female athlete in the world.

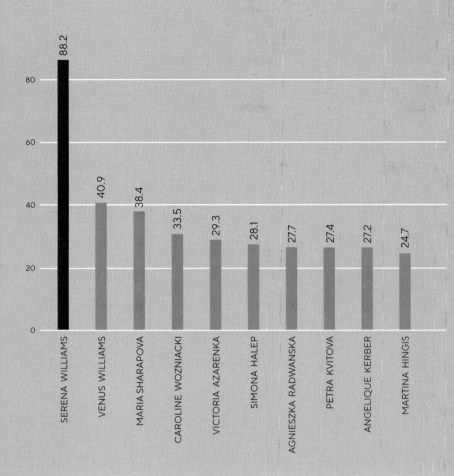

CAREER PRIZE MONEY

Serena has earned more than double the career prize money of the second-placed woman on the list, her older sister Venus. (All figures $ millions)

For a decade, it was Maria Sharapova – who hasn't even won a quarter of the number of Grand Slams that Serena has – who earned more than any other sportswoman, thanks to an extensive portfolio of endorsements. A combination of Sharapova's failed drugs test and Serena's astonishing longevity and success has seen the American eclipse the Russian, however. Despite this, Serena's income might seem shamefully low when you consider how, over that same twelve-month period, Roger Federer earned $77.2 million, more than four times her figure. If Federer appears more attractive to sponsors than Serena, how much of that, you might well ask, is the result of gender inequality? Certainly no one can fault Serena's work ethic. In 2018, she launched her own eponymous fashion label, which was

TIME ON COURT

Average lenth of Serena's matches against opponents
she has played five times or more.

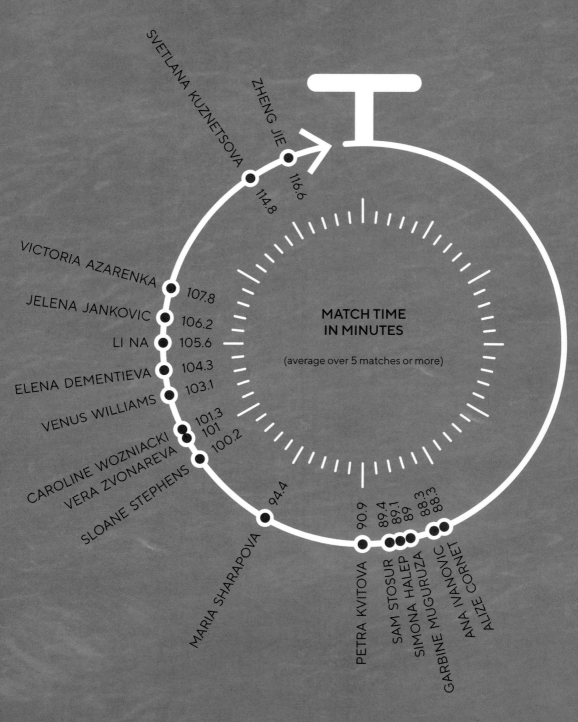

SVETLANA KUZNETSOVA 114.8

ZHENG JIE 116.6

VICTORIA AZARENKA 107.8

JELENA JANKOVIC 106.2

LI NA 105.6

ELENA DEMENTIEVA 104.3

VENUS WILLIAMS 103.1

CAROLINE WOZNIACKI 101.3

VERA ZVONAREVA 101

SLOANE STEPHENS 100.2

MARIA SHARAPOVA 94.4

PETRA KVITOVA 90.9

SAM STOSUR 89.4

SIMONA HALEP 89.1

GARBINE MUGURUZA 89

ANA IVANOVIC 88.3

ALIZE CORNET 88.3

MATCH TIME
IN MINUTES

(average over 5 matches or more)

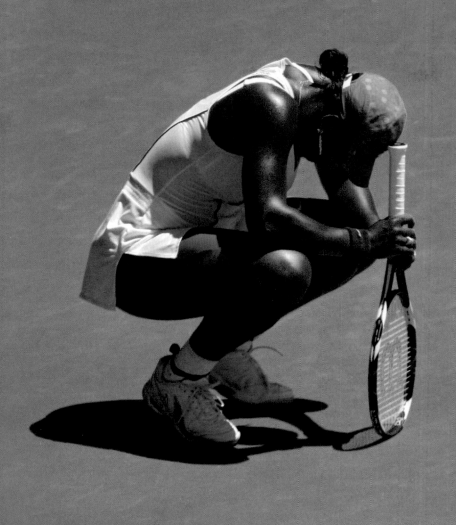

aimed at 'practical' women. Some of these affordable pieces had motivational messages on them such as 'I am beautiful' and 'I am strong'. Building self-esteem is important to the athlete, who has suffered from her own confidence issues throughout her life and is invested in promoting female empowerment. Serena's clothes aren't available in 'plus size' or 'extended size'; instead she has renamed those sizes 'great'. 'I got tired of the word "plus". I don't want to be "plus". I want to be great. I want other women to feel that way too. I wanted to make clothes that would fit a curvy woman and have them feel great, let's focus on that,' she told *Marie Claire* magazine.

How many other athletes, Sharapova included, can you imagine making regular appearances on a shopping channel? Prior to having her own label, Serena collaborated with the Home Shopping Network from 2009, which saw her happily appear on the channel, transformed into a saleswoman. If Serena does something, she is fully committed to it.

In part, Serena's success in fashion is down to her sister, Venus, who signed her up to classes at the Art Institute of Fort Lauderdale, in Florida, when they were teenagers, concerned that Serena was spending too much time sitting on the sofa, watching old episodes of *The Golden Girls*.

More recently, Serena has been encouraged and emboldened by her friendship with Anna Wintour, the editor-in-chief of American *Vogue*, and arguably the most powerful figure in fashion. Wintour has regularly watched Serena competing around the world, and also sat in the front row of her line's catwalk shows during New York Fashion Week. More than anything, Serena has wanted Wintour to critique her work. 'She has such high standards. It definitely makes it stressful, but also we're such good friends,' Serena told the *New York Times*. 'In my job, I take feedback every day, so I'm really good at it. I don't want to hear a positive. I want to hear what I can do better.'

But does she really need to? Such is her success that, combining her roles as friend and fashion entrepreneur, Serena supplied the Duchess of Sussex with a grey blazer during her tour of Australia in 2018 with Prince Harry. Almost inevitably, it sold out. And so Serena took on another role: the accidental courtier turned occasional royal stylist.

▶▶ Serena regularly attends the Vanity Fair Oscar Party.

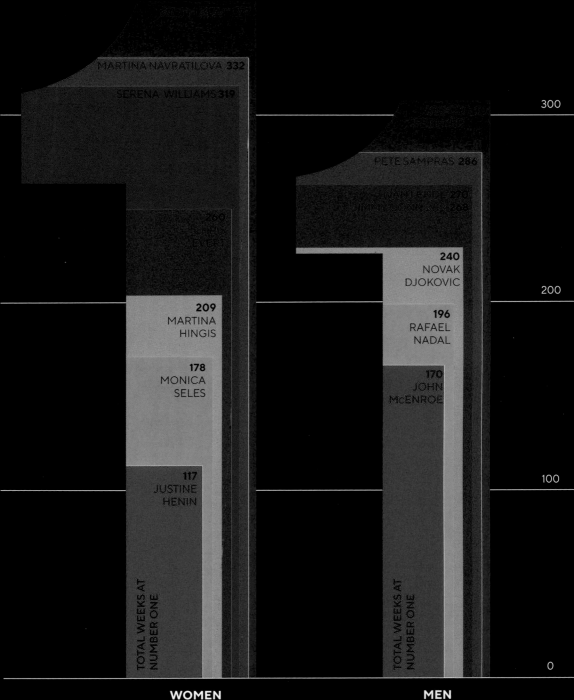

MARTINA NAVRATILOVA **332**

SERENA WILLIAMS **319**

260
CHRIS
EVERT

209
MARTINA
HINGIS

178
MONICA
SELES

117
JUSTINE
HENIN

TOTAL WEEKS AT
NUMBER ONE

WOMEN

PETE SAMPRAS **286**

IVAN LENDL **270**
JIMMY CONNORS **268**

240
NOVAK
DJOKOVIC

196
RAFAEL
NADAL

170
JOHN
McENROE

TOTAL WEEKS AT
NUMBER ONE

MEN

300

200

100

0

WOMEN

LONGEST STREAK
AT NUMBER ONE

MEN

LONGEST STREAK
AT NUMBER ONE

SERENA WILLIAMS AND STEFFI GRAF, TIED AT **186 WEEKS**

MARTINA NAVRATILOVA, **156 WEEKS**

CHRIS EVERT, **113 WEEKS**

ROGER FEDERER, **237 WEEKS**

JIMMY CONNORS, **160 WEEKS**

IVAN LENDL, **157 WEEKS**

TWENTY-THREE

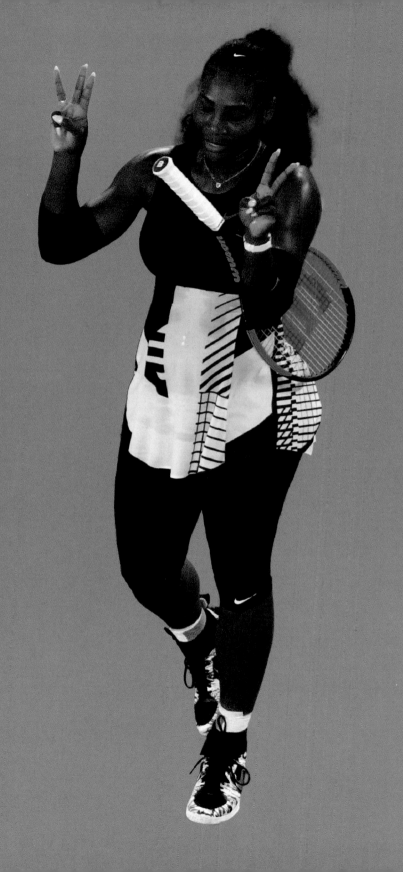

The night Reddit co-founder Alexis Ohanian proposed to Serena Williams, getting down on one knee at the Cavalieri hotel in Rome, there was a small plastic rat on their poolside table.

Rodents and romance don't tend to mix, but that toy was there for a reason on that December evening in 2016: as a reminder of how rats had brought together this unlikely couple, the tennis champion, who hadn't heard of the Reddit website when they met, and the tech entrepreneur, who didn't care at all for tennis.

When she first encountered Ohanian, at the same poolside spot of that Rome hotel, in May 2015, Serena and her circle initially regarded him as a nuisance: in fact, if he had had sharp teeth, a twitching nose and a long tail himself they would hardly have been any less welcoming. She was in the city for a tournament that would help her prepare her clay court game for the French Open, on what would turn out to be the third leg of her second Serena Slam, when she would hold all four majors simultaneously. Ohanian, on the other hand, was in Rome for a tech conference at which he was speaking. Fate, it seems, intervened – ordinarily, Serena doesn't eat breakfast, not even on the morning of her opening match (after receiving a bye or free pass through the first round, she would start the tournament in the second round), yet that morning she had been persuaded by a friend to try out the buffet. Serena and her

entourage had wanted some space to themselves while having a late breakfast, but then Ohanian, hungover and oblivious to them, as Serena recalls it, 'plonked' himself down near their group.

In an effort to shoo him away, one of Serena's friends told Ohanian there was a rat under his table. When Serena asked him if he was scared of rodents, he said: 'I'm from Brooklyn. I see rats all the time.' Amused by this exchange, she invited Ohanian to join her table, and while he thought the woman he was talking to was Serena, he wasn't completely sure. He didn't watch tennis, and had 'no respect' for the sport, though he wasn't so daft as to share that opinion with Serena. Over breakfast, she, in turn, told him that she had been on Reddit that very morning (which wasn't

▲ Until he met Serena, Alexis Ohanian wasn't interested in tennis.

▶ Serena has said she 'met this man, almost out of nowhere, and fell in love'.

true, as this was the first she had heard of it). She then had to be rescued by her friends after Ohanian pushed her on what she liked about it. She couldn't have imagined at that meeting that, within two years, she would be at the 2017 Australian Open, the tournament where she became the most successful tennis player of modern times by scoring her twenty-third major, while pregnant with Ohanian's child.

That evening, Ohanian went to watch her play at the Italian Open at the Foro Italico, after her agent, Jill Smoller, invited him along. While Serena went on to win the match, beating Russian Anastasia Pavlyuchenkova in straight sets, she was carrying an injury and it wasn't the great triumph or showcase of her talent. Not that Ohanian would have noticed. According to an account of their romance in *Vanity Fair*, Ohanian had such a limited knowledge of tennis that when he posted a photograph of Serena on Instagram, it wasn't in a great light – it showed her foot faulting. In the early days of their romance, Serena is also said to have offered Ohanian a tennis lesson to help him improve his knowledge of the sport. He declined – for the simple reason that he wanted to be able to tell his friends that he had turned down a hit with the greatest tennis player of all.

Until she met Ohanian, Serena's private life had always been secondary to her tennis life. She had always defined herself by her triumphs on the tennis court, and her pursuit of Grand Slams and history, not by the men on her arm, who had included the rappers Common and Drake. While Serena was in her mid-thirties when she met Ohanian, she wasn't planning to settle down.

Perhaps, in part, because she was aggrieved at how she had played in Rome, but mainly because she was intrigued by Ohanian, she contacted him again, inviting him to meet her later that month in Paris, where she would be finalising her preparations for the French Open. He accepted, and their first date began in a zoo and turned into a walking tour – for six hours, they roamed through the city. With Serena going on to win the French Open title, despite suffering from flu, it was a memorable trip, both professionally and personally. As Serena said, she 'met this man, almost out of nowhere, and fell in love'.

WILLIAMS VS GRAF

Serena and Steffi Graf were both 17 years old when they won their first Grand Slam title, but how do their career records in major finals compare?

The 2017 Australian Open was **Serena's** 29th Grand Slam final. With 23 victories and just six defeats from those matches, she had a winning percentage of 79.3. Defeats in the 2018 Wimbledon and US Open finals took that percentage to 74.2.

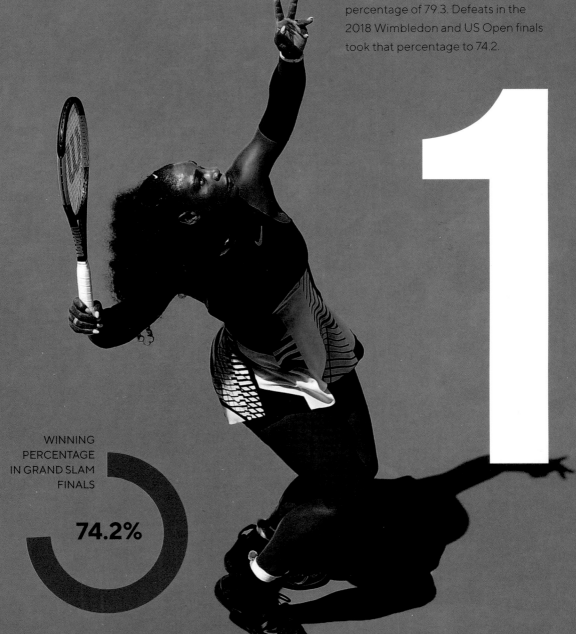

WINNING PERCENTAGE IN GRAND SLAM FINALS

74.2%

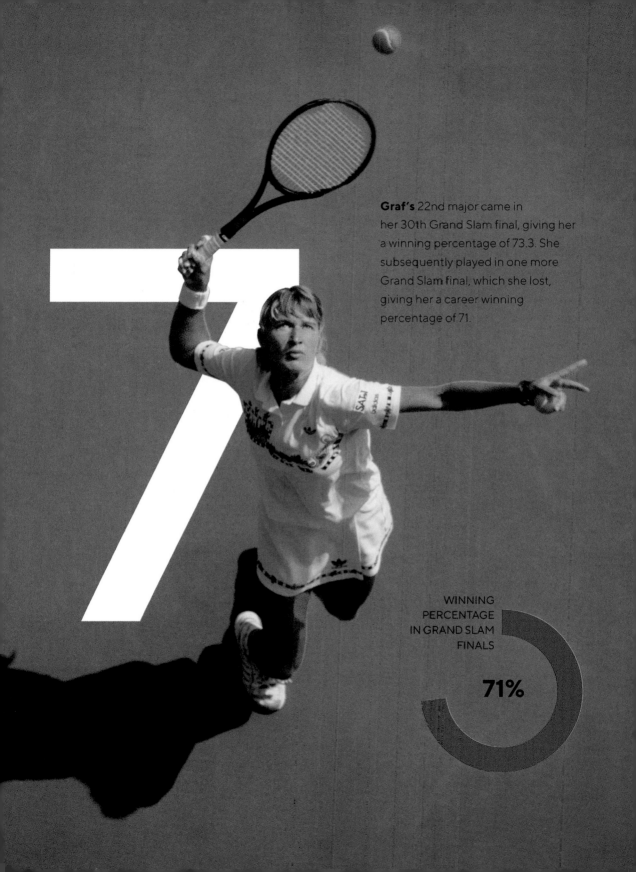

Graf's 22nd major came in her 30th Grand Slam final, giving her a winning percentage of 73.3. She subsequently played in one more Grand Slam final, which she lost, giving her a career winning percentage of 71.

WINNING
PERCENTAGE
IN GRAND SLAM
FINALS

71%

'I always felt I could relate more to a black guy, and that we'd have more struggles in common, you know?' she told *Time* in 2018. Yet, the couple often found themselves talking about race relations in the United States, about the injustices suffered by African Americans. 'Oh my God, literally all I tell Alexis is, "well, you know, there's such a difference between white people and black people." He always gets to hear about the injustices that happen, that wouldn't happen if I were white.'

'It's interesting. I never thought I would have married a white guy, so it just goes to show you that love truly has no colour, and it just really goes to show me the importance of what love is,' Serena told the *New York Times* in 2018. 'Ultimately, I wanted to be with someone who treated me nice, someone who was able to laugh with me, and someone who understood my life, and someone that loved me.'

For all the personal happiness Serena had found away from tennis, she still was feeling considerable anxiety in her professional life, as she sought the twenty-second Grand Slam single title that would put her level with Steffi Graf's record in the post-1968 Open Era.

While Ohanian had been blissfully, dismissively ignorant of women's tennis when he had met Serena, he soon learned about the sport, and about why it mattered so much to her to surpass Graf in the record books: only if she eclipsed the German would she truly be recognised as the greatest player of modern times. Ohanian, who had become a multi-millionaire in his twenties after selling Reddit, had always imagined that he worked hard in an industry, tech, renowned for its long hours – but the more time he spent with Serena, the more he came to realise that her work ethic exceeded his. In her pursuit of Grand Slam trophies, she was relentless, far more driven than he had ever been about his own businesses and investments.

Before he met her, Ohanian had 'zoned out' when any tennis had briefly flashed up on his television – he had watched ESPN for the American football and basketball – but now he was totally consumed by the sport. Like everyone else close to Serena, he was living every point.

Losing in the semi-finals of the 2015 US Open to Roberta Vinci, when she had been just two matches from a calendar year Grand Slam, and

from what would have been a record-equalling major, had been unsettling enough for Serena. But then in 2016 she lost two successive major finals, first to Germany's Angelique Kerber at the conclusion of the Australian Open, and then to Spain's Garbiñe Muguruza at the denouement of the French Open.

Losing these two finals in a row would be disconcerting for any tennis player; they were particularly so for Serena as her career record in such big matches had previously been so strong. Up until 2016, she had only ever lost four times in a Grand Slam final, winning twenty-one of them. Unaccustomed to two 'failures' in succession, she would later confess to some 'sleepless nights', during which she doubted her talent and ability. That insomnia didn't last for long, however – just over a month after the setback in Paris, she reached another Grand Slam final, at Wimbledon, and played some assured tennis.

In beating Kerber, for what was her seventh Wimbledon title, she matched Graf on twenty-two majors. At thirty-four years old, she also improved on her own record, set the year before at the All England Club, for being the oldest Grand Slam champion in history. But Serena was naturally more interested in the Grand Slam leaderboard and her desire to make that Open Era record her own by taking her collection of majors to twenty-three.

The very first opportunity to surpass Graf, at that year's US Open, ended with a semi-final defeat to Karolina Pliskova, and then, just days before the next major, the 2017 Australian Open, she discovered that she was pregnant. Despite the heat in Melbourne, Serena didn't experience any morning sickness; that convinced her she was going to have a daughter, as in her mind only a girl could be that strong, dealing with the extreme Australian summer so well in the womb.

At thirty-five, Serena wasn't the oldest finalist in Melbourne; her sister, Venus, at a year older than her, was thirty-six. Their combined age of seventy-one years made this an advert for the thirty-something player and also the oldest major singles final in history. With thirty-five-year-old Roger Federer and thirty-year-old Rafael Nadal contesting the men's final that weekend, the tournament became affectionately known as the

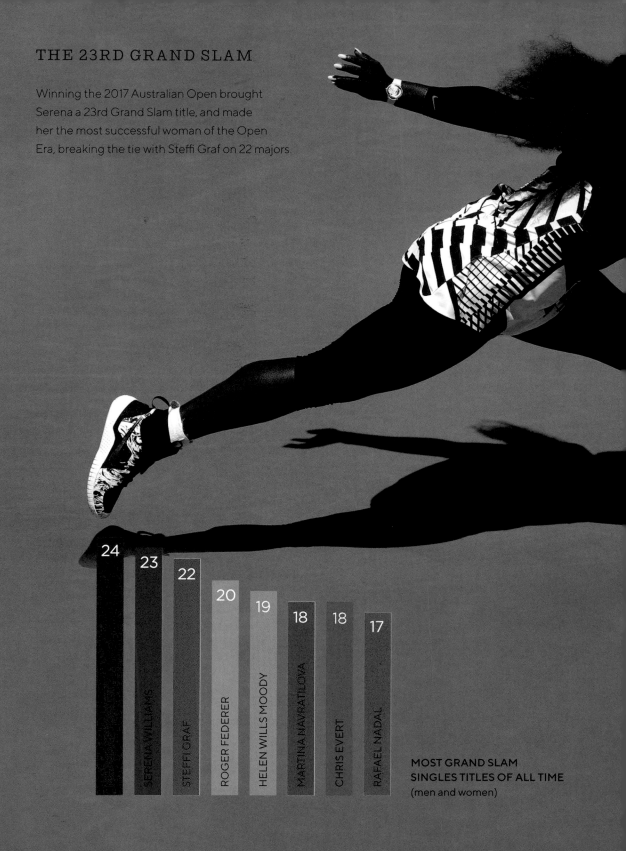

THE 23RD GRAND SLAM

Winning the 2017 Australian Open brought
Serena a 23rd Grand Slam title, and made
her the most successful woman of the Open
Era, breaking the tie with Steffi Graf on 22 majors.

24 — SERENA WILLIAMS

23 — STEFFI GRAF

22 — ROGER FEDERER

20 — HELEN WILLS MOODY

19 — MARTINA NAVRATILOVA

18 — CHRIS EVERT

18 — RAFAEL NADAL

17

**MOST GRAND SLAM
SINGLES TITLES OF ALL TIME**
(men and women)

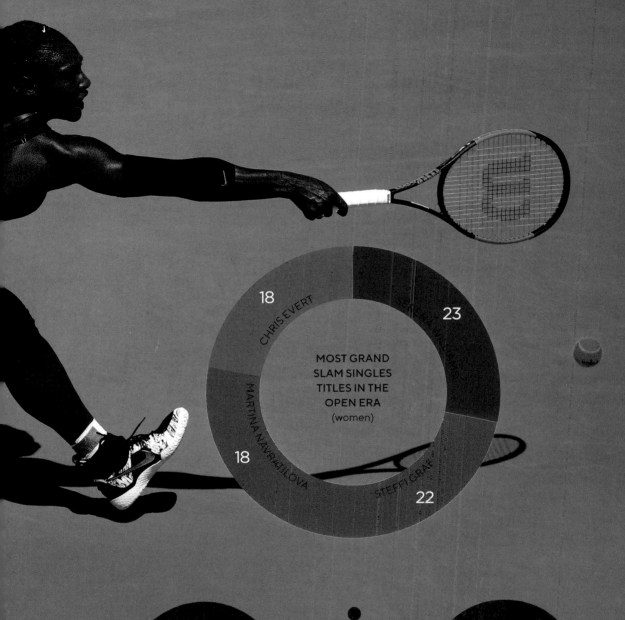

MOST GRAND SLAM SINGLES TITLES IN THE OPEN ERA (women)

SERENA WILLIAMS 23

STEFFI GRAF 22

MARTINA NAVRATILOVA 18

CHRIS EVERT 18

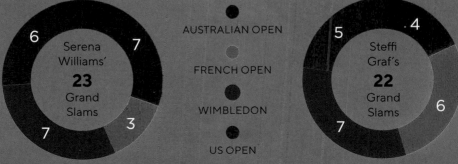

Serena Williams' **23** Grand Slams
- 6
- 7
- 7
- 3

AUSTRALIAN OPEN

FRENCH OPEN

WIMBLEDON

US OPEN

Steffi Graf's **22** Grand Slams
- 5
- 4
- 6
- 7

'Retro Slam'. Venus, who was playing in her first Grand Slam final since the 2009 Wimbledon Championships, would also later joke that it had been an unfair contest against Serena: tennis is supposed to be one-on-one competition, but this had been two against one.

Snaffling just one major in your thirties is a colossal achievement, but with her victory over her elder sister, Serena gathered her tenth Grand Slam title since turning thirty. By some distance, that is the most majors that any woman has won in her thirties – Margaret Court and Martina Navratilova each garnered three Grand Slams. In a further rebuff to Father Time, Serena – by then closer to forty than she was to thirty – extended her own record for being the oldest ever Grand Slam champion. She didn't see that triumph as hers alone; it was a victory to be shared with her unborn child and, when her daughter Olympia was born, she would decorate her child's room in a way that only she could, with a replica Australian Open trophy on the bookshelf.

Serena wouldn't play again in 2017 but, in a quirk of the ranking system, some weeks later she returned to world number one, becoming the oldest ever woman to hold that position – and extending a record that was already hers.

● ● ●

Olympia's birth would end up being the subject of an essay which Serena wrote for CNN's website, of how she came close to death again, this time after childbirth. But for the superb medical care, she suggested that she might not have survived all the complications. 'While I had a pretty easy pregnancy, my daughter was born by emergency C-section after her heart rate dropped dramatically during contractions. The surgery went smoothly. Before I knew it, Olympia was in my arms. It was the most amazing feeling I've ever experienced in my life,' she said. 'But what followed just 24 hours after giving birth were six days of uncertainty.'

Ever since her life had first been endangered by blood clots, in 2011, she had 'lived in fear' of developing them again. Just a day after Olympia came into the world, that fear became a reality when she experienced

GRAND SLAM TITLES IN THIRTIES

Serena has won more Grand Slam singles titles in her thirties than any other player, male or female, with the 2017 Australian Open her tenth since turning 30.

10
SERENA WILLIAMS

4
ROGER FEDERER · KEN ROSEWALL · ROD LAVER

3
MARGARET COURT · RAFAEL NADAL · NOVAK DJOKOVIC · MARTINA NAVRATILOVA

2
CHRIS EVERT · BILLIE JEAN KING · JIMMY CONNORS
ANDRE AGASSI · STAN WAWRINKA

1

ANN JONES · LI NA · FLAVIA PENNETTA · VIRGINIA WADE
JOHN NEWCOMBE · PETE SAMPRAS · ARTHUR ASHE
ANDRES GIMENO · PETR KORDA · ANDRES GOMEZ

CAREER SINGLES TITLES

167

157

107

92

72

NUMBER OF
TITLES WON

○ Martina Navratilova

○ Chris Evert

○ Steffi Graf

○ Margaret Court

○ Serena Williams

familiar symptoms; feeling short of breath, she demanded a scan of her lungs, which subsequently showed clots. In all, Serena would require five operations. The clots caused her to cough so much that her caesarean wound 'popped open', and doctors discovered a haematoma, or a swelling of clotted blood, in her abdomen. Surgeons also fitted a filter that stopped clots travelling to her lungs.

'What I went through was awful. Looking back, I don't know how I got through it all,' she later disclosed. 'I mean I was praying, and I know my mom was praying a lot.' Thankfully for Serena, she had the best possible care: 'I am so grateful I had access to such an incredible medical team of doctors and nurses at a hospital with state-of-the-art equipment. They knew exactly how to handle this complicated turn of events. If it weren't for their professional care, I wouldn't be here today.'

From the emotional high of becoming a father, Ohanian experienced the stress of saying goodbye to Serena before she went into the operating theatre for each of those surgeries. 'It's a lot to change gears from being really happy and thrilled about bringing this life into the world to having to kiss Serena goodbye and praying she'll be OK,' he told *Time*.

For the first six weeks after giving birth, a time when she should have been enjoying the time with her daughter to the full, she was confined to bed. If she wanted to get up, she needed Ohanian's assistance. Feeling lucky that she had survived, she would urge her fanbase to donate to UNICEF to help improve maternal and infant mortality rates: 'I am very fortunate that I am who I am, and also my doctor was very highly recommended and she listened to me. Most doctors don't do that, and people are dying, women of colour in particular. The numbers are insane.'

As a reminder of her surgeries, Serena kept the filter after it was removed; a visitor to the house later saw the device and thought it resembled a badminton shuttlecock.

Almost as soon as Serena was out of bed, she was busy planning her wedding to Ohanian in New Orleans, with its 'Beauty and the Beast' theme, which took place in November 2017, just two months after they became parents. From the bedazzled, crystal-encrusted Nike trainers that she wore under her Alexander McQueen wedding dress (because

▶▶ Serena and Venus met in the 2017 Australian Open final.

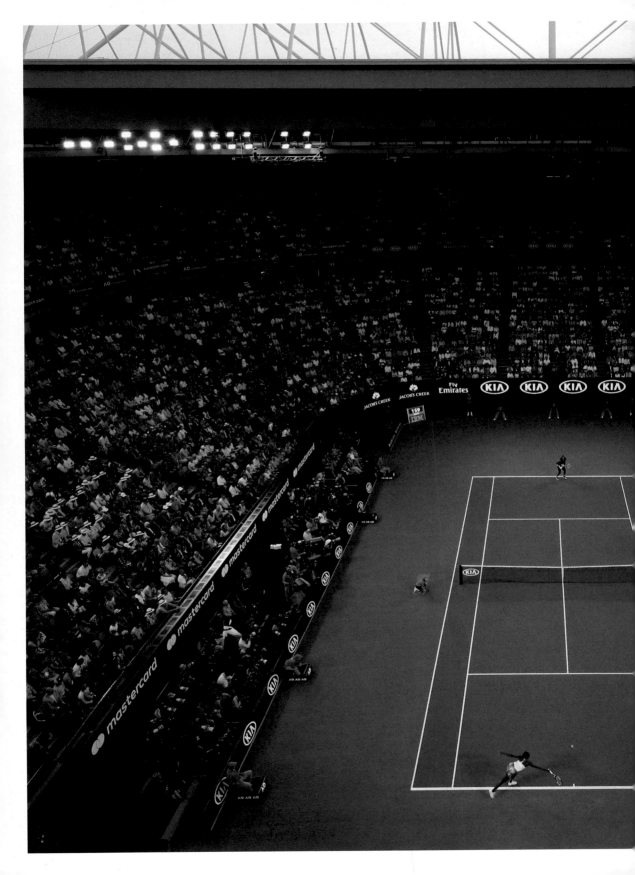

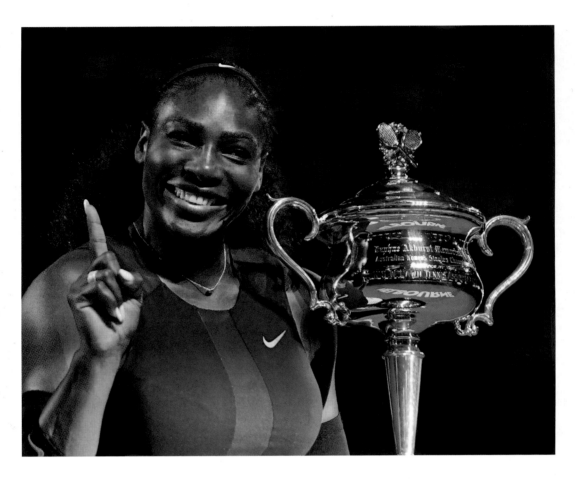

▲ Serena celebrates her twenty-third Grand Slam singles title.

she wanted to be 'practical'), to a guest list that included Beyoncé and Kim Kardashian (Meghan Markle and Prince Harry were unable to attend), this was very much a Serena production. The tables were named after the Grand Slams she had won, while the wedding favours were mini replicas of the trophies, and the couple were married by her fitness trainer Mackie Shilstone. There was even a 'surprise carousel', which Ohanian had organised, much to the delight of his new bride.

As fulfilled as she was in her private life, as a new mother and wife, she was already thinking ahead to her return to competition on the tennis tour. She was the most successful tennis player in the Open Era, eclipsing

RIGHT- AND LEFT-HANDED OPPONENTS

Serena and other players' winning percentages against left-handed and right-handed opponents.

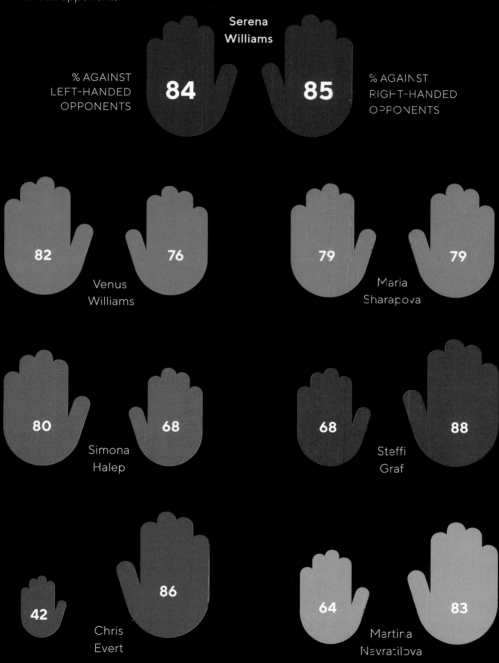

Serena Williams

% AGAINST LEFT-HANDED OPPONENTS

84

85

% AGAINST RIGHT-HANDED OPPONENTS

82 76

Venus Williams

79 79

Maria Sharapova

80 68

Simona Halep

68 88

Steffi Graf

42 86

Chris Evert

64 83

Martina Navratilova

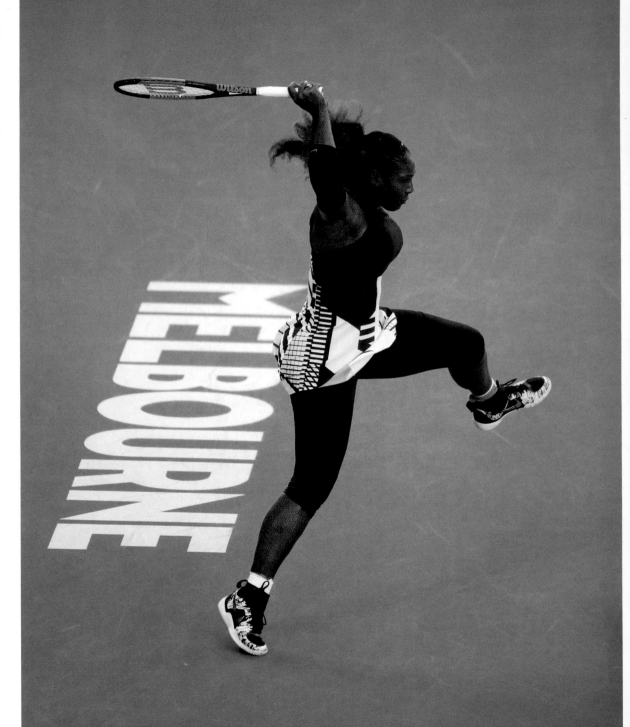

all women, and also men, who had competed since 1968, but, Serena being Serena, her thoughts immediately turned to Margaret Court, and the Australian's all-time record of twenty-four majors, won across the amateur and professional eras. Eleven of Court's Grand Slams came at the Australian Open, at a time when few of the leading female players made the trip from Europe and the United States, lacking the funds or the inclination to travel.

In her own era, Serena had never had that luxury of picking up soft slams along the way. While many might have suggested that she had already established herself, without equivocation, as the greatest tennis player in history, and that she had already achieved more than Court, the American was motivated by the numbers. First Serena wished to equal Court, and then to surge ahead of her. She was also urged on by those in the sport who were increasingly uncomfortable with some of the views forcefully articulated by the Australian. In addition to opposing same-sex marriage, the athlete turned Christian minister had suggested tennis was 'full of lesbians', comments that resulted in a campaign for her name to be scrubbed off the Margaret Court Arena at the Australian Open.

By returning to the tour, Serena wouldn't just be chasing down Court and standing up for those the Australian had offended with her comments about same-sex relationships. She would be representing all working mothers, including those who went quietly about their business, a long way from the public eye.

After twenty years on the tour, Serena probably thought she was accustomed to the media and public scrutiny, that she could deal with the attention, the criticism and the trolling and also with all the pressures and stresses that her opponents would never truly experience, because of all the expectations loaded on to her. But, as it turned out, there was to be another greater level of pressure for Serena – the new mother would be watched more closely than ever before, by the media, the public and by her peers. She couldn't have anticipated that her return from maternity leave would turn out to be so eventful, culminating with a night of high emotion and controversy, yet again at the US Open.

◄ Winning the 2017 Australian Open made Serena the most successful player of the post-1968 Open Era.

GRAND SLAM PERFORMANCE

From 2008-18, Serena's serve was more effective at
the Grand Slams than on the WTA Tour:

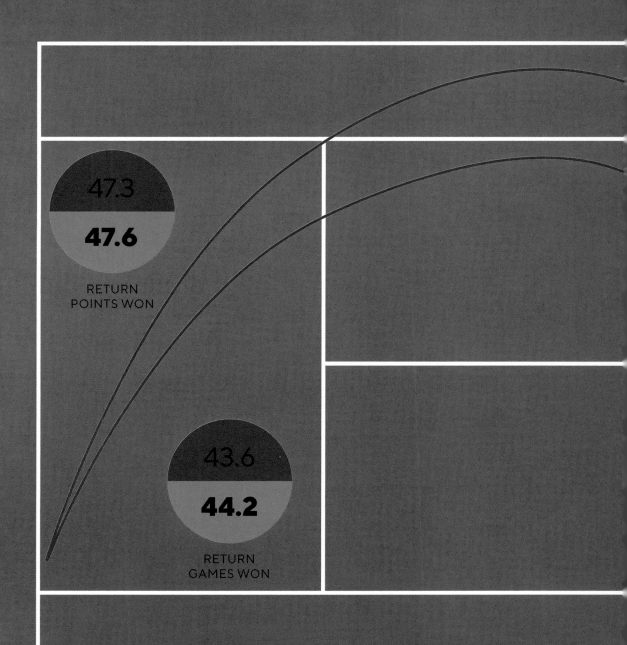

47.3
47.6

RETURN
POINTS WON

43.6
44.2

RETURN
GAMES WON

GRAND SLAMS

WTA TOUR

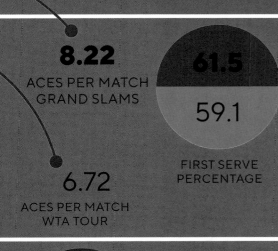

8.22

ACES PER MATCH
GRAND SLAMS

61.5

59.1

FIRST SERVE
PERCENTAGE

6.72

ACES PER MATCH
WTA TOUR

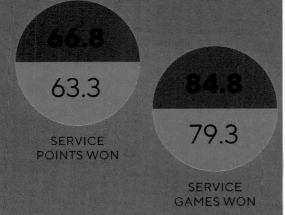

66.8

63.3

SERVICE
POINTS WON

84.8

79.3

SERVICE
GAMES WON

77.5

71.9

PERCENTAGE OF
MATCHES WON
WHEN IT WENT TO
THREE SETS

THE
MOTHER
OF ALL
CONTROVERSIES

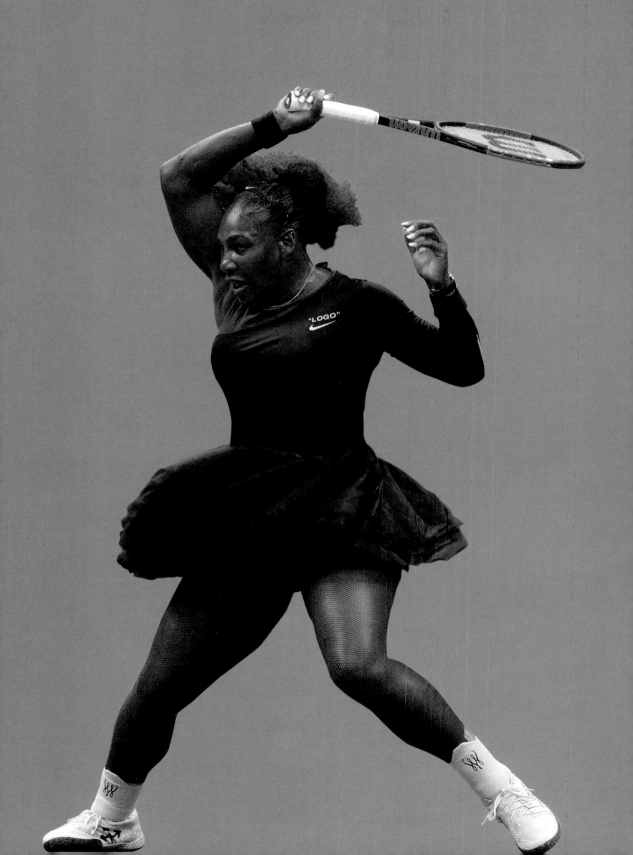

When you have appeared on as many billboards as Serena has, it's probably not going to give you the same thrill in your mid-thirties as it did at the beginning of your career and you perhaps become inured to them.

T hen, one spring day in 2018, she spotted four billboards by the side of a Californian highway approaching the Indian Wells Tennis Garden, near Palm Springs, and she was so touched, she cried. This wasn't yet another big-dollar campaign, orchestrated by a creative or advertising agency, but rather the work of her husband, Alexis Ohanian, who was trying to introduce a new word to the tennis lexicon. While every tennis fan is familiar with 'GOAT', which stands for the 'Greatest of All Time', Ohanian had rented that roadside space to brand his wife as 'GMOAT', or the 'Greatest Momma of All Time'. Those words appeared alongside giant images of their baby daughter, Olympia, and were designed to encourage Serena as she prepared for her first competitive tennis in fourteen months. The Indian Wells tournament was a mere six months after Serena became a mother, after a birth that had brought a slew of complications which might well have killed her. Bedridden for the first six weeks, she was understandably fatigued as her body recovered from the trauma of the blood clots, the haematoma and the operations. For a while, she didn't even have the energy to walk to her mailbox, let alone run and swing a tennis racket. She had hardly been training at full tilt. Despite her twenty-three Grand Slams, Serena was now an unranked, unknown quantity.

▶ Serena's catsuit made her feel like a 'warrior princess' at the 2018 French Open.

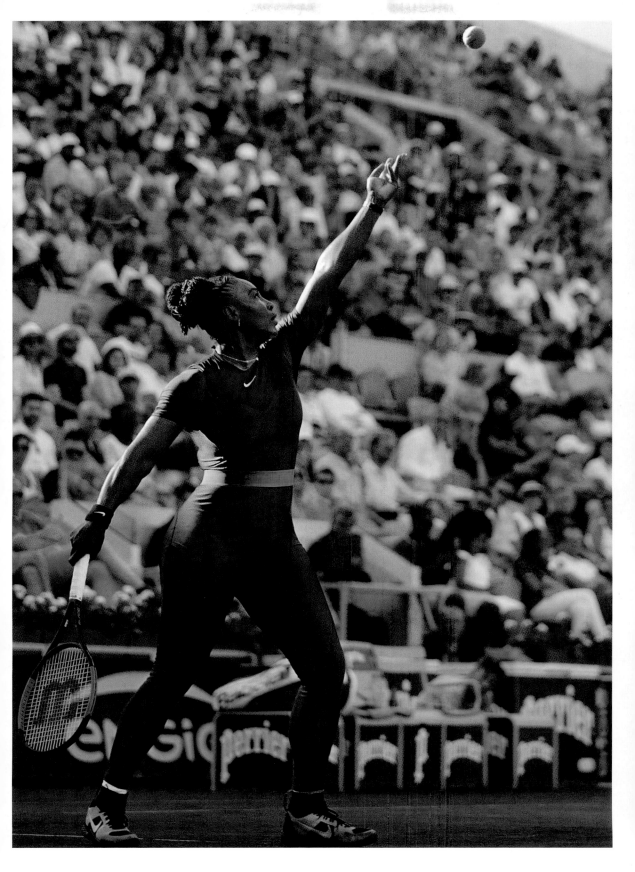

Driving into Indian Wells, looking out through teary eyes at her own personalised highway, Serena couldn't have realised that she was coming back to tennis too soon, that this was one occasion when she was too ambitious for her own good. In time, even her coach, Patrick Mouratoglou, would admit that she should have taken more time to recuperate and regain her fitness level, and put off resuming her quest for that twenty-fourth Grand Slam title.

While she won her first two matches in Indian Wells, she came up against Venus in the third round, and lost in straight sets to her sister. At her next event, in Miami, in late March, she lost her opening match to Japan's Naomi Osaka, also in straight sets, and was so aggrieved that she headed straight off in a waiting SUV without doing her mandatory news conference. Preferring to take the fine from the Women's Tennis Association for skipping that interview rather than explain herself to the media would turn out to be the least controversial of their two matches in 2018, the other at the US Open final.

Serena didn't play again until the French Open began, towards the end of May. In an interview published on the Women's Tennis Association website, just before the French Open, Mouratoglou said that Serena had 'felt the competition' in Indian Wells and Miami and that had shown her just how much she needed to do if she were going to win titles again.

At the same time, Serena was also adjusting to the new realities of being a working mother – trying to marry her tennis ambitions with a desire to be the best possible parent. They say the greatest tennis players need to be selfish – only by organising your life around your practice, training sessions, matches and travel can you possibly give yourself a chance of fulfilling your talent. That's where tennis runs into conflict with motherhood, and with selflessly putting your baby first and yourself second though, of course, it helps when you are able to afford a nanny and as much childcare as you require. Aside from Belgian Kim Clijsters, who won three of her four majors after becoming a parent, there were no women who had been Grand Slam champions and mothers during Serena's own lifetime. Even after Serena came back to the tour, Mouratoglou told *Time* he believed that some of the decisions she made

VOLLEYS

A look at Serena's volleys on her comeback in 2018 at Wimbledon and the US Open. Statistics taken over 7 matches in run-up to the finals.

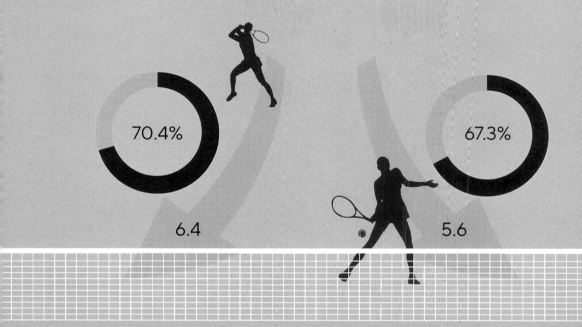

70.4%

6.4

67.3%

5.6

WIMBLEDON 2018

70.4% of points won when completed at the net

6.4 net approaches per set

0.3 approach shot winners per set

How hard did her opponents find it to pass her?

0 average passing shot winners per set

1.5 average passing shot forced errors per set

0 average passing shot unforced errors per set

US OPEN 2018

67.3% of points won when completed at the net

5.6 net approaches per set

0.9 approach shot winners per set

How hard did her opponents find it to pass her?

0 average passing shot winners per set

0.7 average passing shot forced errors per set

0.2 average passing shot unforced errors per set

MOTHERS & PREGNANCIES

Women who have won Grand Slam singles titles as a mother or while pregnant.

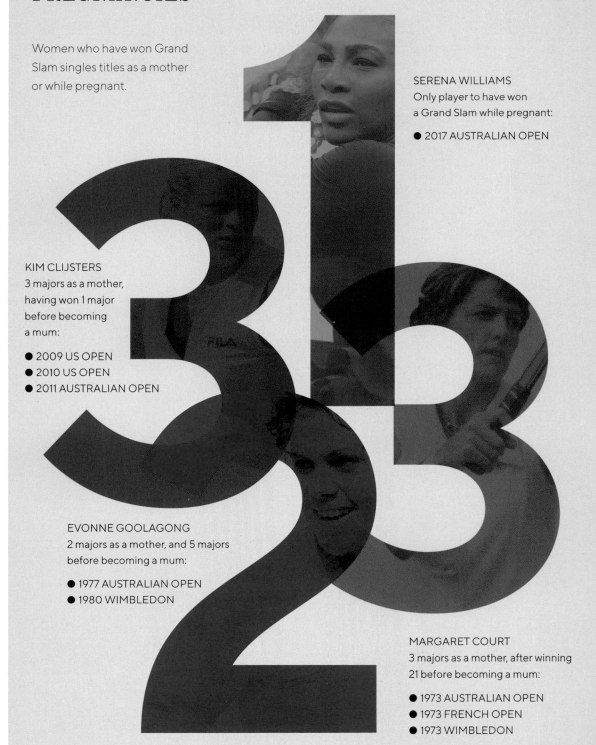

SERENA WILLIAMS
Only player to have won a Grand Slam while pregnant:

● 2017 AUSTRALIAN OPEN

KIM CLIJSTERS
3 majors as a mother, having won 1 major before becoming a mum:

● 2009 US OPEN
● 2010 US OPEN
● 2011 AUSTRALIAN OPEN

EVONNE GOOLAGONG
2 majors as a mother, and 5 majors before becoming a mum:

● 1977 AUSTRALIAN OPEN
● 1980 WIMBLEDON

MARGARET COURT
3 majors as a mother, after winning 21 before becoming a mum:

● 1973 AUSTRALIAN OPEN
● 1973 FRENCH OPEN
● 1973 WIMBLEDON

were 'taken through the angle of the family, where before, every decision was taken through the angle of tennis. This is a big difference. Even if you are Serena, if you want to be successful in tennis, tennis has to be priority number one.'

Of all the discussions that Mouratoglou had with the tennis player, the most delicate concerned breastfeeding. He wanted her to stop, believing that her nursing of Olympia was slowing down her return to something like her physical prime. Serena, though, wished to continue and found Mouratoglou's request that she switch from the breast to the bottle, 'absolutely hard to take from a guy'. She thought Mouratoglou couldn't possibly understand the connection between mother and child or that the best part of her day wasn't on the practice court, doing forehand drills or improving her serve, but rather feeding her daughter. 'You have the power to sustain the life that God gave her,' she disclosed. 'You have the power to make her happy, to calm her. At any other time in your life, you don't have this magical superpower.'

Eventually, she relented, though only after 'talking it through' with Olympia, telling her: 'Listen, Mommy needs to get her body back, so Mommy's going to stop now.' But when she stopped breastfeeding, that didn't end the anguish. On the practice court or in the gym, Serena, who hadn't anticipated feeling quite so attached to her daughter, told *Time* how she would often find herself thinking: 'I wonder what my baby is doing?'

On an emotional level, motherhood was more challenging than the American had anticipated, to the extent that she once cried when she couldn't find Olympia's bottle. In the nursery, as on the tennis court, she was striving for a perfection that wasn't achievable.

'Sometimes I get really down and feel like, man, I can't do this. No one talks about the low moments – the pressure you feel, the incredible letdown every time you hear the baby cry. I've broken down I don't know how many times,' she told *Vogue*. 'Or I'll get angry about the crying, then sad about being angry, and then guilty, like, "Why do I feel so sad when I have a beautiful baby?" The emotions are insane.' Serena had had periods of depression in the years before giving birth and had been open about

those dark times – her willingness to once again discuss her emotional state, and to talk about how she was feeling after becoming a mother, helped other new mums going through a similar experience.

She felt as though the post-natal lows were 'almost like the fourth trimester, part of the pregnancy'. Having to spend the first few weeks of motherhood in bed, rather than enjoying her baby, hadn't been easy, but, months later, she was still experiencing some 'rough' days, when she worried that she wasn't a good enough mother.

Writing on Instagram, Serena was open with her millions of followers about her insecurities as a mother, and how she found herself 'in a funk'.

I read several articles that said postpartum emotions can last up to three years, if not dealt with. I like communication best. Talking things through with my mom, my sisters, my friends, lets me know that my feelings are totally normal. It's totally normal to feel like I'm not doing enough for my baby. We have all been there. I work a lot, I train, and I'm trying to be the best athlete I can be. However, that means that although I have been with her every day of her life, I'm not around as much as I would like to be. Most of you moms deal with the same thing. Whether stay at home or working, finding that balance with kids is a true art. You are the true heroes. I'm here to say: If you're having a rough day or week, it's OK, I am too. There's always tomorrow.

There was also remorse for the photograph she had posted on Instagram of her post-pregnancy body – she had wanted the world to know that she was back in shape. But, like many pictures on the social media site, the image didn't quite match with reality. She would later admit to using a waist trainer to push in her stomach, and she 'hated' that she had 'fallen victim' to that, especially as a body-positive advocate, commenting that it put 'a lot of pressure on women, young and old'.

In half a century of professional tennis, only three women had landed Grand Slams after starting families: Court, Goolagong and Clijsters.

Becoming a parent changes how everyone views their work. Before becoming a mother, Serena had needed Grand Slam titles as a kind of affirmation of her talent and education and her alpha status. Now, though, her thinking had shifted. Whereas she had once *needed* Grand Slams, now she *wanted* them: 'That's a different feeling for me.'

Arriving in Paris in the spring, she had her first opportunity, in her first Grand Slam for almost a year-and-a-half, to join Margaret Court at twenty-four majors. There was another way in which she was trying to emulate Court – she was hoping to join the small club of mothers to have won majors. In half a century of professional tennis, only three women had landed Grand Slams after starting families: Court, Evonne Goolagong and Clijsters.

However, Paris was to result in two controversies, the first before the tournament had even started: many among her fanbase were furious that the world number four hundred and fifty-one wasn't among the thirty-two seeds. That would have given her some protection in a draw of one hundred and twenty-eight athletes, as seeded players can't meet another seed until the third round at the earliest. 'When I returned to tennis from maternity leave, I was penalised for taking time off,' Serena would write in an article for *Fortune* magazine, published on International Women's Day in March 2019.

The second controversy concerned what Serena chose to wear on court – a black catsuit, designed to help protect her against blood clots, which also made her feel like a 'warrior princess' from Wakanda, a fictional African nation from Marvel's *Black Panther*. Some within the French Tennis Federation were extremely unhappy with what Serena had worn, the president Bernard Giudicelli telling *Tennis* in August 2018, three

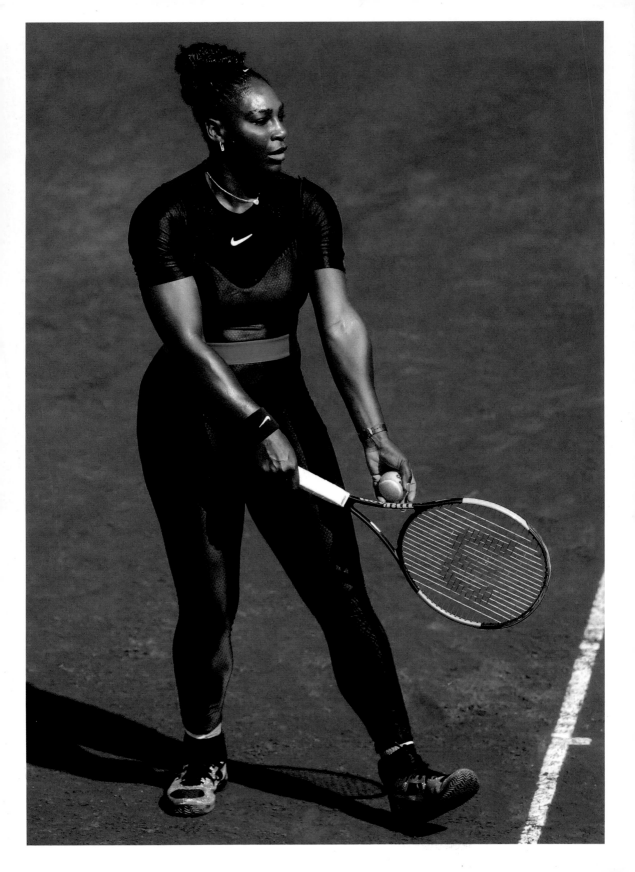

months after that year's tournament, that the catsuit would 'no longer be accepted' at Roland-Garros: 'I believe we have sometimes gone too far – you have to respect the game and the place'.

Whether it was the catsuit, or more likely the work she had been putting in after Miami, Serena progressed to the fourth round, where she was scheduled to play Maria Sharapova. Unfortunately, that match never happened – about an hour before they were due on court, Serena withdrew from the tournament, citing a pectoral injury. For all the disappointment that followed, her performance at the French Open suggested that she was playing herself back into form, and Serena still had the best part of a month to treat her injury before Wimbledon.

The normal rules simply don't apply to Serena. At the start of the 2018 Wimbledon Championships, which was only the fourth tournament of her comeback, she was only just ranked inside the world's top two hundred players. Yet Martina Navratilova, a former great and also an astute judge of the modern game, was openly describing Serena as the favourite for the Venus Rosewater Dish. Serena could have been the world number 1,000, and still she would have been Navratilova's pick. As the Wimbledon fortnight progressed, it appeared as if Navratilova's prediction would be proved right, with Serena dropping just one set in her first six matches, in the quarter-final against Italy's Camila Giorgi. In reaching the final, where she would play Germany's Angelique Kerber, Serena extended her undefeated run on the Wimbledon grass to twenty matches. Defeat on those lawns would have been a distant memory for Serena, who hadn't lost at the All England Club since 2014 – she was the champion in 2015 and 2016, and was absent in 2017, when pregnant.

Every Wimbledon final comes with great historical heft, but none more so than when Serena walked on to Centre Court just two sets away from becoming the joint most successful player in history with Court, on a day she dedicated to 'all the moms out there who've been through a lot'. Only Kerber stood in her way and unfortunately, it just was not meant to be. While Serena didn't play with quite the same freedom that she had done in her first six rounds, and made too many errors, Kerber turned in a fine performance, going on to win in straight sets.

◄ Some within the French Tennis Federation didn't like the catsuit Serena wore at Roland-Garros in 2018.

►► Serena reached the 2018 Wimbledon final, coming close to winning a twenty-fourth Grand Slam singles title.

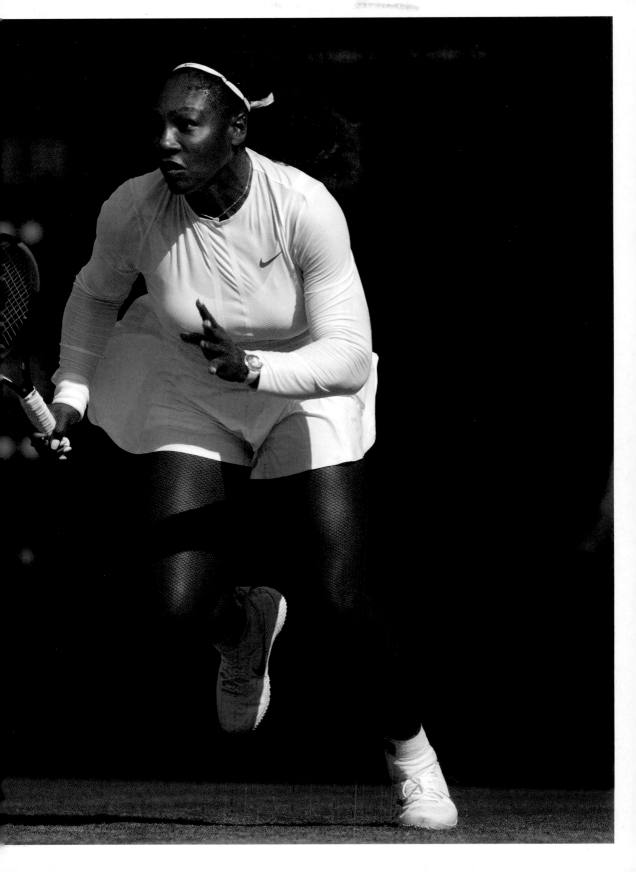

Should Serena have viewed the tournament as a missed opportunity? Or as an encouraging sign that she could still compete at the highest level? Perhaps both. Less than two months later, she would appear in another Grand Slam final, at the US Open in New York City, with another chance to score a twenty-fourth major. It would prove to be the most emotional match of her tennis life. It would also be the most contentious.

● ● ●

Any time an umpire is given a security escort as he walks off court at the end of a Grand Slam final, and then doesn't appear at the post-match ceremonies, you know the tournament is seriously concerned about unrest among the crowd. Even during quiet and uneventful matches, the Arthur Ashe Stadium at the US Open can be a volatile, febrile place, so the 24,000 New Yorkers were never going to keep their opinions to themselves when they believed the Portuguese official, Carlos Ramos, had overstepped his authority in dealing with a raging Serena. Aside from the player's blunt words to Ramos – she called him a 'liar' and a 'thief' – the soundtrack to the night was the booing, the rising indignation and the fury of the biggest, angriest audience in tennis. Somehow Serena's outfit, a tutu, inspired by the quiet grace and refinement of ballerinas, didn't sit right with how the day played out.

As Martina Navratilova would later remind everyone, Serena came into the match with 'some serious scar tissue' from previous appearances at the US Open. Yet of all the chaotic nights that she had been involved in at Flushing Meadows – the 2004 quarter-final remembered for the questionable line calls, the 2009 semi-final, when she threatened to stuff a tennis ball down a line judge's throat, and the 2011 final, when she called the umpire 'a hater' and 'unattractive inside' – this one was the most unsettling.

Possibly even without all the dramas, Serena would have lost, such was the level of Naomi Osaka's tennis. Serena wasn't the only one chasing history. Her desire to win a twenty-fourth Grand Slam was colliding with Osaka's own ambition to become the first Japanese player

▶ At the 2018 US Open, Serena appeared in the second Grand Slam final of her comeback.

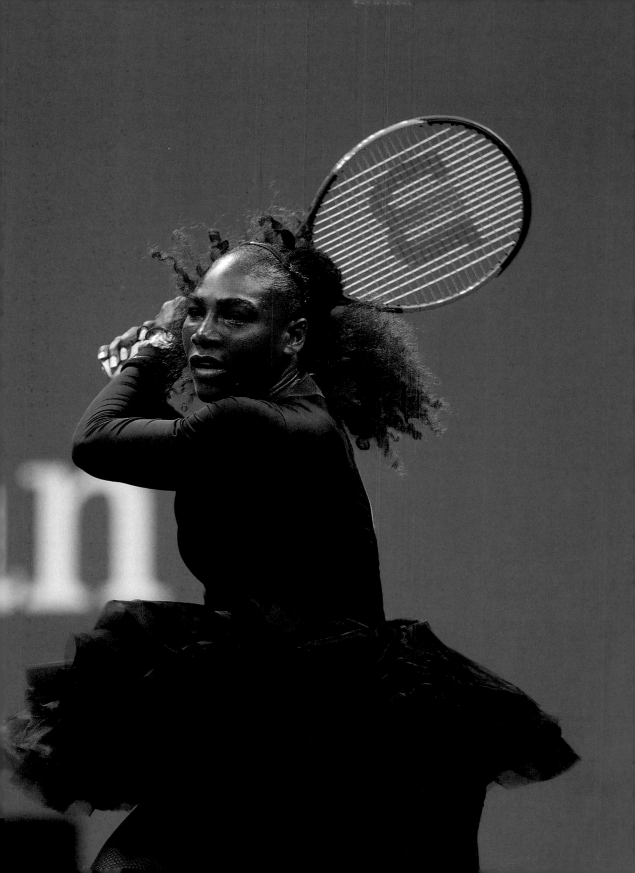

...mid-match coaching is considered a grey area, some taking the view that everyone's doing it and it should be allowed.

to win a Grand Slam. Playing against her idol didn't seem to unnerve Osaka, who would herself become a tennis idol to others that night, and it was the Japanese woman who took the opening set.

It was early in the second set when umpire Ramos made his first intervention, spotting Patrick Mouratoglou making hand gestures which appeared to indicate that he wanted the American to move forward. While signals from the box are regarded in the rulebook as illegal, mid-match coaching is considered a grey area, some taking the view that everyone's doing it and it should be allowed. Not Ramos, however, who was already known among the players for his strictness, for robustly enforcing the rules. He reaffirmed that reputation by giving Serena a code violation for coaching. It didn't matter that it was Mouratoglou and not his player who had transgressed – it's the player who is reprimanded and punished for whatever the coach happens to be doing in the stands.

In the first of many exchanges with Ramos during the match, Serena denied she had been looking to Mouratoglou for signals. 'I don't cheat to win, I'd rather lose,' she said. 'If he's giving me a thumbs-up, he's telling me to come on. We don't have any code, and I know you don't know that, and I understand why you thought that was coaching, but I'm telling you it's not.'

The argument between player and umpire escalated a few minutes later when Serena smashed her racket on to the ground. As she had earlier been warned for coaching that brought a point penalty. In Serena's view, Ramos owed her an apology for suggesting that she had been receiving illegal coaching, and she didn't just want a private apology – she demanded Ramos make the announcement over the public address

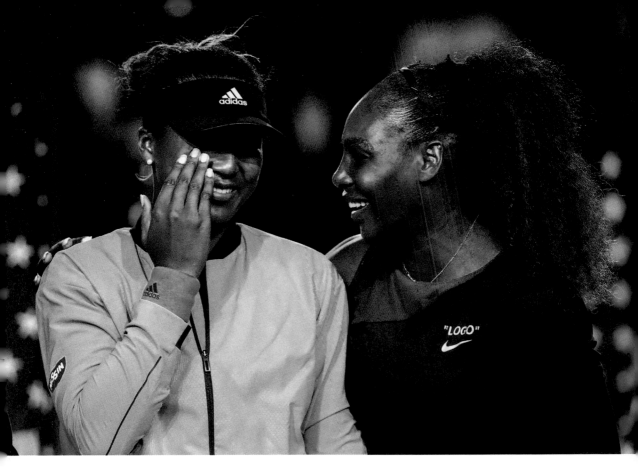

system. However forcefully Serena made her point, Ramos was not going to say sorry, publicly or privately.

Once again, the American was getting into difficulties with officials at her home Grand Slam – she had never experienced such conflict and tension in Melbourne, Paris and London. If something happened, it always seemed to be while playing in New York City.

'This is unbelievable, every time I play here, I have problems. I did not have coaching, I don't cheat. You need to make an announcement,' she said to Ramos. 'You owe me an apology. I have never cheated in my life. I have a daughter and stand for what's right for her and I have never cheated. You owe me an apology.'

The argument continued at the next change of ends, with the player's language considered so inflammatory that she received a third code violation: 'For you to attack my character, then something is wrong. It's wrong,' she railed against the umpire. 'You are attacking my character.

▲ Serena with Naomi Osaka after the controversial 2018 US Open final.

You will never, ever, ever be on another court of mine as long as you live. You are the liar. You owe me an apology. Say it. Say you're sorry. How dare you insinuate that I was cheating? You stole a point from me. You're a thief, too.'

Having already received a warning, and a point penalty, that outburst resulted in a game penalty, Osaka jumping into a 5–3 lead. That left Osaka just a game short of beating her idol in straight sets to score her first Grand Slam title.

In a hold-up in play, Serena spoke to tournament referee Brian Earley and Women's Tennis Association supervisor Donna Kelso; she made accusations of sexism against Ramos, saying that she would have been treated more leniently if she had been a man. 'You know my character. This is not right. This has happened to me too many times. To lose a game for saying that, it's not fair. I mean, it's really not. Do you know how many other men do things that are – that do much worse than that? This is not fair. There's a lot of men out here that have said a lot of things, but if they're men, that doesn't happen to them.' Once more, Serena's complaints came to nothing; she would not be getting a reprieve or an apology.

Serena held serve to stay in the match. In such astonishing circumstances, with boos all around the stadium, perhaps other players of Osaka's age would have folded when asked to serve out the match against a player of Serena's calibre; the American could then have found a way of turning the final around. Twenty-year-old Osaka, however, playing with great poise and composure, somehow held it together.

In what was one of the most excruciating post-match ceremonies, the umpire was missing, as was any sense of normality; the booing rained down from the stands during the prize giving. While Osaka pulled her sunvisor down and began to weep, apologising to the crowd for not giving them the home win they wanted, Serena urged them to stop booing, and to show respect for the new champion. When the crowd did quieten down, it was too late to stop the chaos from spoiling Osaka's night: she never experienced the pure joy, the unadulterated happiness and relief, that every other first-time major champion had done. Winning

WINNERS AND UNFORCED ERRORS

Ratio of winners to unforced errors – sample of
players from the 2018 US Open

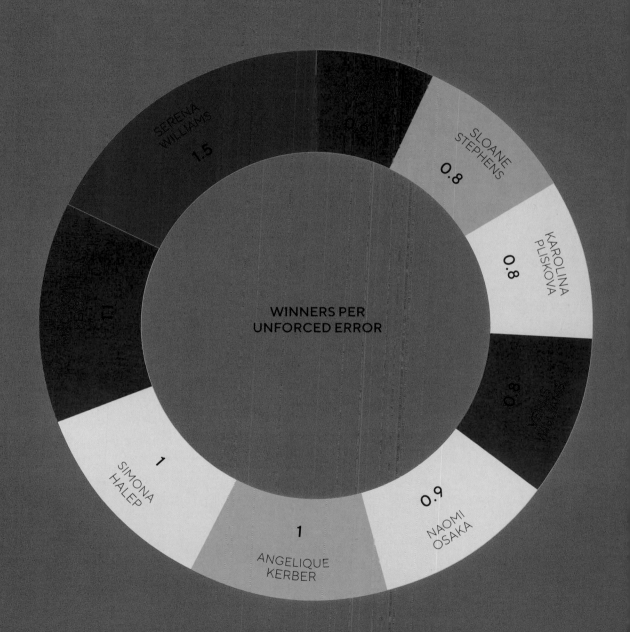

WINNERS PER
UNFORCED ERROR

SERENA WILLIAMS 1.5

SLOANE STEPHENS 0.8

KAROLINA PLISKOVA 0.8

0.8

0.9

NAOMI OSAKA

ANGELIQUE KERBER 1

SIMONA HALEP 1

WINNING PERCENTAGE IN DECIDING SETS

Serena's winning percentage
year-by-year.

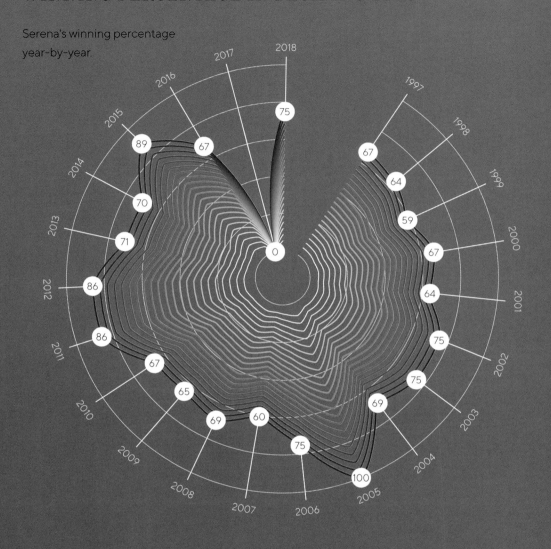

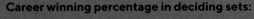

Career winning percentage in deciding sets:

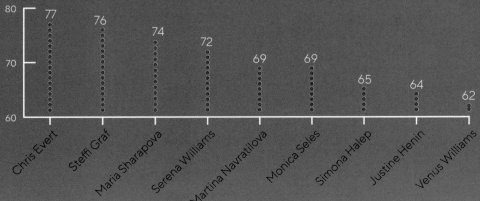

the tournament in such a fashion had been 'bittersweet', she would say a few days later, and 'not necessarily the happiest memory for me'.

Naturally, that wasn't the end of the drama, which rolled into the night and beyond, with Serena contending in her media interviews that her arguments should be viewed as her championing of women's rights, of allowing 'strong women' to be emotional. 'I'm here fighting for women's rights and for women's equality and all kinds of stuff,' she said. This was a subject she would return to in her article for the March 2019 edition of *Fortune* magazine: 'Women are deemed "emotional", "hysterical" or "aggressive" while men who behave in the same way face no such consequences. They are perceived in a completely different light.'

In his own post-match debrief, Mouratoglou confessed that he had been coaching and also suggested that Osaka's coach, Sascha Bajin, Serena's former hitting partner, had been doing exactly the same from the other end of the stadium. When his comments were relayed to Serena, she was confused, however: she had never believed that Mouratoglou was passing signals to her. And why would he? That wasn't how she operated. On this issue, the player is a traditionalist, believing that tennis is a one-on-one sport and that players should be happy to compete on their own without relying on their coaches.

In an unseemly game of diplomatic tit-for-tat, the governing bodies of tennis quarrelled over the meaning of the evening, with resulting statements and comments from the Women's Tennis Association, the United States Tennis Association and the International Tennis Federation.

'The WTA believes that there should be no difference in the standards of tolerance provided to the emotions expressed by men versus women,' the WTA's chief executive Steve Simon said. 'We do not believe that this was done last night.' The president of the USTA, Katrina Adams, said men 'are badgering the umpire on the changeovers and nothing happens. We watch the guys do this all the time. There's no equality when it comes to what the men are doing to the chair umpires and what the women are doing, and I think there has to be some consistency across the board.' Yet the ITF countered that Ramos had acted 'at all times with professionalism and integrity'. 'It is understandable that this high-profile and regrettable

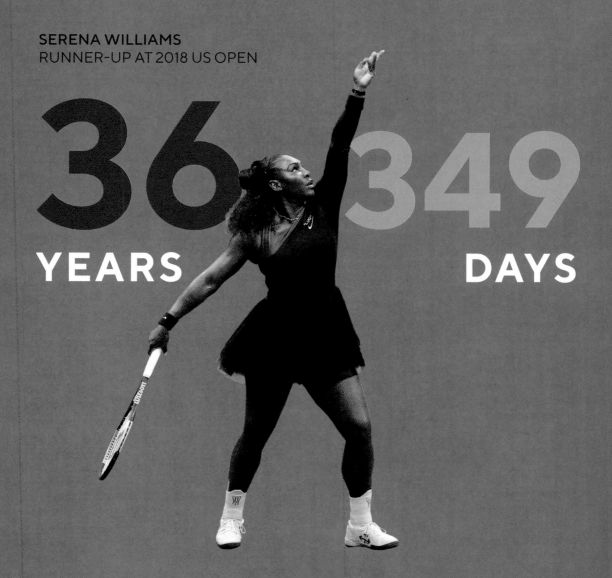

OLDEST GRAND SLAM FINALISTS IN THE OPEN ERA

Serena was 35 years and 125 days old when she won the 2017 Australian Open title, extending her record as the oldest woman in the Open Era to win a Grand Slam title – but the majors have seen even older finalists.

SERENA WILLIAMS
RUNNER-UP AT 2018 US OPEN

36 YEARS 349 DAYS

MARTINA NAVRATILOVA
RUNNER-UP AT 1994 WIMBLEDON

37
YEARS

258
DAYS

VENUS WILLIAMS
RUNNER-UP AT 2017 WIMBLEDON

37
YEARS

29
DAYS

▶ Nothing divides a
room - or the sport -
like a Serena
controversy.

incident should provoke debate. At the same time, it is important to remember that Mr Ramos undertook his duties as an official according to the relevant rule book. Mr Ramos' decisions were in accordance with the relevant rules and were reaffirmed by the US Open's decision to fine Ms Williams for the three offences.'

Nothing, it seems, divides a room – or, indeed, splits the sport or the wider public – like a Serena controversy, and this was the third of her comeback, after the debates about being denied a French Open seeding and wearing a catsuit. While the tennis had long since stopped, the arguments continued for days afterwards, to the extent that the champion, Osaka, sadly became lost in all the discussions.

Even legends of the sport took opposing views. 'When a woman is emotional, she's "hysterical" and she's penalised for it. When a man does the same, he's "outspoken" and there are no repercussions,' said Billie Jean King. 'Thank you, Serena Williams, for calling out this double standard. More voices are needed to do the same.'

Navratilova, though, had a different take on the night. 'It's difficult to know, and debatable, whether Williams could have gotten away with calling the umpire a thief if she were a male player. But to focus on that, I think, is missing the point,' she wrote in a column for the *New York Times*.

'If, in fact, the guys are treated with a different measuring stick for the same transgressions, this needs to be thoroughly examined and must be fixed. But we cannot measure ourselves by what we think we should also be able to get away with. In fact, this is the sort of behaviour that no one should be engaging in on the court. There have been many times when I was playing that I wanted to break my racket into a thousand pieces. Then I thought about the kids watching. And I grudgingly held on to that racket.'

The reminder of how many young children, and adults too, have idolised Serena came from her conqueror. Osaka had always admired Serena, and the final hadn't changed that. Hugging her opponent at the net, Osaka 'felt like a little kid again'. For both players, it was the only moment of comfort that night.

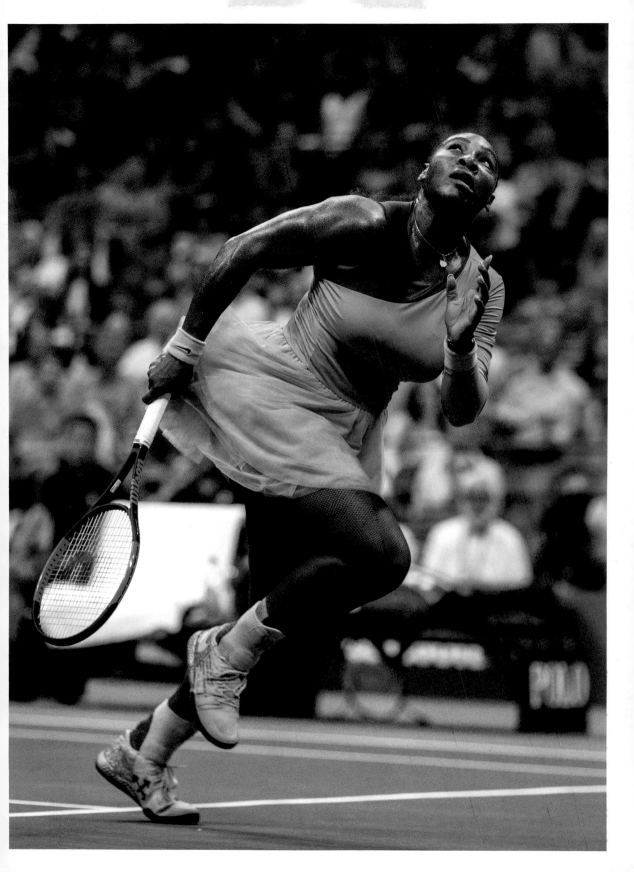

RETURNING FROM MATERNITY LEAVE

The numbers behind Serena's comeback in 2018 – she returned at the Indian Wells tournament in March 2018, which was her first competitive tennis since winning the Australian Open in January 2017.

17

GRAND SLAM
MATCHES PLAYED

FINALIST-
WIMBLEDON 2018
US OPEN 2018

88

WINNING
PERCENTAGE

15

2

1

WINS

DEFEATS

WITHDRAWALS

24

TOURNAMENT
MATCHES PLAYED

0 TITLES
WON

75

WINNING
PERCENTAGE

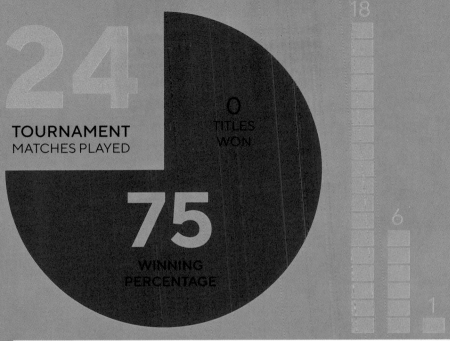

18

6

1

WINS

DEFEATS

WITHDRAWALS

3

4

WINS

DEFEATS

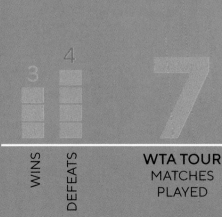

7

WTA TOUR
MATCHES
PLAYED

43

WINNING
PERCENTAGE

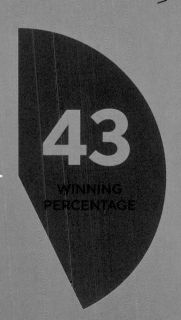

EPILOGUE

A year is a long time on the tennis road: twenty years among the sport's elite, of contending for and winning Grand Slams, is almost impossible to comprehend. The 2019 season would bring the twentieth anniversary of Serena Williams' first Grand Slam title, at the 1999 US Open.

Naturally, much had changed in Serena's world in that time, both on and off court. Life was certainly more complicated as a 37-year-old wife and mother of one, and the pressures and expectations that came with taking a swing at history and the record books, than it had been when she was a 17-year-old kid just starting out. Deep down, though, nothing had really changed. Serena's love for tennis, and her lust for competition, were just the same at the 2019 Australian Open as they had been in 1999 at Flushing Meadows – or, going back even further in time, to her childhood playing with Venus in Compton.

Travelling the tennis road takes it out of you like no other professional sport – physically, mentally and emotionally – but somehow in 2019 Serena was still hustling for Grand Slam titles, as ambitious as she had ever been, still aiming to put herself above Margaret Court's all-time record of twenty-four singles majors. That was clear from her disgust

▶ Twenty years after winning the 1999 US Open, Serena was still contending for Grand Slam titles.

and disappointment at Melbourne Park when she lost the quarter-final, in which she had led 5–1 in the third set and held four match points, to Czech Karolina Pliskova.

Above all, Serena will be remembered as a tennis player who, whatever her age, circumstances or the challenges she might have been facing away from tennis in that moment, doesn't deal in half-measures. Whatever the other apparent contradictions of Serena – her genius in conflict with her occasionally self-destructive side, her ambition and self-belief abutting her depression and self-doubt, and her status as tennis icon and idol while also being one of the most heavily fined players in the sport's history – you can be sure she gives her all, on and off the tennis court. Serena is the most successful of all tennis players in the Open Era, in no small part because she is also the most uncompromising.

A line from the 2019 'Dream Crazy' advert for her clothing sponsor Nike encapsulates her approach. Commenting on how some might consider her 'crazy' for 'winning twenty-three Grand Slams, having a baby and then coming back for more', Serena said: 'So if they want to call you crazy? Fine. Show them what crazy can do.'

◄ Serena has never dealt in half-measures.

BIBLOGRAPHY

NEWSPAPERS, WEBSITES AND MAGAZINES

BBC website
ESPN
Forbes
Fortune
The Guardian
Harper's Bazaar
The Independent
The Mail
Marie Claire
Miami Herald
The New Yorker
The New York Times
Sports Illustrated
The Telegraph
Time
The Times
Vanity Fair
Vogue
Wall Street Journal
WTA website

BOOKS

Mouratoglou, Patrick – *The Coach,* Wymer Publishing, 2017

Sharapova, Maria – *Unstoppable: My Life So Far*, Particular Books, 2017

Williams, Richard – *Black and White: The Way I See It,* Atria Books, 2014

Williams, Serena – *My Life: Queen of the Court,* Simon & Schuster, 2010

DATA SOURCES

Where applicable, data is correct to the end of the 2018 season.

Page 17 *Women's Tennis Association (WTA);* **22** *WTA and Game Insight Group (from a selection of matches at the Australian Open);* **30** *Wimbledon/IBM (from a selection of matches at Wimbledon);* **41** *Grand Slams;* **42** *Grand Slams;* **48** *Game Insight Group (from a selection of matches at the Australian Open);* **54** *WTA and Grand Slams;* **62** *WTA;* **66** *US Open/IBM and Game Insight Group (from a selection of matches at the Australian Open);* **74** *WTA;* **78** *WTA;* **89** *Internet Movie Database;* **90** *WTA and Grand Slams;* **93** *WTA;* **98** *Laureus;* **100** *WTA, Grand Slams and International Tennis Federation (ITF);* **106** *WTA and Grand Slams;* **112** *WTA and Grand Slams;* **114** *WTA and Grand Slams;* **118** *WTA, Grand Slams and ITF;* **123** *WTA;* **132** *WTA and Grand Slams;* **140** *WTA and Grand Slams;* **144** *WTA and Grand Slams;* **146** *WTA;* **149** *WTA and ATP;* **150** *WTA;* **156** *WTA and Grand Slams;* **160** *WTA;* **164** *WTA, Grand Slams, ATP and ITF;* **166** *Forbes;* **167** *WTA;* **168** *WTA;* **174** *WTA and ATP;* **180** *WTA;* **186** *WTA, Grand Slams and ITF;* **189** *WTA, Grand Slams and ITF;* **190** *WTA;* **195** *WTA;* **198** *WTA and Grand Slams;* **205** *2018 Wimbledon and 2018 US Open;* **206** *WTA and Grand Slams;* **219** *2018 US Open;* **220** *WTA;* **221** *WTA and Grand Slams;* **226** *WTA and Grand Slams*

PICTURE CREDITS

Getty (Mike Hewitt/Staff) 2, 129, (Mike Stobe/Stringer) 5, (Julian Finney/Staff) 7, (Quinn Rooney/Staff) 10, 120-121, 182, (Jamie Squire/Staff) 13, (Paul Harris/Contributor) 15, 18(Caryn Levy/Contributor) 21, (Al Bello/Staff) 25, (Mark Sandten/Staff) 29, 34, (Visionhaus/Contributor) 32, (Rick Maiman/Contributor) 39, (AFP/Stringer) 41, (MIKE NELSON/Staff) 45, (Erza Shaw/Staff) 47, 80, (Clive Brunskill/Staff) 48, 49, 52-53, 70-71, 106-107, 108, 124, 186-187, (Professional Sport/Contributor) 50, 72, (Nick Laham/Staff) 56-57 (ODD ANDERSEN/Stringer) 59, (Vince Bucci/Stringer) 65, (Tim Clayton – Corbis/Contributor) 67, 179, 212-213, 223, 225, (Ryan Pierse/Staff) 77, 86-87, (The AGE/Contributor) 83, 97 (DOMINIC LIPINKSKI/Stringer) 93, (Cynthia Lum/Contributor) 94-95, 206, (Cameron Spencer/Staff) 99, 192-193, 229, (WILLIAM WEST/Staff) 101, 169, (Icon Sports Wire/Contributor) 103, (Jim McIsaac/Staff) 105, (CARL DE SOUZA/Staff) 110, (GREG WOOD/Staff) 116, (MARTIN BERNETTI/Staff) 126, (Michael Dodge/Stringer) 135, 196, (Matthew Ashton/Contributor) 136, (LUIS ACOSTA/Staff) 138, (Mike Kemp/Contributor) 142-143, (Mike Pont/Contributor) 154, 181, (WPA Pool/Pool) 157, (CBS Photo Archive/Contributor) 161, (Will Russell/Stringer) 165, (Jon Kopaloff/Contributor) 170, (Alberto E.Rodriguez/Staff) 172-173, (SAEED KHAN/Staff) 177, (Leo Mason/Popperfoto/Contributor) 183, (Elsa/Staff) 201, 206, 215, 230, (THOMAS SAMSON/Contributor) 203, (Tony Duffy/Staff) 206, (Rolls Press/Popperfoto/Contributor) 206, (Anadolu Agency/Contributor) 222, (Gary M. Prior/Staff) 223; **Alamy** (Allstar Picture Library/Alamy Stock Photo) 26, 36, (Everett Collection Inc/Alamy Stock Photo) 89, (PCN Photography/Alamy Stock Photo) 158-159, (Frank Molter/Alamy Stock Photo) 210, (Xinhua/Alamy Stock Photo) 217

INDEX

Page numbers in *italic* type refer to pictures and diagrams.

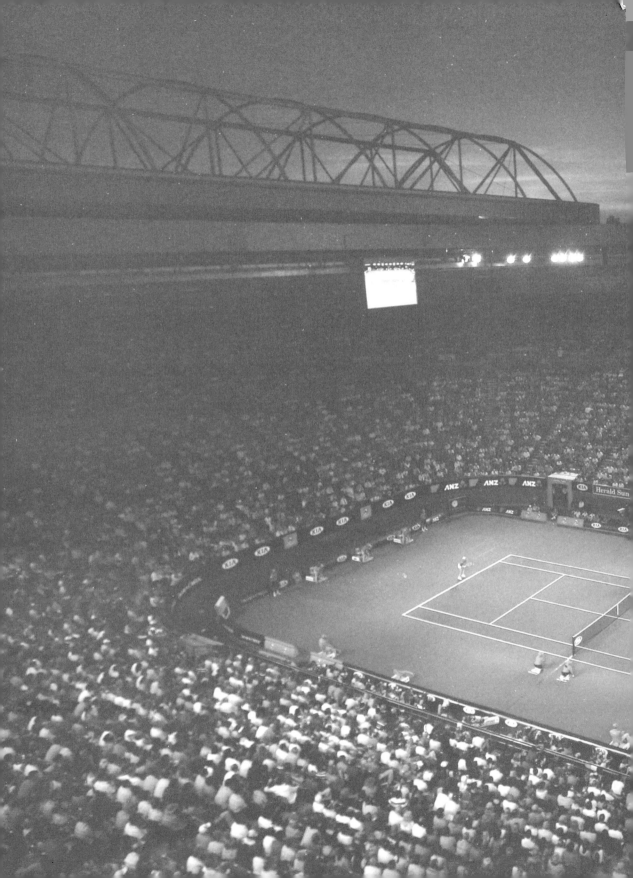